FACE TIME

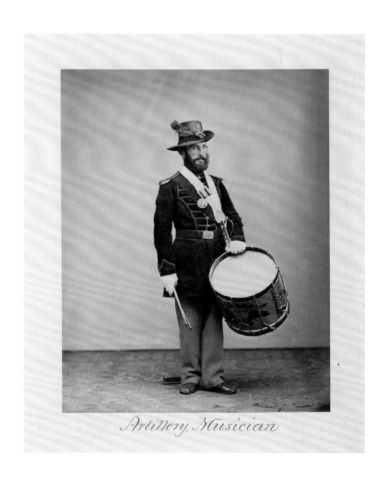

Artillery Musician

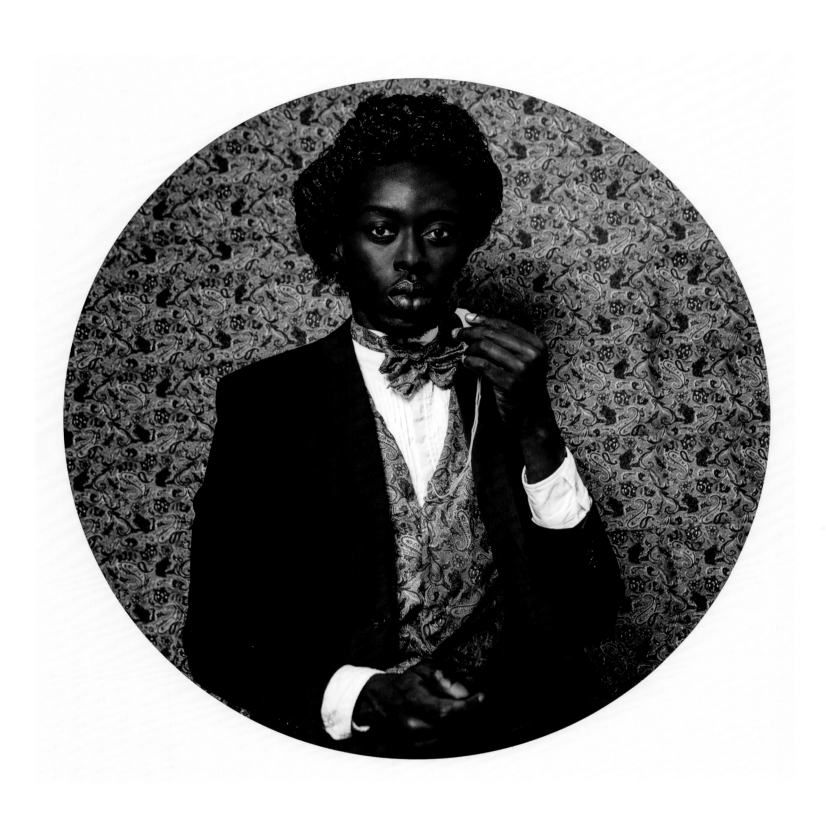

p. 1 **Attributed to Oliver H. Willard**
Artillery, Musician, 1866

p. 2 **Omar Victor Diop**
Frederick Douglass 1818–1895, 2014,
from the series 'Diaspora', 2014

pp. 4–5 **Nigel Shafran**
The Spice Girls (Mel B; Geri Halliwell;
Emma Bunton; Victoria Beckham; Mel C), 1997

Phillip Prodger

FACE TIME

A History of the
Photographic Portrait

Contents

Preface

Portraiture is one of the most dynamic and exciting fields of art, yet we rarely stop to consider what it means, or how and why portraits are made. This book attempts to address these questions by highlighting key issues in the making and viewing of photographic portraits. It is a history written from an art historian's point of view, but it is not a conventional one, since it does not attempt to trace influences or changes in practice over time in a systematic way. Nor is it a comprehensive survey or a 'best of', since it omits any number of distinguished artists, including many whom I personally know and admire. It is, in some ways, a personal and anecdotal book. The examples reproduced herein were chosen not just for their excellence, but for the variety of approaches they represent, and because I believe they touch on issues of lasting interest in photographic portraiture.

I have worked with portraits throughout my career, but it was not until I became Head of Photographs at the National Portrait Gallery, London, that I began thinking critically about the nature and importance of portraiture as a discipline. My second day on the job, I attended my first gallery curatorial meeting. Held once every two weeks, it was the forum where senior curators and administrators worked through questions about the collection, including loan requests, auction items and new acquisitions, whether by gift, purchase or bequest. All the curators from every division, including myself, were asked to weigh in on everything being considered. If a seventeenth-century painted portrait was offered, for example, a curator from that division would probably introduce it, but the Director, Chief Curator, and a majority of the other curators had to agree before it could be approved. The same was true with photography. If the photography division wanted to acquire a picture, we had to persuade colleagues that it belonged in the collection, including some who had little background in the field. Every time a work came in, we had to defend it.

On that particular day, the agenda included an offer from a commercial gallery proposing to sell a three-quarters-scale, full-length oil painting by the artist Alessandro Raho of the singer, songwriter and philanthropist Bryan Ferry (see opposite). The curator who presented it was on the fence about it herself, so it was not a case of trying to convince the others, so much as trying to gauge interest around the room.

The curator began by giving us a brief biography of Bryan Ferry. Born in 1945, he co-founded the avant-garde band Roxy Music in 1970. The band did not enjoy commercial success until later in the 1970s and early 1980s, with epoch-defining hits like Dance Away and More Than This. The band broke up and reformed over time, but Ferry thrived as a solo artist, with more singles including the anthemic Slave to Love. During his early years as a performer, he collaborated with influential musicians such as Brian Eno, Phil Manzanera, Mark Knopfler, Nile Rodgers and many others. His stage persona and dress sense contributed to his appeal, becoming a touchstone of the 1980s New Wave.

Everyone at the meeting listened as this biography was recounted – the proof, in a sense, that Ferry's achievements merited his inclusion in the collection. Not just anyone can have their portrait enter the gallery, since, according to its own rules, it prioritizes portraits of 'people who have made or are making significant contributions to British society and culture'. 'Significant' does not necessarily mean 'good': in theory, criminals, corrupt politicians, traitors and dissidents might find a place in the collection. In practice, however, the gallery rarely seeks out portraits of villains. It still sees itself, much as its founders did in the mid-nineteenth century, as an aspirational place – a beacon of achievement, to motivate, encourage and inspire.

The curatorial committee began looking closely at Raho's picture. It was an excellent piece, painted in his signature style – a lone figure set against a milky white background, with little sense of floor or horizon, other than twin shadows cast at the feet. The lighting was bright and balanced, filling the face and chin. The committee noted details such as the way Ferry's right hand was slid awkwardly into a trouser pocket, pulling at the cloth and displacing the belt buckle slightly, a pouch of fabric gathered above the waist. The other hand rests at the side, the thumb touching the forefinger absentmindedly. The overall effect is of someone interrupted, as if on the way to do something else. One or two committee members felt the facial expression was a little distant, but others argued that the ambiguity added to its charm. I remember, too, the long

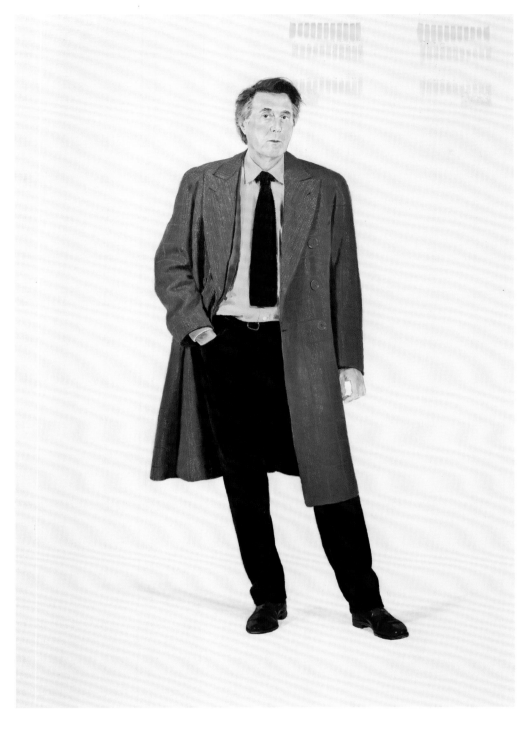

Alessandro Raho
Bryan Ferry, 2014

portrait; major figures can have substantially more. At the time of writing, for example, the gallery held 922 portraits of Queen Elizabeth II, and 213 portraits of Winston Churchill. Paul McCartney has 55.

In the case of Ferry, the previous acquisitions had been very good. One of the best was Swannell's 1985 picture of the musician shortly after he launched his solo career (see p. 8). He is shown from the waist up against a brooding studio backdrop, resembling gathering storm clouds, as if they were the product of his turbulent creative mind. Swannell positioned Ferry on the right side of the picture, an unlit cigarette dangling from his lips, his eyes downcast, and his long hair flicked across his brow. Placing him on one side of the picture made him look isolated and withdrawn. He wore a light-coloured shirt and a dark jacket, creating a deep 'V' of light at his chest, rising up to his head. The picture presents Ferry as a romantic figure, moody and introspective, while capturing the distinctive fashions of the 1980s – the long thin collar points, the shoulder pads, and the glam sweep of his hair.

In the gallery's boardroom, with rain now falling gently outside the window, the discussion then took an unexpected turn. One curator pointed out that the Raho painting was made in 2014, long after Bryan Ferry first became famous. If we were going to have a painting, they said, it should be from a critical period of achievement, when he was still with Roxy Music, or early in his solo career. It would be great to have some representation of Ferry in later years, they reasoned, since he remained active as a musician and philanthropist, but perhaps a photograph would suffice to show that. A consensus grew that if the gallery were to acquire a painting, it should be from that critical, early period.

On the face of it that made sense, but the more I thought about it, the more troublesome this idea became. All photography curators get used to hearing photographs described as secondary to paintings, so the idea that the gallery's definitive picture should be a painting, while a photograph would suffice for a lesser, more 'documentary' depiction, was not too surprising. What was different – an idea that I had never heard articulated quite so succinctly – was that a portrait made during a particular period of a person's life was more authentic than one made later. In other words,

green jacket being a topic of discussion, and whether this was typical for him.

It turned out that the gallery already owned eight photographs of Ferry and one of the entire 1974 lineup of Roxy Music, by various makers including Andrew Catlin, Bob Carlos Clarke and John Swannell. This, in turn, triggered more discussion. The gallery is often faced with the question of how many portraits of a given individual are enough. It is not always the case that each sitter is represented by just one

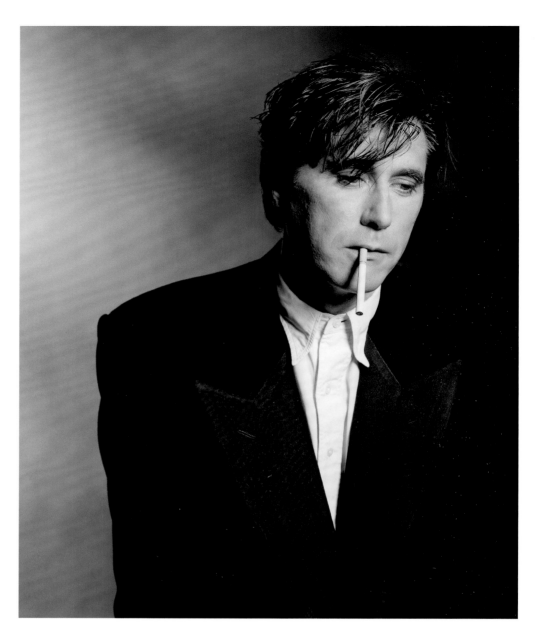

that a 1980 painted portrait of Ferry would be better than one made in the 2000s, since it was closest to the time of his most important achievements.

Philosophically speaking, this does not add up. People change all the time, but are we meant to believe that the older Bryan Ferry is somehow a fundamentally different person from his younger self? Does having an earlier portrait somehow tell us more about him? What if the 1980s picture were mediocre and the 2000s one a masterpiece: which would we prefer then? Who is Bryan Ferry, anyway, and how can we best represent the identity of any person when most of us don't even know ourselves? These questions became the inspiration for this book.

Part of what was being discussed that day, without acknowledging it directly, was the culture of celebrity. There are certain professions – pop star, actor, athlete or artist, for example – where we automatically favour pictures that transport us to the source; those lightning-in-a-bottle moments when records fell or hearts were moved. Indeed, it is fascinating to see Jackson Pollock portrayed while making one of his famous drip paintings in 1949, or the Beach Boys posing with surfboards in 1962. With other professions, however, such as scientist, cleric, author or scholar, we accept the ageing process more generously, tacitly acknowledging that such fields entail the accumulation of wisdom over time. Few would argue that a portrait of the

The Douglas Brothers
Bryan Ferry, 1993

late American author Toni Morrison made in 2010 is by definition worse than one made in 1987, when her celebrated book *Beloved* was first published. In the same way, the National Portrait Gallery did not acquire its first portrait of World Wide Web inventor Tim Berners-Lee (a photograph by Adam Broomberg and Oliver Chanarin) until 2005, even though his work on the web began around 1989. The picture is no less convincing, or revealing, simply because it showed him sixteen years later.

If we believe that identity is cumulative – that Bryan Ferry today is the sum total of all the Bryan Ferrys that came before, and maybe a few that drifted away – then there would be no point in prioritizing a 1970s or 1980s picture over a later one. The uncertainty of childhood, the musical training, the small clubs and big arenas, personal relationships and marriages, parenthood, the hijacked British Airways flight to Nairobi that almost ended in a fatal crash: if all these things, together, make up the true character of Bryan Ferry, then the later portrait is best. On the other hand, if we think

there might be some spark of genius – a manic, irrepressible, incandescent 'something' visible only during the height of Ferry's fame and never again – then we might prefer an early picture. Whether that picture would be better as a photograph or a painting, sculpture or something else entirely is another question worth serious thought, since different media have different virtues.

For the rest of the meeting I listened carefully, but did not say anything. Raho's painting was politely declined. However, I never stopped thinking about the gallery's portraits of the singer, and some two years later I brought one to the committee myself. It was made by the British duo The Douglas Brothers in 1993, some twenty years after Ferry's musical breakthrough, but still at the peak of his fame. In the picture, he appears as a dematerialized fragment against a sooty grey background, the top of his head trimmed away, one eye recessed into darkness, and a thick curl of hair covering the other (see below left). And yet, there he was – the natty, but slightly unkempt clothing, the framing of the head with the collar, the suave demeanour, and the romantic air. Grainy, double-printed, and with untrimmed edges on textured paper, it showed Ferry as a mysterious entity, emerging from a primeval soup of inky pigment. It is a picture that speaks in smoke signals, providing no easy answers but leading us toward a deeper understanding of the man – who he is, who he was, and who he has been. I proposed it for acquisition at the first curatorial meeting I could schedule, and it sailed through unanimously. It is, without doubt, a great portrait.

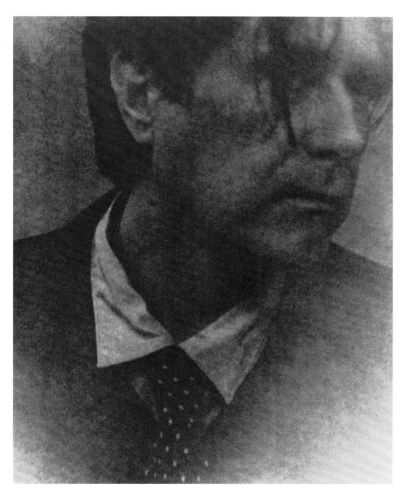

1 Me, Myself and I

Portraiture and the Search for Identity

That photography is useful in portraiture at all is nothing short of miraculous. Like a pitiless shark with one vacuous eye, the camera is mechanical, cruel and thoughtless. It is incredible to think that such a device could capture something as beautiful, ineffable and fundamentally human as identity. Yet we accept the camera as the uncontested chronicler of our times, relentlessly submitting ourselves, and the people around us, to being photographed over and over again. From gallery walls to online and social media, more photographs are made of people than any other subject, and no aspect of human behaviour escapes the camera's steely gaze. Our joys and hopes, achievements and disappointments are all laid bare for the camera, every minute of every day. Considering the nature of the process, it should not work. Nevertheless, somehow, the best photographs seemingly achieve the impossible, revealing the very essence of humanity – our selves.

The portraitist is an excavator of truth, revealing qualities of which the sitter might not even be aware, or may wish to hide. A great portrait is a psychological exploration, an artistic journey into a person's heart and soul. It is hard enough to get to know another person in life, but to convey the intricacies of personality through photography is especially daunting. Successful portraits reveal aspects of character, pushing beyond superficial appearance to provide insight into who a person or group is or was. There are those who maintain that portrait photography is ultimately a formal exercise. 'I'm really interested in the surfaces of people,' the Massachusetts-based photographer Elsa Dorfman said. 'I am totally not interested in capturing their souls.'[1] It is understandable that an experienced photographer might become philosophical about the physical appearance of skin and muscle, hair and bone. However, if portraiture were merely about recording how people look, then every

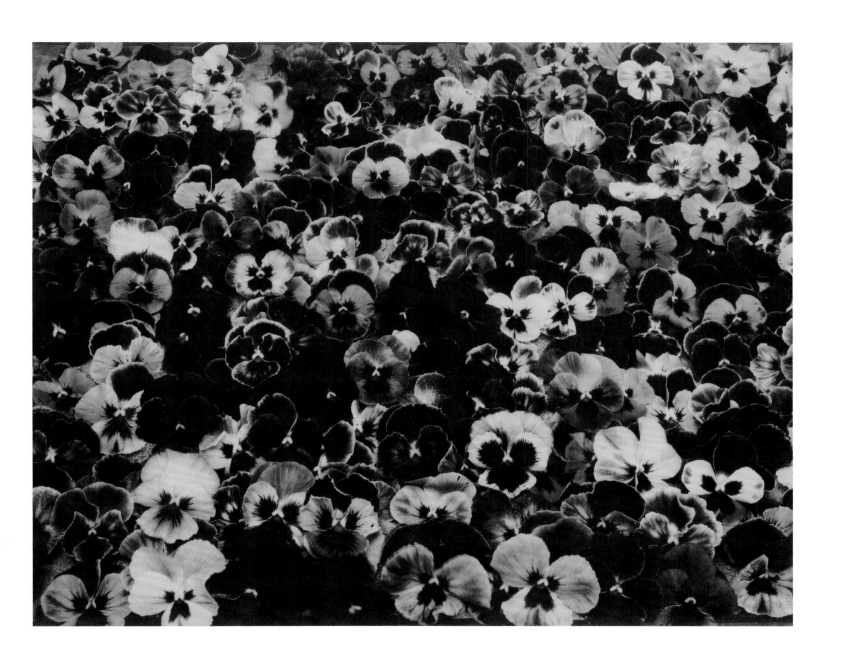

Edward Steichen
Friends, Romans, Countrymen, c. 1920

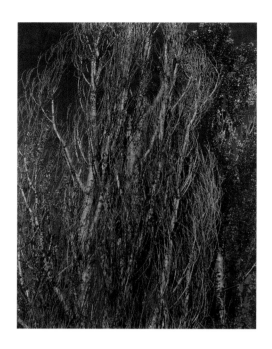

photographer with a sharp lens would be a master. Instead, it is among the most difficult undertakings in art.

At first glance, photography would seem the worst possible tool for the task. Anyone who has ever sat for a formal portrait knows the unflinching stare of a camera. In the studio, lamps glare brightly from metal stands and reflectors, radiating with light. As with a performer on a stage, the glare often makes it difficult to see the photographer and their crew clearly. Studios can be hot and stuffy, or damp and chilly. A makeup artist may be brought in to cover up blemishes and reduce the shine of oily skin, and clothes supplied by a wardrobe artist may be tight-fitting and unfamiliar. Often, the sitter has never met the photographer before. Even to seasoned veterans, the process can be unnerving. Celebrities learn to sit for effective portraits but it is a skill, arguably as much a product of the sitter's personality and training as it is the photographer's.

Photographers have different ways of dealing with the discomfort of the studio. Some embrace the strangeness of the situation, reasoning that an unsettled sitter is more likely to reveal their true self than one who maintains a calculated façade. Others develop strategies to relieve the tension. The 1920s Anglo-German portraitist Emil Otto Hoppé prepared by immersing himself in his sitter's interests before they arrived, reading whatever they had written, going to their performances, and familiarizing himself with their hobbies.

He would then talk with them about the things they loved, in an effort to draw them out. Edward Weston, the American Modernist, would simply make a series of mock 'exposures' without any film, inserting empty film holders and removing the dark slides on his view camera, until the sitter let down their guard. When he felt they were ready and had got over their nerves, he loaded film into his camera, and started making actual pictures.

A great portrait is both a collaboration and a negotiation – a dance of wills in which photographer and subject push and pull to arrive at a compelling result. This is not to suggest that the photographer and sitter should be at odds, or that the process is always difficult. On the contrary, portrait photographers are often charming and accomplished diplomats. The job demands it. They have to be able to engage with all kinds of people, and make them feel at ease.

As if sitting for a portrait were not hard enough, portrait photographers face additional hurdles due to the medium's temporal nature. Conventional photographs are made in a tiny sliver of a lifetime. Most camera manufacturers advise a setting of 1/60th of a second to make a sharp handheld picture of a subject prone to movement, like a person. Considering there are 86,400 seconds in a day, and 27,000 days in the average lifespan, this means a single photograph might capture just 1/140 billionth of a person's time on earth. The idea that this might turn out to be one, defining moment in a person's life strains belief. Nevertheless, a photographer might aim to condense all that is worth knowing about a person – aspirations and fears, talents and shortcomings, humour and affect – into one such microscopic slice of their existence.

Identity is itself a complex and elusive subject. While it may be that certain aspects of our character remain more or less consistent throughout our lives, individuals change from moment to moment, learning from some experiences and forgetting others. Moods may differ from morning to night, and temperament may change from childhood to old age. Births, deaths, marriages, lost pets and old love affairs affect who we are as individuals, just as parking tickets, the daily news, and a friendly exchange at the supermarket can change us from day to day. Some people are very good at masking their true feelings, while others are more transparent. Like jelly in our hands,

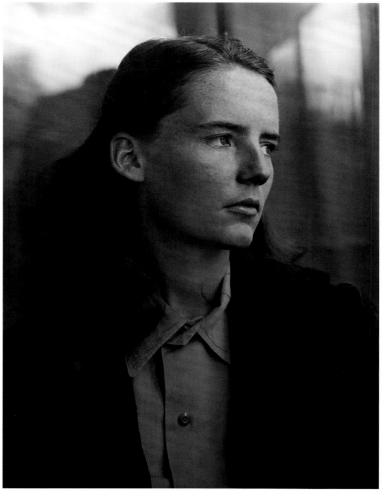

we can feel the weight of personality, but we cannot easily find its centre. Successful portraits can be just as ambiguous as the subjects they portray.

Over time, the understanding of portraiture has liberalized in photography and other media to include almost any picture that meaningfully depicts human identity. Traditional modes of head-and-shoulders and full-length portrait photography have been joined by more experimental forms based on depictions of individual body parts (hands, eyes, hair, etc.), as well as fluids, strands of DNA, X-rays, electrical 'auras' and pure photo manipulation. Indeed, portrait photographs need not depict a recognizable human being at all. Edward Steichen's *Friends, Romans, Countrymen* imagines a crowd of people as a field of violas, the variations in tone and the tilt of the petals suggesting ethnic, geopolitical and physical difference (see p. 11).

From the late 1920s until around 1935, gallerist and photographer Alfred Stieglitz produced a series of photographs of poplar trees, which have been widely interpreted as self-portraits. Poplars first appeared in the background of his 'Equivalents' in 1927 – a series of abstract depictions of sky and clouds taken near his summer home in Lake George, New York, meant to demonstrate correspondences between natural forms and inner feeling. Over time, the poplars became an important subject in their own right. Since poplars are fast-growing, and most common species have a lifespan roughly the same as a human, Stieglitz, then in his mid-sixties, knew that the ageing poplars near his property were planted around the time he was born (see opposite). With their silvered bark and thinning leaves, and with their dense branches massing heaven-ward like flames, they were emblems of his mortality.

It is not always clear what constitutes a portrait, even when the identity of the subject is known. Nudes, for example, are not usually considered portraits, although the reasons for this are sometimes debatable. The photographs Edward Weston made of his model, lover and later wife, the writer Charis Wilson, illustrate the problem. Few would argue that Weston's photograph of Wilson standing against the windows of a house (possibly their newly built house on Wildcat Hill, Carmel Highlands) does not qualify as a portrait. In the picture, she is shown head and shoulders against an out-of-focus background, which dissolves into graphic forms of light and grey (see left). Her head is turned away from the viewer, her eyes fixed on the distance, brows lowered in contemplation, and hair pulled back to reveal one ear. The picture shows her as serious, thoughtful, and radiant – her face bathed in warm light, with splashes of brightness rising from her head like a halo, or like energy emitting from her mind. At the same time, she exhibits delicacy and balance, the single visible button on her blouse neatly fastened beneath her closed lapels and positioned in the dead centre of the width of the composition. It is a clever and sympathetic portrait.

Weston's portrayals of Wilson lying nude in the sand dunes in Oceano, California, are a less straightforward case. Weston made a number of variant photographs of Wilson posing in the sand in various positions in 1936; they have since become some of the most recognizable photographs of the early twentieth century.

Wilson is shown nude, full figure, under the blazing sun, her skin glowing in luminous silvery grey. In one of the most celebrated of these pictures, *Nude on a Dune (Charis Wilson)* (see below), Wilson lies on her back, arms folded behind her head, which rests in the crux of one elbow like a pillow. Her legs are bent inwards at the knee, preserving her modesty while at the same time creating a long, angular line along the right side of her body from the tip of her toes to her folded right arm. At this time in his career, Weston was busy extending his exploration of natural forms (his famous *Pepper #30* was made six years earlier), and in this sense *Nude* might be considered a 'study'. The crenulations and curves of sand, and the patterns of light and dark caused by wind erosion, are contrasted with the angles and bends of Wilson's body; her feet and arms are partially submerged into the sand itself, suggesting a oneness with the earth. At the same time, it is an erotic picture. Wilson lies on her back with her breasts exposed, an object of sexual desire in what might be interpreted as a post-coital pose.

Is *Nude* not also a portrait? As in the conventional portrait, Wilson's head is bathed in light, a luminous being, one ear directed towards the viewer, listening. Her body is centred in the middle of the picture – measured, in control, like a single button lying on the dune. Her eyes are closed as if asleep, dreaming, her rich inner life mysterious to the viewer. And her body – alternately lithe and awkward, frankly nude and artfully covered – suggests a myriad of contradictions. Here is Wilson stripped bare, literally: bold and reserved, a physical and mental presence, at one with the earth but divorced from it. One might even argue that *Nude* is a more nuanced and complete portrait of Wilson than Weston's later Carmel picture.

The example of Weston and Wilson raises another important issue – the charged gaze of the person who made the picture. Implicitly and explicitly, knowingly and unwittingly, a maker visits her or his attitudinal biases on a picture. Despite their mechanical origins, the circumstances under which photographs are produced, and the motivations for their creation, are often evident within an image. Portraits nearly always betray something of the cultural context in which they were made and the personal beliefs of the maker. In the case of Weston, there is no escaping the sexual politics of a heterosexual male photographing a nude female in 1930s America, and the power relationship this implied.

At the time this picture was made, Wilson was twenty-two years old and Weston fifty; Weston was an established professional, while Wilson was just beginning her career. Though the two would marry three years later, it is noteworthy that when *Nude* was made, Weston was still married to his first wife, Flora. At the same time, he was living with his lover, the photographer Sonya Noskowiak (see p. 47) – one of a string of extramarital relationships Weston had with (admittedly strong and impressive) women. One might argue that this unequal and distinctly patriarchal arrangement inflects and perhaps discredits Weston's photographs of Wilson. At the very least, it adds a layer of complexity worthy of deeper investigation. One must always consider not just the message but also the messenger; socioeconomic, racial, ethnic, religious and gender politics frequently shape photographic practice. The 'male gaze' and 'colonial gaze' are not only real, they are intrinsic to understanding certain works.

Photography and painting have many things in common, but the manner of their creation is conceptually opposite. Most painting is additive: the artist begins with a blank

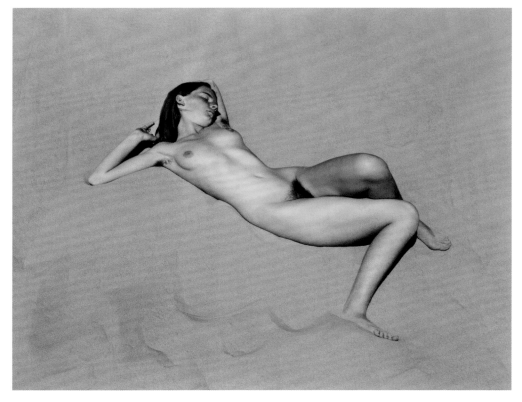

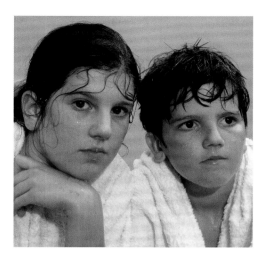

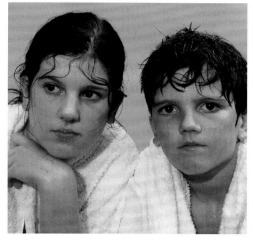

Barbara Probst
Exposure #35: Munich studio, 07.29.05, 3:36 p.m., 2005

canvas, then adds pigment to the surface to build up the picture. This addition can happen slowly, as in an Old Master canvas, some of which took months or even years of study and revision, or it can happen quickly, like a Damien Hirst spin painting. On a philosophical level, the results are the same. Paintings are built up according to their own rules, and may bear little or no resemblance to events as they happen in real time.

Conventional photography, by contrast, is a reductive process. The artist begins with everything visible in the real world, and edits down to what they want to show. The position of the camera, the chosen film format and the length of lens determine the geometry of the picture. Short lenses provide wider views (wide angle), while long lenses magnify and flatten space (telephoto). Once these ingredients are set, the photographer chooses the moment to depress the shutter. Depending on how they operate, the photographer might take a single frame or a series of pictures of the same subject repeatedly at different times and varying points of view, resulting in a group of images, which must also be edited after the fact. He or she selects the best of these to print or publish, cropping unwanted detail to arrive at the final image. Most photographs result from several waves of this kind of editing, selection and deletion.

Minuscule shifts in time and point of view can lead to dramatic differences in meaning. The New York- and Munich-based artist Barbara Probst has made numerous portraits using two or more cameras aimed at different angles, wired to fire at the same time. Her *Exposure #35*, for example, shows

the same boy and girl against a neutral blue background, photographed simultaneously from two slightly different angles, wrapped in white towels as though they have just emerged from a swimming pool or bath (see left). On the left side, the girl engages the viewer directly, while the boy looks away. On the right, the roles are reversed, and the boy looks at the viewer while the girl looks beyond the frame. This subtle change transforms the emotional content of the picture as the protagonist shifts. In the first frame, the girl commands sympathy while the boy looks absent. In the second, the boy becomes the centrepiece, even though the moment recorded is identical.

Ultimately, it is human subjectivity, combined with photography's unique optical and mechanical qualities, that makes portrait photography special. When the organic, fluid and unquantifiable force of the spirit meets the immovable object of photographic clarity fixed in time, it creates an irreconcilable tension. The narrow slice of life a camera dispassionately records – that unrepeatable and immutable moment of being – is exactly why photographic portraiture succeeds and endures. A photograph is sand in the oyster of understanding. Except, the pearls it produces are seldom clear or obvious. They are complex, ponderable, multidimensional and fleeting. Just as people are.

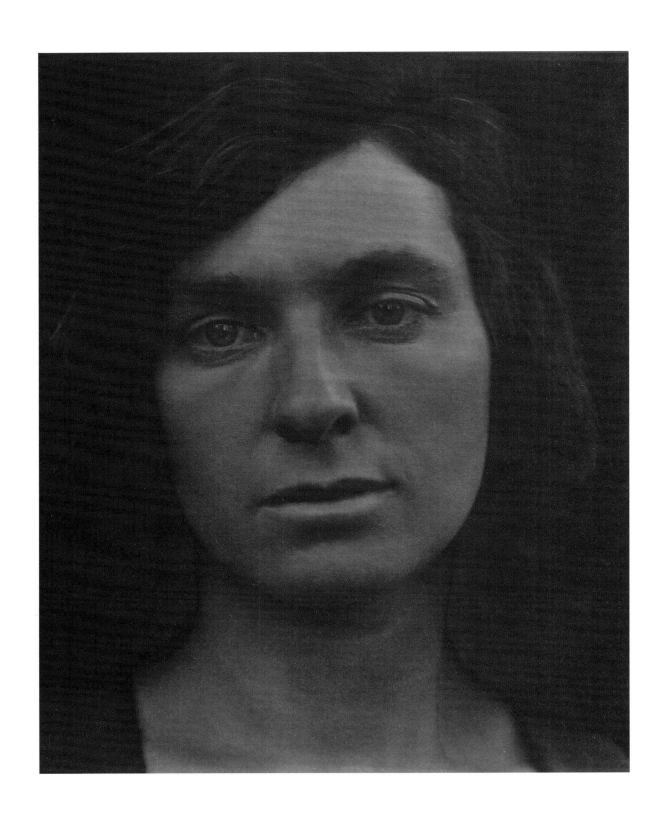

Paul Strand
Rebecca, New York, 1920

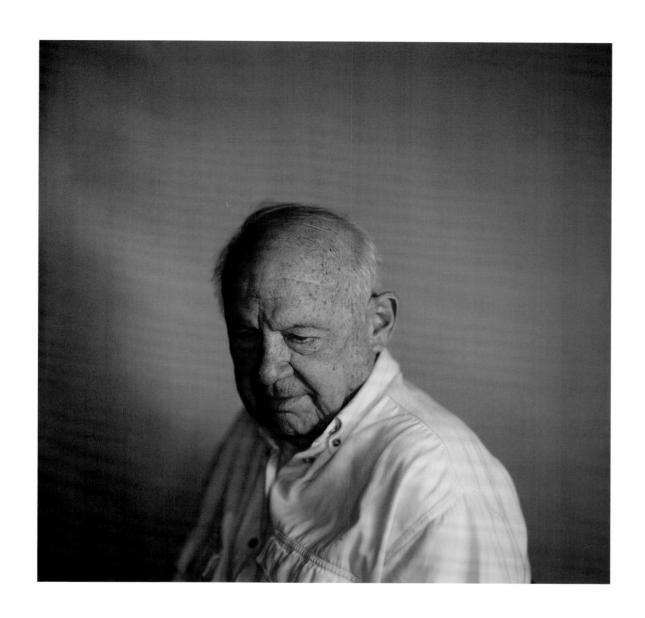

Richard Learoyd
Blind Man, 2012

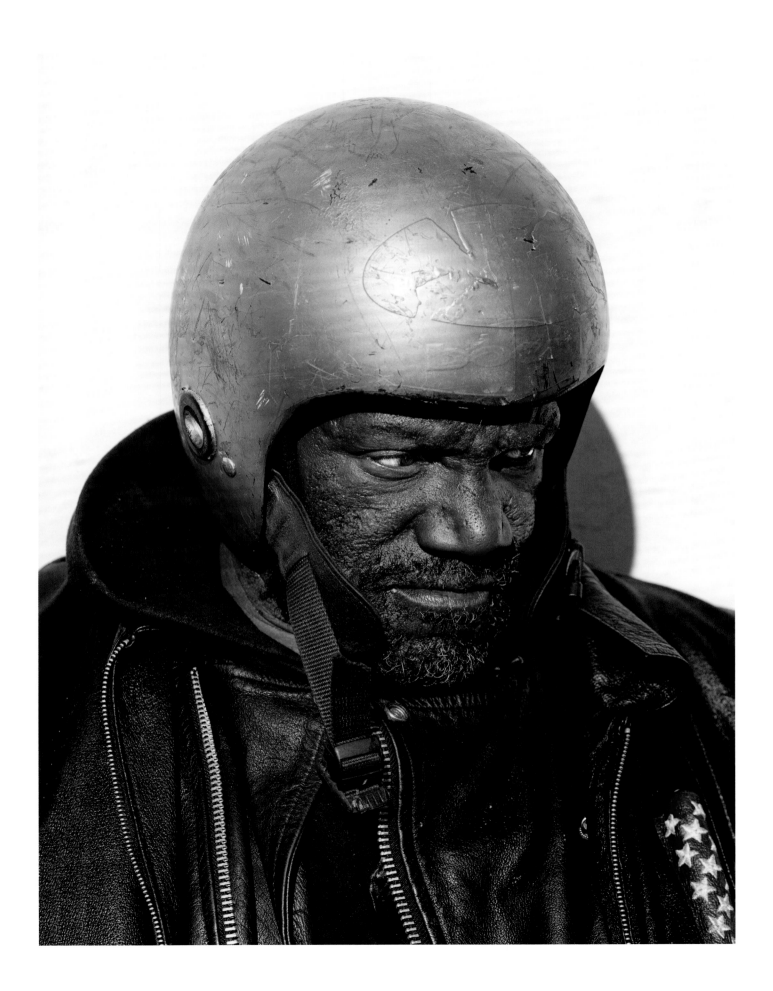

Katy Grannan

Anonymous, Oakland, California, 2011, from the series 'The 99', 2011–14

The gold helmet in Katy Grannan's striking portrait of an unnamed African American man resembles a planet in some distant solar system, the hood resting on his shoulder one half of a celestial ring completed by the semicircular shadow on the wall. It glows under the strong California sun, revealing dings and scratches from years of use and reuse. On close inspection its shimmering paint was applied by hand; uneven and rough at the edges, it covers an old label on the forehead. The helmet is luminous like the man it protects; it is also worn and abraded. A sliver of the American flag – stars – is visible like a flare on the left side of his jacket.

Grannan made this portrait at a time when she was beginning to explore the communities of California's Central Valley – an area she would come to think of as 'the 99' after Route 99, the north/south highway that spans the state's agricultural interior. The seasonal, poorly paid work in these areas has resulted in large numbers of marginalized people, living on the social and economic fringes. Eventually, Grannan would narrow her focus on 'the 9' – South Ninth Street in Modesto – where people persevere under extreme deprivation. This would become the subject of her 2016 feature film.

Strictly speaking, this picture does not belong to the 99, as it was made in coastal Oakland, on the eastern edge of San Francisco Bay. However, it embodies the same qualities: the desire to look closely at those who are often overlooked, to give the 'anonymous' resonance, and to reflect on their humanity.

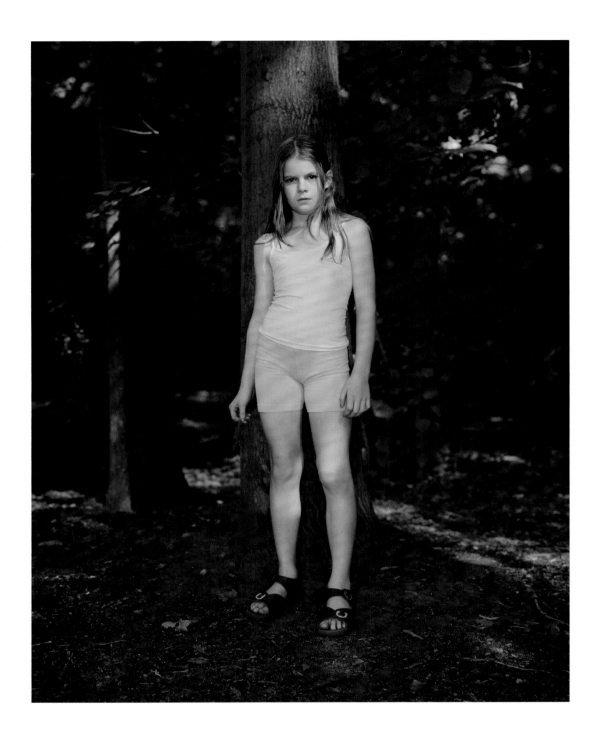

Rineke Dijkstra
Kora, Tiergarten, Berlin, Germany, July 1, 2000,
from the series 'Tiergarten', 1998–2000

Rineke Dijkstra's portrait of a girl posing in Berlin's famous Tiergarten, her arms held awkwardly at her side and her gaze directed intensely at the viewer, is a study in transformation and change. Her body poised between childhood and adolescence, the girl appears frozen in time, one sandalled foot slightly ahead of the other, ready to move, her fingers curled, seemingly about to clench. The Tiergarten itself is a liminal space, cleaved from East Berlin during the partition of Germany and situated near the edge of the former Berlin wall; the dappled light of its woods, neither light nor dark. Even the date, the midpoint of the first year of the new millennium, is transitional – a pivot point. Although Dijkstra photographed both boys and girls in the Tiergarten, this picture in particular invites questions of feminine identity. Quaintly dressed and with shiny yellow buckles on her shoes, the girl is shown as innocent, even vulnerable. At the same time, the picture foreshadows her development into womanhood, her lithesome body contorted into a subtle curve, like a young Botticelli's Venus. The tall, mature tree behind her reinforces the theme, anticipating her rise into adulthood, and sunlight splashes across her face, revealing her strength.

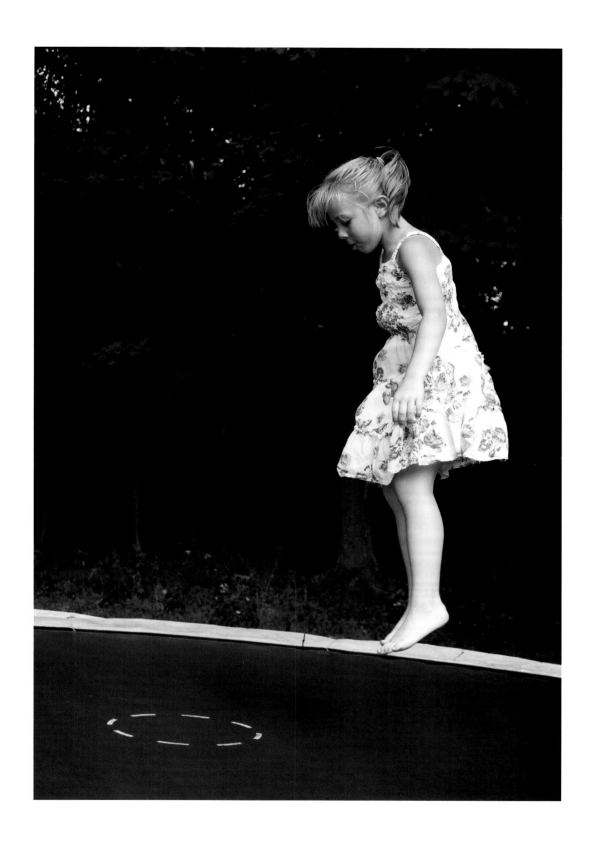

Nandita Raman
Alyssa, 2015, from the series 'When Mountains
Rise and Fall Like Waves', 2013–ongoing

Barbara Bosworth
Emily with Grackle, 2003, from the series
'Birds and Other Angels', 2002–ongoing

Historically, portraitists have conveyed information about sitters by providing them with attributes – props that symbolize elements of the subject's occupation or personality. Here, Barbara Bosworth photographs an environmentalist as she captures, bands and releases birds to help study their population and range. The grackle she holds in her left hand makes this aspect of her job clear, while at the same time suggesting other associations. Birds are not only emblematic of nature, they may move easily between earth and sky – heavenly creatures able to transcend the bounds of gravity. As an attribute of the sitter, the bird invites the viewer to reflect on Emily's identity.

Animals have appeared as companions in Western portraiture since before the Renaissance, signifying status and hinting at personality traits. In Bosworth's picture, the grackle has momentarily lost its freedom to fly, as it sits, half perched, half pinched, in the sitter's fingers. Emily resembles nothing so much as a grackle herself, her brunette hair echoing the bird's feathers, and her head cocked slightly, avian-like. Coincidentally, a wedding ring is clearly visible on her left hand and another can be seen on the middle finger on her right: ironically, she is, like the grackle, banded.

Valérie Belin
Carol, 2016, from the series 'All Star', 2016

Carol is both a portrait and a still life — a psychological exploration of a semi-anonymous woman, and an exploration of media and consumption in an age of hyper-abundance. The intense stare of the figure as she gazes out of the frame is partially overwritten by a vintage American comic and the wavy sinuous lines of a graphic pattern resembling a map, as her line of sight intersects the swirling disc of the superhero's famous shield. It is an image riven with cultural expectation — valour, violence, and unbridled machismo. As a portrait, the superimposed imagery forms a palimpsest of the woman's riotous mental state, as vivid and dynamic as it is out-dated and misappropriated. Immersed in and partially obscured by cultural detritus, she is a sympathetic presence, overwhelmed by consumerist baggage.

Alternatively, the picture may be seen as a diagnosis; the figure an emblem of artificiality no more real than the fictional characters that surround her. With her heroic pose and confident bearing, she evades eye contact, providing little sense of personal engagement or connection.

Looking like a professional model, mannequin, or even a portrait bust, she is resolutely artificial, another in a collection of problematic elements gathered in complex arrangement. While undeniably feminist in perspective, the picture is universal in its message. Where does identity reside in the context of consumer culture, and to what extent are we, as individuals, complicit in our own failure to find the genuine in contemporary life?

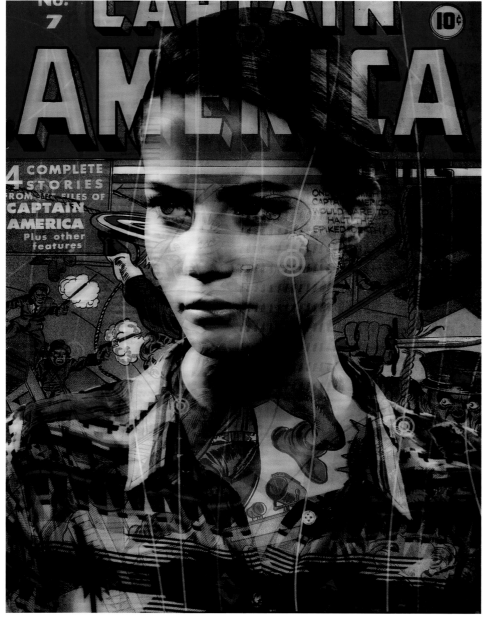

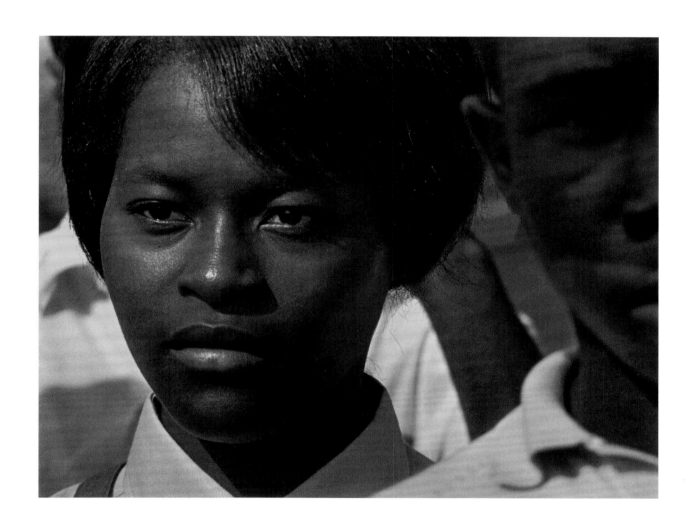

Above **Roy DeCarava**
Mississippi Freedom Marcher, Washington DC, 1963

Opposite **Magdalena Wywrot**
Birthday Girl, Krakow, 2017

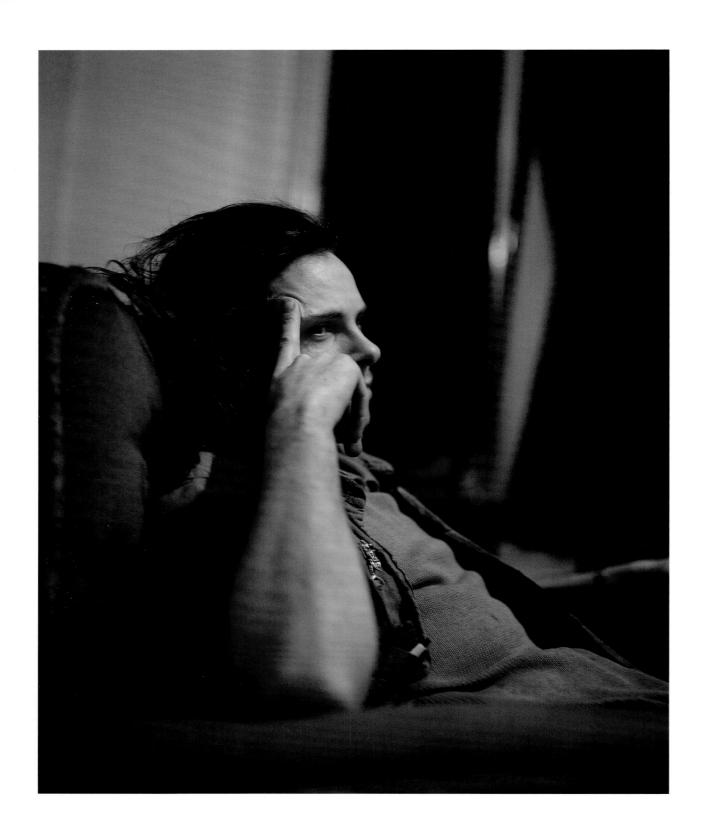

Paul Graham
Jack, Bradford, 1988, from the series
'Television Portraits', 1989—94

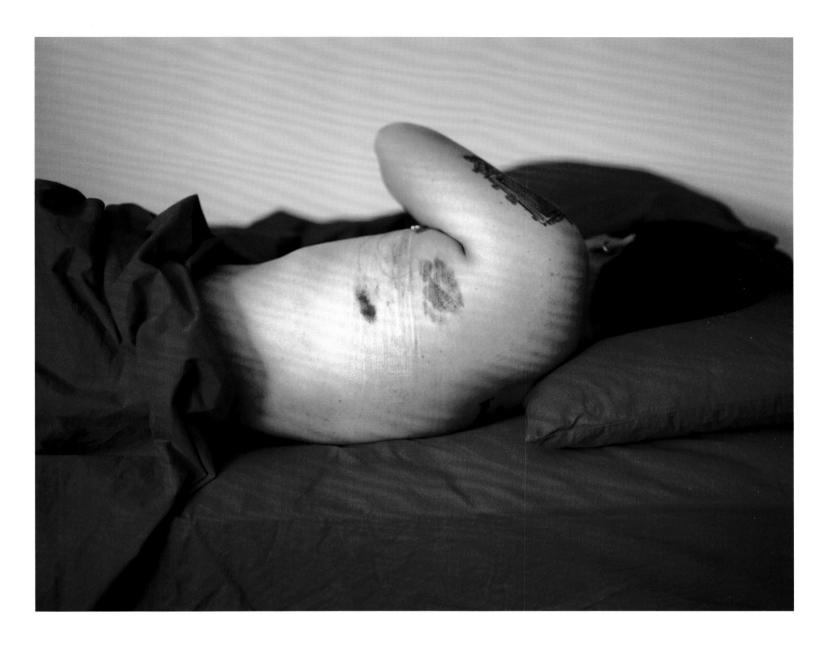

Jess T. Dugan

Self-portrait (revision), n.d.

This moving and humane self-portrait by Jess T. Dugan, who identifies as queer and non-binary, shows a deeply personal moment after an unnamed medical procedure. Lying in blood-red sheets, the artist turns away from the viewer, revealing deep bruises on their chest and underarm. The shallow depth of focus is precisely aimed at their side, highlighting the faint residue of blue surgical pen and compression marks from a cloth bandage recently wrapped around their body. An emotional picture, it is nevertheless candid in its depiction of the human body. Using a 4×5 view camera, every pore is laid bare for the viewer. The picture shows the artist as simultaneously strong and vulnerable – indomitable in their determination, yet unmistakably flesh and blood.

In their portraits of transgender and gender expansive people, including the artist themself, Dugan seldom attempts to idealize the subject. Photographed using available light, with minimal props, and set in everyday locations including sitters' homes, their pictures are instead quiet and sure, presenting queer people as individuals, with the same beauty and flaws as non-queer ones. This is facilitated by the artist's technique: the large-format camera they use not only results in sharp images, it is also an unavoidable presence in a sitting, requiring thoughtful interaction and engagement with the subject. Although Dugan's portraits celebrate and explore queer and transgender communities, they are nevertheless inclusive in their approach, and universal in their outlook. Differences are proudly acknowledged, yet unexpectedly melt away.

Christopher Bucklow
Guest, 12.27pm 10th July 2001

An energy field, a spirit, a vision – the dematerialized figure in this complex portrait is actually made up of thousands of small pinhole photographs. To make this life-sized picture, Christopher Bucklow etched the sitter's outline on a thick sheet of aluminium foil (tin foil), then meticulously pricked the surface to create 25,000 pinhole cameras – the approximate length of a human lifetime measured in days (three score and ten, or seventy years), as described in Psalms. This aluminium 'lens' was then loaded into a boxlike camera, with a single sheet of photographic paper in the back and the lens in front. When exposed to light, each pinprick creates an upside-down photographic image of whatever it is pointed at, transforming the silhouette into a field of tiny photographs. Since this picture was exposed on a sunny summer afternoon in Venice – 12.27 pm in July – the component photographs are actually Italian midday suns, the rich azure background a product of the luminous Mediterranean light.

By concentrating the pinholes in certain parts of the body, Bucklow was able to vary the intensity of light, differentiating parts of the figure and giving it volume. The sitter's head, in particular, seems to glow with energy where many of the pinpricks were clustered. This had a secondary effect of causing stray light to bounce around inside the camera, creating the cloud-like wisps swirling around the figure's head. It is a reminder that a body is merely a vessel, and a guest is a visitor – a temporary presence in another's life – just as a human lifetime is finite.

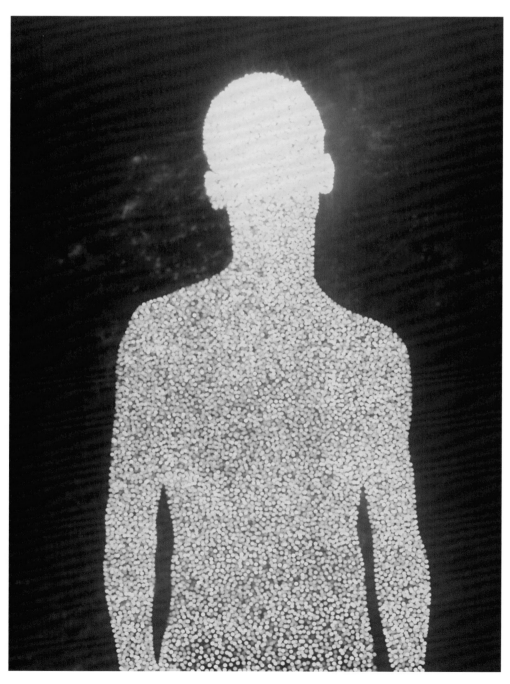

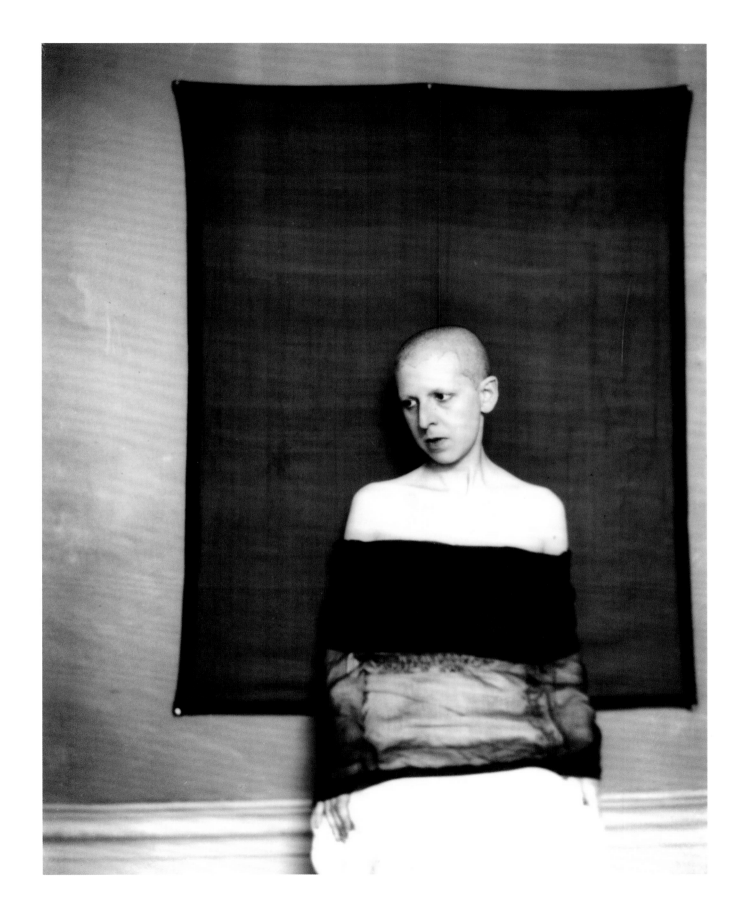

Claude Cahun
Self portrait, c. 1928

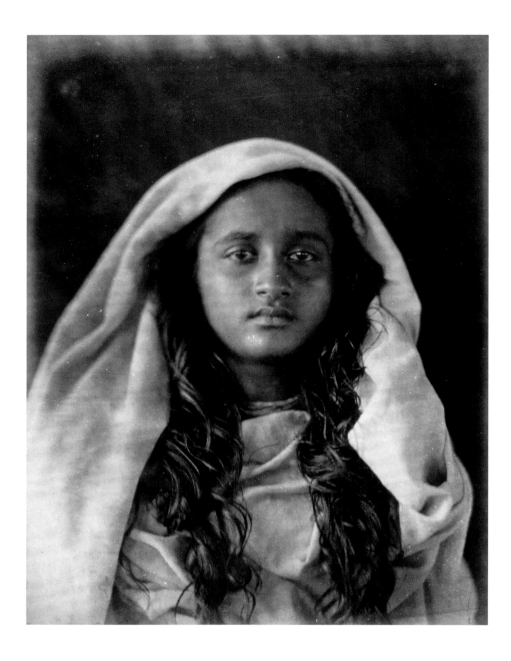

Julia Margaret Cameron
Young Ceylonese Plantation Worker, c. 1875–78

Julia Margaret Cameron spent the last four years of her life in Ceylon (Sri Lanka), where she and her husband owned large coffee and rubber plantations. By that time, Cameron, who famously did not take up the camera until age forty-eight, had only been photographing for a little more than ten years. She brought her equipment with her, but produced fewer than thirty pictures between leaving England and her death in January 1879. This photograph of a young Sinhalese woman is arguably the most successful of the pictures she made during this period, and one of her last great works.

Although Cameron claimed she had no interest in topographical photography, which she referred to as 'map making and skeleton rendering', most of her other Ceylon pictures, made of plantation workers and local families, have a pronounced anthropological quality. This picture marked a return to form, portraying the sitter with the same remarkable sensitivity as ones made years earlier. With her face framed by the folds of her head-covering, and strands of curly hair cascading from her shoulders, the woman's powerful gaze is amplified by the artist's signature deep chiaroscuro, as well

as 'Rembrandt-style' lighting. Earlier in her career, Cameron frequently posed women in scenes from the life of the Virgin Mary. It is unclear whether the woman's head-covering reflects personal religious belief or artistic licence; nevertheless, the association with the New Testament story and the rise of a fateful, powerful woman would not have escaped Cameron.

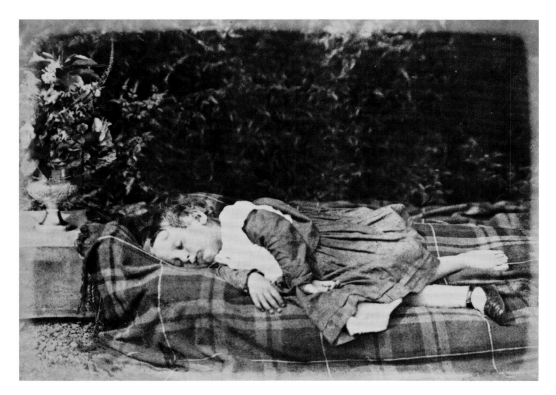

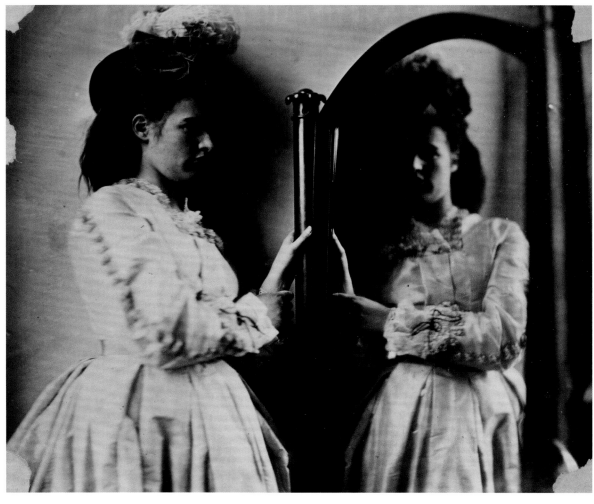

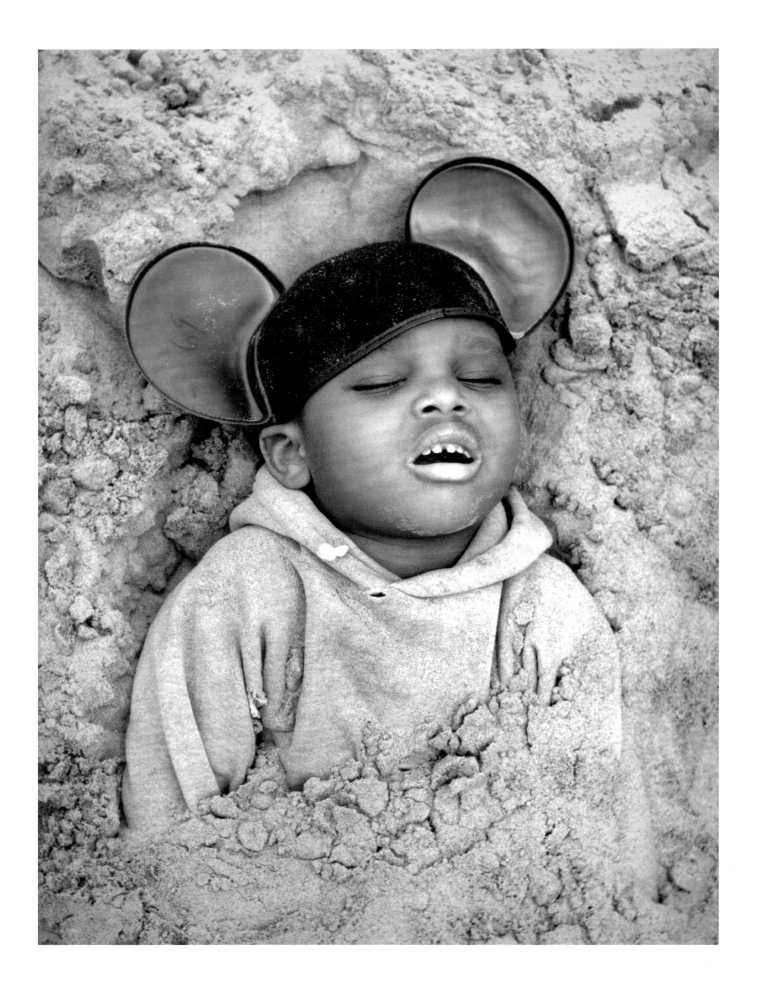

Diana Markosian
15 year old Hanan from Iraq, 2018,
from the series 'The Big Sea', 2017–18

Opposite **Arthur Tress**
Child Buried in Sand, Coney Island, 1968,
from the series 'Dream Collector', 1968–79

Arthur Tress led a peripatetic existence for most of the 1960s before returning to his native New York, where he began making unprecedented pictures like this one. Spurred by an interest in the subconscious, trance-like states and dreams as a form of religious experience, Tress had travelled across Africa, Central America, Europe and Japan, searching for what he described as shamanistic cultural practices. On returning to New York, he was invited to participate in programmes at the newly formed Touchstone Center for Children. By chance, the curriculum featured children painting and writing about their dreams, which inspired the artist to begin his own project interviewing children about dreams, and photographing re-enactments of them.

In this picture, published in the landmark *The Dream Collector* in 1972, a boy is shown buried in sand, eyes closed, with a pair of Mickey Mouse ears askew on his head. Although his upper body is free, his arms seem bound by his side, as though tied in a straitjacket. His ambiguous expression straddles horror and relief, as it is unclear whether his dream involved being buried alive, emerging from the earth, or simply being stuck in place. Tress was particularly drawn to subjects like this, which suggested an archetypal or mythological dimension, in line with his investigations into collective consciousness and folk beliefs. By seeking to explore deep-seated and sometimes hidden aspects of personality, and by using performance as a vehicle for artistic expression, his work influenced photographers looking for an alternative to the straight reportage that had come to dominate post-war photographic circles.

Margrethe Mather
Billy Justema, c. 1922

36

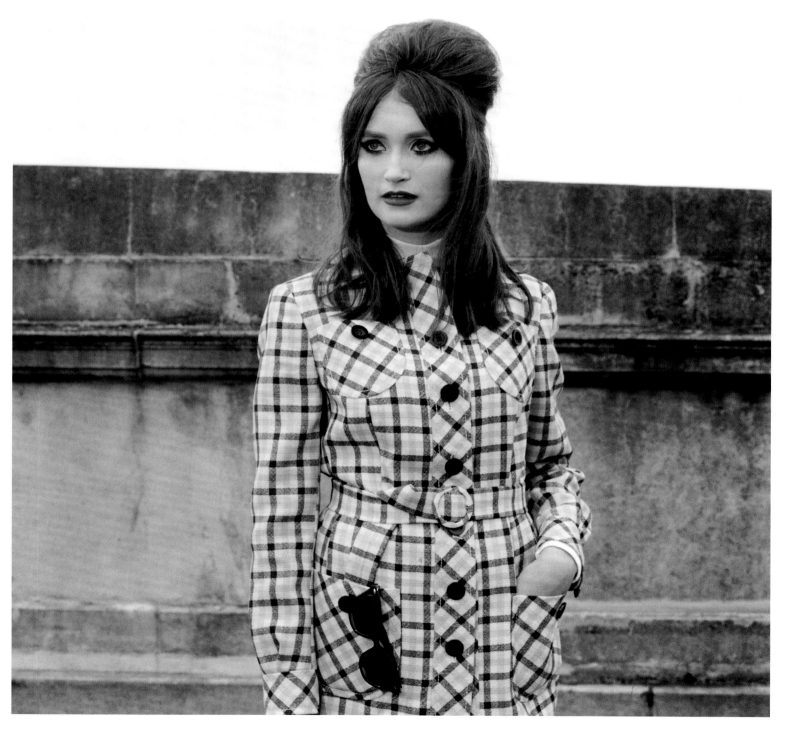

Pushpamala N.
Image #10, 1998, from 'Sunhere Sapne
[Golden Dreams]: a photo-romance', 1998

Opposite **Peter Puklus**
Destroyer, Budapest, 2017, from the series
'The Hero Mother – How to build a house',
2016–20

Hannah Starkey
Untitled, March 2013

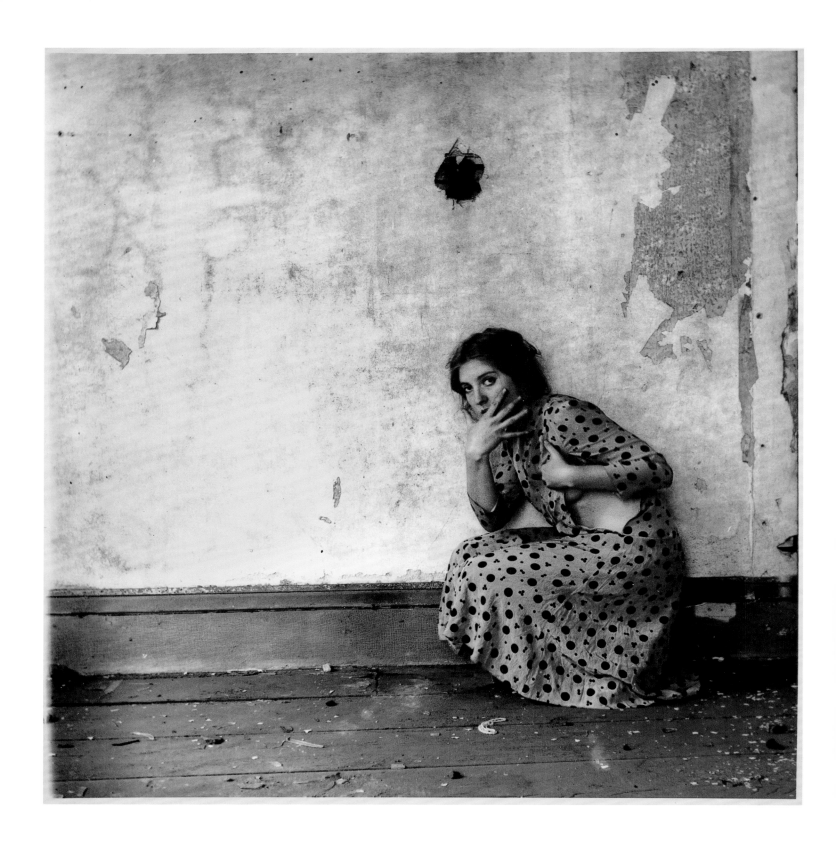

Francesca Woodman
Untitled, from Polka Dots Series, Providence,
Rhode Island, 1976

Jo Spence

A Picture of Health: Property of Jo Spence?,
1982, collaboration with Terry Dennett

Few if any photographers have so forcefully engaged with issues of mortality and body image as activist Jo Spence, who contracted breast cancer the year this photograph was made. Spence viewed her experience as an opportunity to educate and inspire others suffering a similar fate; however, it was not the first time she and collaborator Terry Dennett had attempted to use photography as a therapeutic tool. The two developed a socially critical approach that they termed 'photo theatre', in which they built and staged scenes as a form of political action.

Their radical approach to the medium, and faith in its ability to elicit change, suggested new directions for the revitalization of documentary practice in the 1980s.

With this photograph and others like it, Spence was also asserting agency over her body and her medical condition, making public what was then considered a largely private affair. Exposing her breasts on a city street without a hint of shyness, she defused any stigma associated with the disease and provided an example for others not to suffer in silence.

At the same time, the question written in marker on her left breast, 'Property of Jo Spence?', conveys some of the uncertainty and fear associated with breast cancer. Is her breast hers to keep, or does it belong to her illness? Spence was a naturopath who successfully treated herself with alternative medicines. Although she would succumb to leukaemia some ten years after this picture was made, she survived the cancer that precipitated this photograph, with humour and a sense of purpose, on her own terms.

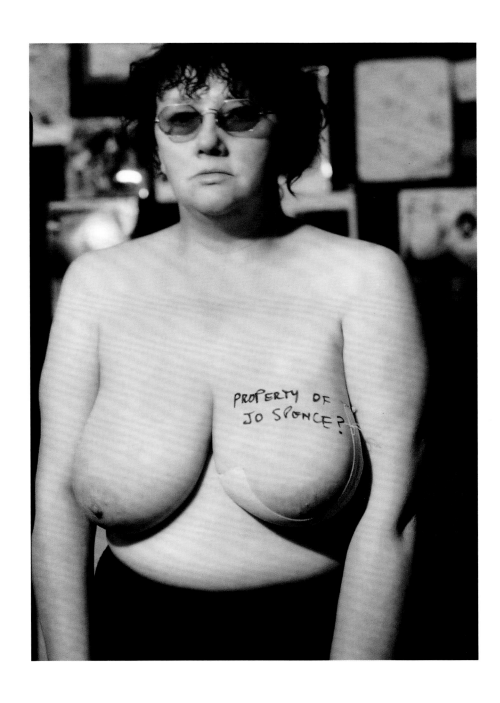

Opposite **Robert Howlett**
*Isambard Kingdom Brunel Standing Before the
Launching Chains of the* Great Eastern, 1857
(printed 1863–64)

The legendary engineer Isambard Kingdom
Brunel is shown here against the launching
chains of his last major work, the steamship
SS *Leviathan*, later renamed the *Great Eastern*.
The ill-fated vessel would prove, if not Brunel's
undoing, then his greatest frustration. This
photograph commemorates the first attempt
to launch the ship on 3 November 1857. At the
time of construction, it was easily the largest
in the world, and had to be eased into the water
sideways. On the occasion of this photograph the
vessel was christened while thousands looked on,
but failed to budge from her ramp. It took three
attempts, and the loss of two lives, before she
was finally launched the following January.

Standing casually, almost cockily, in front
of the chains' massive links — each bigger than
the sitter's head — Brunel poses at the foot of
his creation, like an artist before a monumental
sculpture. His ill-fitting suit with sagging pockets,
mud-splattered trousers, partially buttoned
vest and tattered hat indicate a hands-on figure
not entirely comfortable with formal occasions.
The photographer, Robert Howlett, was clearly
drawn to the graphic impact of the backdrop, as
the otherworldly scale of the chains symbolizes
Brunel's herculean mastery of iron and concrete.
The setting may also have had a practical
dimension, since at this vintage giving a sitter
something to lean against helped avoid blur
resulting from long exposure times.

In hindsight it is tempting to see the
chains as shackles, and their impressive scale
the inescapable machinations of fate. Escalating
costs would eventually send two firms into
bankruptcy. The *Great Eastern* did not launch
until the following autumn, when the boiler
exploded during trials, killing six and necessitating
extensive repairs. Brunel himself did not live to
see her maiden voyage on 17 June 1860, having
suffered a stroke the previous September.
Howlett, too, one of the most promising
photographers of his generation, died of fever
in December 1858, aged twenty-seven.

Alexander Rodchenko
Varvara Stepanova, 1936

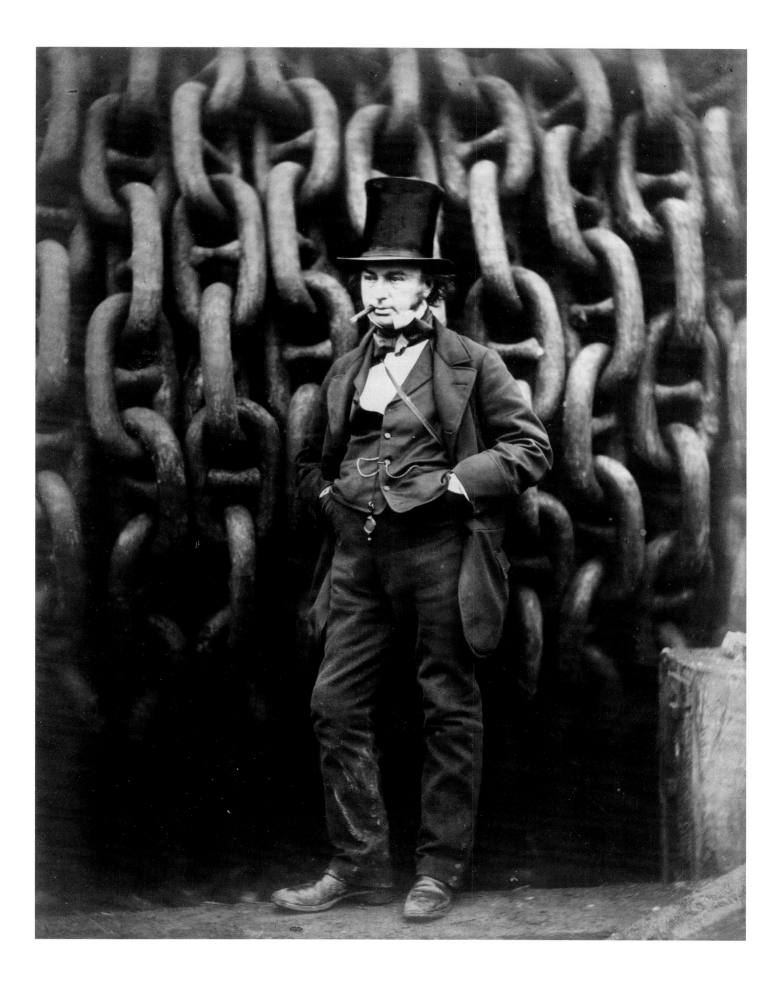

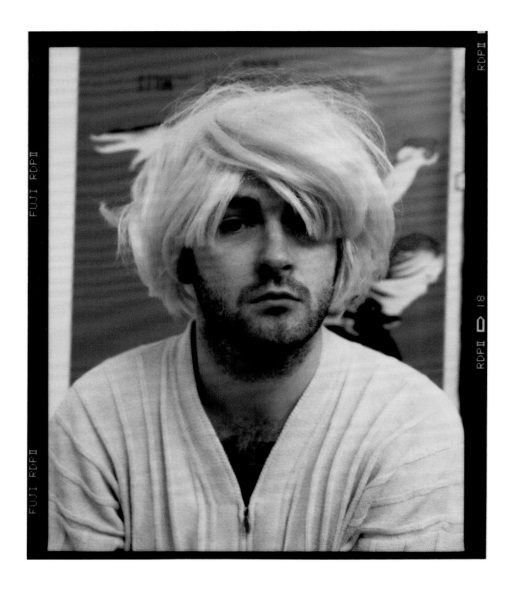

Douglas Gordon

Self-Portrait as Kurt Cobain, as Andy Warhol,
as Myra Hindley, as Marilyn Monroe, 1996

The addition of a tousled blond wig transforms this single self-portrait into five, as the contemporary artist appears simultaneously as himself, lead singer of the rock band Nirvana, famed pop artist, reviled serial killer and beloved actress. At the time of this picture only Moors Murderer Hindley, the most hated woman in Britain, was still alive, condemned to life in prison. She was said to have adopted her bleach-blond hairstyle in sympathy with Nazi ideas of Aryan perfection. Cobain died in 1994 of his own hand, and Monroe also committed suicide, with an overdose of barbiturates, in 1961. Warhol too died young; having survived a near-fatal shooting to the stomach by deranged artist Valerie Solanas in 1968, he eventually succumbed to complications from gall bladder surgery at age fifty-eight.

The dark humour of such ignominious history, linked by a distinctive pop-inflected hairstyle, is belied by Douglas Gordon's equivocal appearance. His wide eyes and resigned expression signal his recognition of this sad history. Only the inverted movie poster behind him hints at the artifice of his adopted guise. Like Warhol himself, Gordon has long been drawn to popular representations in cinema, fashion, news and publicity photography, and the uneasy tension between identity and perception. The biographies represented by Cobain, Warhol, Hindley and Monroe, though extreme, reflect the sinister sides of human nature, present in some measure in the artist himself, as in all of us. Fortunately, Gordon was able to remove the wig after the picture was made; the others were not.

Sonya Noskowiak
Langston Hughes, 1934

Frederick Evans
Aubrey Beardsley, 1894

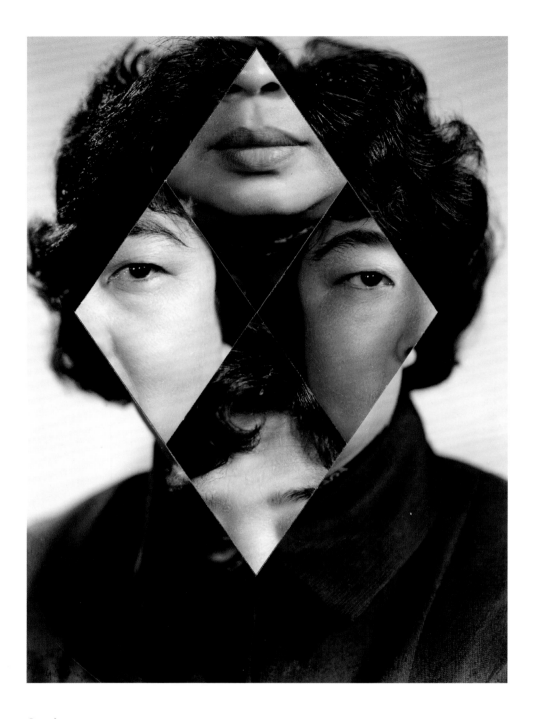

Kensuke Koike and Thomas Sauvin
Untitled #21, 2017, from the series 'No More
No Less', 2016–17

Painstakingly cut apart and reassembled by hand, Kensuke Koike and Thomas Sauvin's collaborative portraits scramble appropriated imagery to produce new, surrealistic compositions in which facial features are preserved, but the original appearance of the sitter is no longer apparent. The source imagery comes from artist and collector Sauvin's archive of salvaged Chinese vernacular photographs, Beijing Silvermine. Sauvin invited collage artist Koike to choose material to work with from the collection; Koike selected an album of conventional studio portraits made by an anonymous student at Shanghai University in the 1980s. By rephotographing the portraits in the album, cutting them apart and reassembling them, Koike causes the viewer to see the individuals depicted with fresh eyes, drawing attention to certain qualities in the original portraits, and creating graphic programmes echoing their ambiguities.

Koike and Sauvin's collages have ancestors in Dadaist art of the early twentieth century; however, in the twenty-first century, such pictures take on new meaning, reflecting digital image processing and facial recognition techniques. The anonymity of the figures, too, gives the project added resonance, since the student portraits were made at a time when individualism was not encouraged in China, and the biographies of the sitters have in any case been lost.

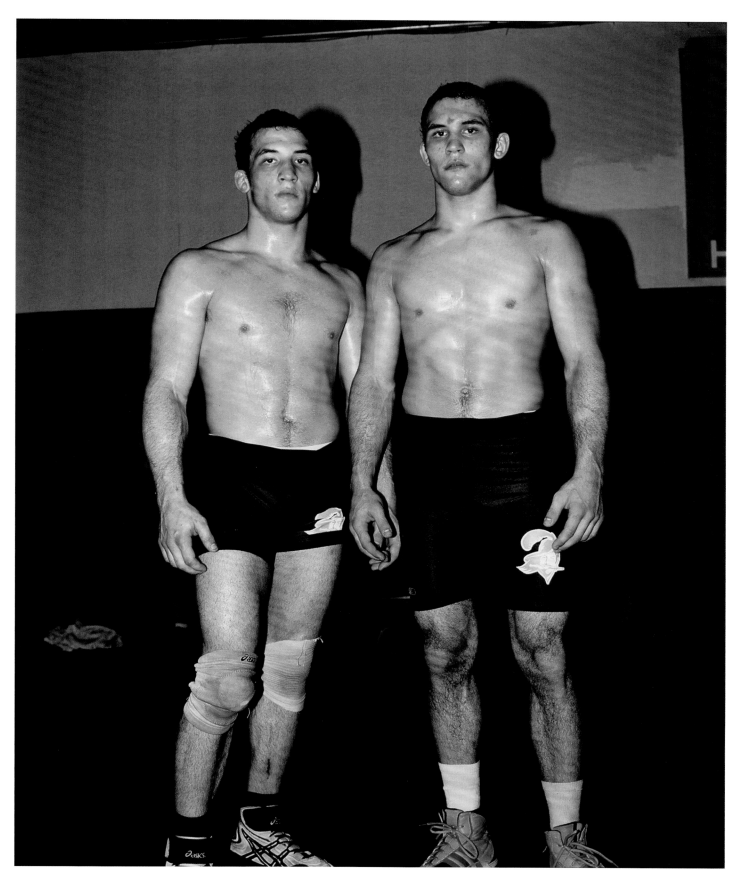

Collier Schorr
Brothers (A.M. & M.), 2003, from the series
'Wrestlers', 2001–3

Phumzile Khanyile
Untitled, 2016, from the series 'Lady Zile', 2016–17

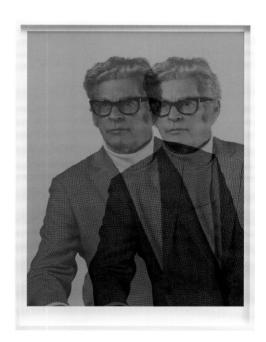
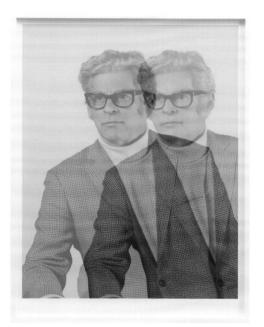
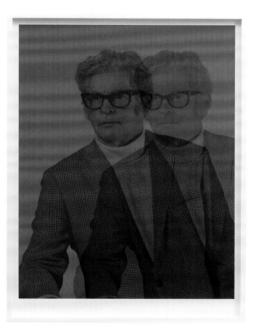

Rodney Graham
Canadian Humourist (Cyan, Yellow, Magenta), 2012

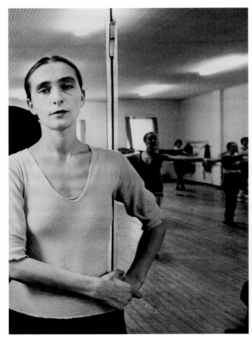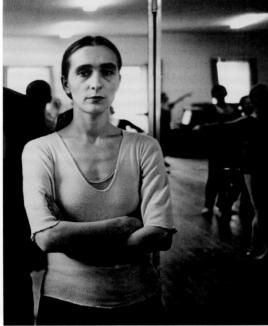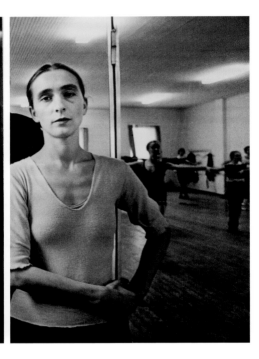

Above **Timm Rautert**
Pina Bausch, 1972

Opposite, above **Timm Rautert**
Gerhard Richter, Köln, 1988

Opposite, below **Timm Rautert**
Isa Genzken, Köln, 1988

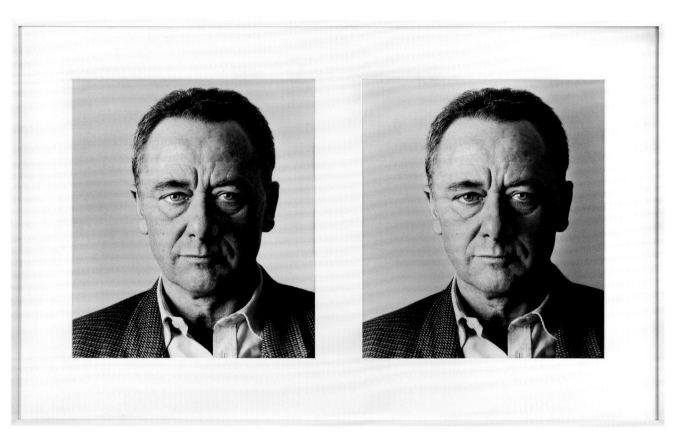

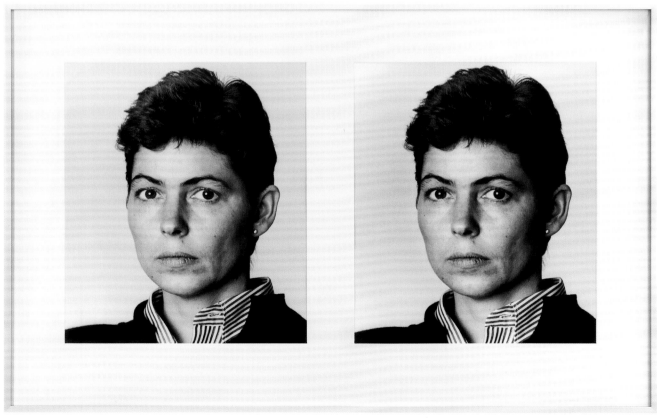

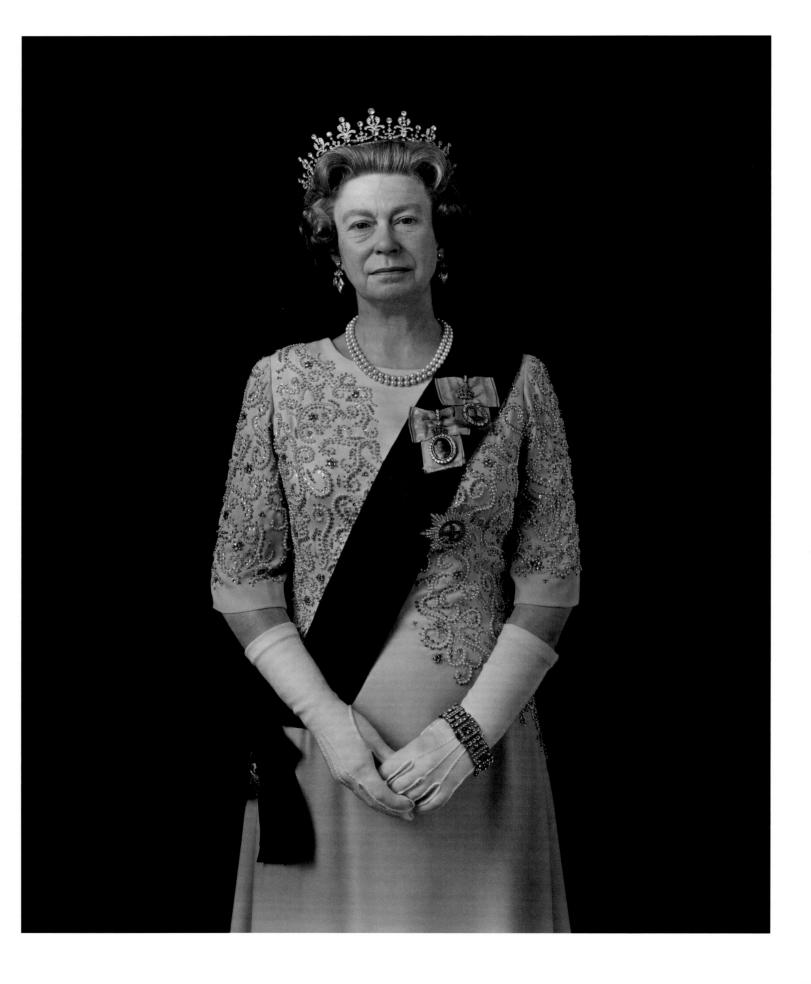

Hiroshi Sugimoto
Queen Elizabeth II, 1999, from the series
'Portraits', 1999

Hiroshi Sugimoto's photograph is not a picture of the Queen herself, but a wax figure at Madame Tussauds. It is one of a series the artist made of figures at the tourist attraction, which he posed in the style of Hans Holbein the Younger, court painter to Henry VIII. Set against a neutral background and with full, even lighting, Sugimoto's pictures invoke Holbein's exquisite attention to detail and sparing use of contextualizing information such as props or scenery. Without these visual clues, and without the ability of the viewer to scrutinize the figure from different perspectives, the picture is arguably as convincing as a photograph of the Queen herself might be.

Sugimoto has a long-standing interest in artificiality and cultures of display. Among his first public works, begun in 1976 and returned to every decade since, was a series depicting dioramas at the American Museum of Natural History. Posed in elaborate tableaux, the taxidermy animals they contain seem arrested in time while engaged in carefully orchestrated behaviours deemed typical of their species. Sugimoto's camera froze them once again, capturing the diorama itself at a particular moment.

This picture of the Queen takes this nested approach to representation one step further. Two iterations removed from the sitter herself, it is a photograph of a wax sculptor's interpretation of the subject, which was in turn made from one or more photographic studies. Sugimoto nevertheless insists his picture is a portrait, and indeed it arguably reveals more about the Queen and her identity than a more conventional picture might.

2 Death by Selfie

Photography for a Digital Age

In the early twenty-first century, photographic portraiture has become one of the most popular creative activities on earth. In 2017, the tech analysis company Statista reported that an estimated 1.2 trillion digital photographs would be made that year. Of those, some 85% are believed to have been taken on smartphones. The rest were produced using tablets or digital cameras, meaning that traditional film cameras have now become a statistically insignificant portion of photographic practice.[1] Some professional artists, students and serious amateurs continue to use film for aesthetic reasons: the translucent colour and subtle grey tones that can be obtained using traditional materials are as yet difficult, if not impossible, to replicate using a digital camera. However, as popular expectations shift regarding what a photograph should look like, as digital technologies get better at simulating analogue materials, and as the environmental impact of old technologies is increasingly scrutinized, film photography is certain to become largely obsolete. Like etching and engraving, which photography itself displaced, film photography is unlikely to go away completely. Those drawn to photography's material presence, or hypnotized by the development of the latent image in the darkroom, will always feel its pull. Nevertheless, digital photography not only dominates practice, it has become more widespread and abundant than analogue photography ever was.

The lion's share of digital photography is undoubtedly made of people. Between formal portraits and selfies, social media images and pictures made for travel, news, sports and school – whether for meetings, competitions, fairs, performances, birthday parties, weddings, anniversaries, quinceañeras and bar mitzvahs, from hen parties to stag nights, and from reunions to dates to family picnics – there are few circumstances in which a photograph will be made without people in it. If we suppose only two-thirds of all photographs feature people as the main subject, then out of 1.2 trillion pictures made every year, roughly 800 billion are made of people – eight times the number of stars in the Milky Way. The real figure is probably much higher, but this is in any case a mind-boggling number.

Arguably the most beloved category of social media portraiture is the 'selfie' – a not-entirely new form of self-portraiture that

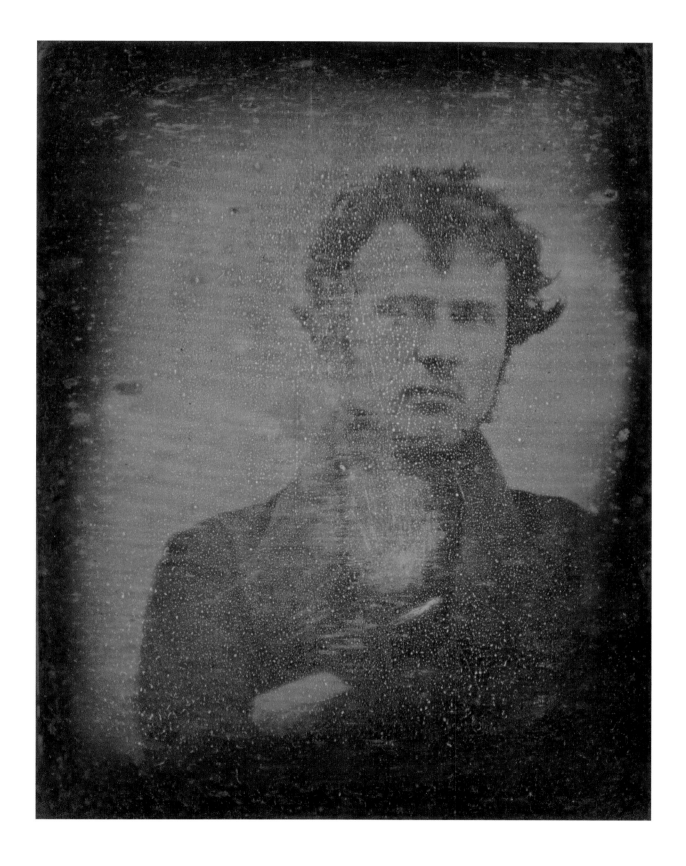

Robert Cornelius
Self-portrait, 1839

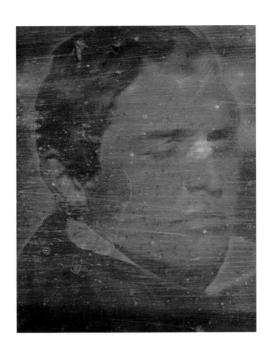

Henry Fitz Jr.
Self-portrait, November 1839

has found full expression in the digital age. Selfies as we now know them originated in 1990s Japan, where they began with purikura – digital photo booths placed in video arcades. Unlike previous generations of photo booths, purikura allowed the user to take a self-portrait photograph, alter the background and add special effects, printing the result as a sticker. However, smartphone selfie culture is truly a twenty-first-century phenomenon: it was not until 1999 that the Japanese electronics corporation Kyocera released the Visual Phone VP-210, the first mobile phone with a front-facing camera, enabling selfies to be made on personal electronic devices. Originally designed for videophone calling (now familiar in services such as Skype and FaceTime), the front-facing camera feature allows the user to pose for a picture while at the same time seeing what that picture will look like in real time. A selfie is a picture 'of myself' made 'by myself'. Photographers of the past could make self-portraits with some of the same qualities, but they would have had to use another method such as a self-timer or cable release, or ask someone else to depress the shutter for them.

Selfies are more than just self-portraits made on smartphones. They portray a sitter in context, providing evidence 'I was there' in a particular time or place, or in the presence of a certain person. The informality and fun of a selfie is part of its appeal: usually light-hearted and tinged with humour, the best are spontaneous reactions to circumstances and not heavy with meaning.

It has been suggested that the first selfie was made by the Philadelphia daguerreotypist Robert Cornelius in October or November of 1839 (see p. 57). To make any photograph at that vintage was an impressive feat: Louis Daguerre had only announced his invention to the French Academy of Sciences in August of that year (the American polymath Samuel Morse had seen examples in Paris earlier, in March, sending a report to the *New-York Observer*, without formulas).[2] But Cornelius did not merely make a photograph; he produced arguably one of the most beguiling and original photographs of his time. For such an early portrait, it is bristling with energy, transporting the viewer into Cornelius's presence, and revealing his charm. The unkempt curls of his hair, the gentle turn and tilt of his head, and his extraordinary eyes, darting to the side and

twinkling ever so slightly with reflected light: all animate the figure, giving him an authentic, real-life appearance seldom equalled in photography for the next half century. It is as though the viewer caught Cornelius walking down the street or at a party, catching only a glimpse of him. The picture was largely unplanned, as Cornelius would later explain. 'You will notice the figure is not in the center of the plate. The reason for it is, I was alone, and ran in front of the camera after preparing it for the picture, and I could not know until the picture was taken that I was not in the center. It required some minutes with iodine to produce the effect.'[3] The genuine candour of the photograph makes it a worthy progenitor of modern selfies.

Whether one considers Cornelius's picture an actual 'selfie' is in some ways a matter of semantics; he seems to have intended his photograph mainly as a test of the new photographic technology rather than an artistic statement. He is not standing in a noteworthy place or in the company of a celebrity in the manner of contemporary selfies, but we may forgive him this omission since his self-portrait places him at a momentous event of self-generated significance – the dawn of portrait photography. Selfie or not, Cornelius's photograph is widely recognized as among the first photographic portraits ever made in the United States, and indeed one of the first produced internationally.

Henry Fitz Jr.'s self-portrait daguerreotype of the same year (see above left) is also sometimes claimed to be America's first self-portrait photograph, but was probably made slightly later. It is not clear why Fitz closed his eyes for the portrait. He noted that the photograph took five minutes to expose in bright light; he may have felt the duration of the exposure and the intensity of the light would cause him to squint or move his eyes. Seated upright and formally dressed, he is neither sleeping nor dead; instead, the camera seems to have captured him in a moment of contemplation, or stealing a catnap.

The growing popularity of selfie photography has had several unintended consequences. The most surprising, perhaps, is physical injury, and even death. In 2019, the British photographer Martin Parr published *Death by Selfie*, a collection of photographs made by Parr of selfie photographers in India. In

2017, the country had the ignominious distinction of leading the world in selfie-related deaths: in both 2016 and 2017, sixty-eight people perished while taking selfies, up from twenty-seven in 2015. These tragic circumstances result from the near-total absorption photographers sometimes experience while taking a selfie. At the extreme, this can cause makers to wander absentmindedly into traffic, fall off cliffs, or be swept away by currents. Less severely, it may result in the photographer simply feeling isolated and removed from the events around them. The irony of the proliferation of selfies is that the people who take them may wish to show that they are present in a place, but many times they are not really 'present' at all; they are physically there, but have no genuine sense of the situation they are in. This is hardly a new phenomenon in photography, but it is arguably most intense with selfies. Parr's title, 'Death by Selfie', may therefore be thought of as a double entendre – literally, death as a result of selfie-making, but

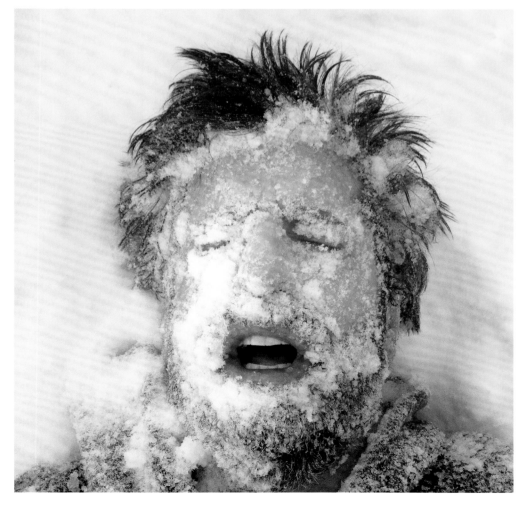

also the extinction of thought and feeling that may accompany the single-minded pursuit of camera-phone self-portraits in tourist sites.

In response to the growing onslaught of selfies, the American photographer Alec Soth produced a series of 'Unselfies', which he first shared on Instagram in 2015. In each, his face was intentionally obscured – masked, pixellated, photographed in dim light, hidden in a cloud of steam, distorted by bubbles of water, and even shot with a gun. His 'Unselfie covered with snow' shows the artist lying head and shoulders in a snow bank, his hair, eyes, face and beard frozen white, his skin pink from the stinging cold, with only his red lips, mouth formed into an oval, uncovered (see below left). It is a portrait of the artist after an avalanche; an avalanche of selfies, perhaps, yet the viewer is allowed to entertain other possibilities. Has he been frozen alive, his gaping mouth the only vestige of one final cry for help? Is he, like the casualties in India, the victim of a selfie gone wrong? Or should we read the picture more metaphorically – a latter-day answer to Munch's famous 'Scream'? If it is an Unselfie, perhaps it depicts his Unself: the 'not me', or a me that others never see.

The recent exponential rise in photographic picture-making has been accompanied by new and unprecedented uses for photographs online. Many of these loom large in the public imagination and are supported by powerful corporations – Facebook, Instagram, Snapchat, Pinterest, WhatsApp, LinkedIn, Weibo, WeChat and Twitter, for example, each of which uses photographic imagery in different ways. Users post images to social media sites to network and share thoughts and experiences; dating and lifestyle apps such as Tinder and Grindr allow users to connect using pictures of themselves; and image-hosting platforms like Google Photos, SmugMug, Imgur, Pinterest and Flickr allow groups of images to be shared publicly or among defined groups. Many of these sites also support video and 'live' broadcasts, while a growing number of companies specialize in short-form videos, such as TikTok, Tangi and Firework.

In 2020, the American country singer Dolly Parton launched a playful 'Meme Challenge', inviting users to submit grids of four photographic portraits in the style of four of the more prominent social media platforms: LinkedIn,

Facebook, Instagram and Tinder. Parton did not invent the meme, which had been around for some time, but her contribution (see opposite) caught the public imagination and inspired an outpouring of copycat posts, including from other celebrities. The LinkedIn frame shows Parton in the professional dress fans remember from her 1980 comedy *9 to 5*, with hair neatly set, buttoned-down checked jacket, a ruffled scarf wrapped tightly around her neck and a pencil behind her ear. In the Facebook version she is relaxed and pretty, one hand on her hip and another resting casually on her knee, wearing a holiday jumper. In the Instagram picture she is leaning in the doorframe of what looks like the backdoor of a nightclub, holding her guitar by her side. Finally, the Tinder picture presents her as a Playboy Bunny, complete with furry ears and a fluffy pink tail. Parton's challenge may have been a harmless bit of fun (and shrewd marketing), but it pointed up an idea that users of social media know implicitly: different platforms require different approaches, and consequently different styles of portraiture. The LinkedIn portrait is restrained and serious; Facebook, the way we want our friends and family to see us; Instagram, spontaneous and of the moment; Tinder, sexy and alluring. There are exceptions to these generalizations and crossover in every possible direction; nevertheless the exercise reveals how digital portrait photographs are often targeted to perceived audiences.

It is unlikely the current lineup of platforms for digital image sharing will remain in the distant future. Many social media and image-hosting platforms have overlapping functions, and there are many smaller players aimed at specialist audiences, from religious groups to knitters. The companies that survive will be those which best meet online community needs, are lucky and/or well run, and are not bought up by other firms and intentionally mothballed. Since even the most established digital platforms are young in business terms, mergers and acquisitions are common; and because internet and smartphone culture is by its nature innovation-driven, and loyalties are volatile, the popularity of these platforms tends to wax and wane. Consequently, it is not clear which, if any, of these companies will endure over time. The one thing they have in common is that in each the photograph has no physical presence: no print is ever produced, unless the viewer wants to go to the trouble of printing it out. In other words, social media and other digital platforms share 'images' rather than photographs in the traditional sense. Yet the power and influence of these firms is such that the definition of a photograph is quickly changing, so that the old idea of a photograph as a work on paper (or other support) no longer holds true.

Whereas previous generations of photographers carefully controlled the palette and tonal range of their photographs, in the digital world such qualities are largely notional, as viewers experience images on different devices with a wide variety of scales, resolutions and colour balances. Even professionally calibrated monitors vary, so that what photographers think they are sending out into the world may not match what viewers actually see. And while photographers theoretically enjoy copyright protections over their imagery, in the largely unregulated domain of international consumption most are powerless to control the appropriation and reuse of pictures. Interventions can be subtle, as when a user increases the brightness and contrast of a picture, or they can be more comprehensive, for example when Photoshop is used to change a smile to a frown, alter the manner of dress or location of a sitter, or introduce other individuals. Snapchat has made such transformations routine, with the easy morphing of portraits into animated characters or the exaggeration of facial features at the touch of a button. The role of the photographer in the creation of the original may be reasonably straightforward, but their part in the waves of alterations and variants that arise later is unclear. As frustrating as this can be to the maker, it is not necessarily a bad thing. The appropriation and reprocessing of imagery is one of the linchpins of contemporary art.

One of the questions raised by all of this activity is the significance of pictures that are made but never 'used'; that is to say, which are never shared with others or potentially never viewed by the photographer. Like trees falling in a forest when no one is around to hear, the impact made by billions of photographs being captured but never seen is an implacable riddle, and the artistic agency of the photographers who made those pictures is up for debate. To be fair, the same problem

Dolly Parton
Meme Challenge, 2020

existed with film photography, just on a smaller scale. What does one make of vast repositories of slides and negatives which photographers of the past exposed, developed but never printed? In some cases, estates and archivists have gone back after an artist's death and made prints of these 'set asides', frequently finding material equal to or better than pictures previously printed and published. However, to posthumously sift through the vast soup of unviewed exposures found in the cloud servers, SD cards and memory sticks of today's photographers scarcely bears contemplation. Perhaps it is not just photographic prints that must be re-evaluated in the digital age but also the act of photographing; in the twenty-first century it may be enough for the photographer to conceive and execute a picture, even if it is never seen again. Navigating through the world photographically, processing things seen and felt, can be a noble enterprise unto itself. Private resonance may be all one can hope for in such circumstances.

Another challenge to the traditional idea of photographic portraiture is the influx of video, supported by most social media platforms to varying degrees. The result has been a blurring of the historical line between still and motion-picture photography. Virtually all modern cameras are equipped with both still and video photography modes, and many cameras now shoot micro videos (short bursts of still photographs over 1–2 seconds), enabling the photographer to choose the precise moment in which the eyes were open, the smile most pleasing, and the posture just so. With rapid advances in video capture and playback technology, and expanding computer memories, the long-held dream of some photographers to simply shoot video of a subject, enabling high-quality stills to be produced later on, is already occurring in professional studios, and will soon be available to ordinary consumers. Not only will this fundamentally alter the way stills are made, it will erode the production of individual photographs altogether. It is not hard to imagine a situation where still photography becomes quaint and old-fashioned, and the weight of photographic production moves to video capture. The recent popularity of video-hosting platforms like YouTube and TikTok suggests this process is under way. Eventually, videos will likely come to dominate popular photography, forcing us to rethink, again, what is meant by photographic portraiture.

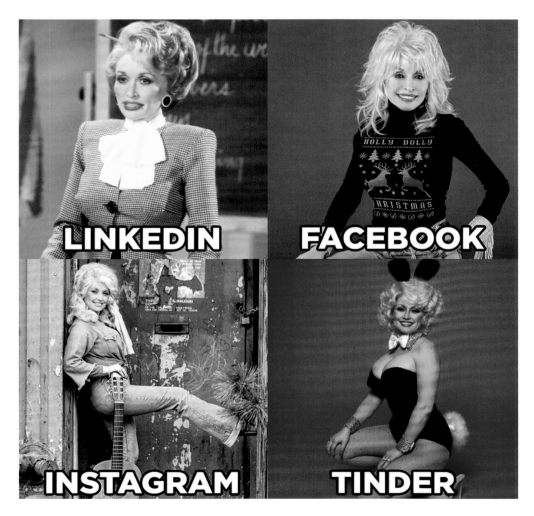

Martin Parr

Online dating profile picture, Hey Saturday, London, UK, 2016, from the series 'Autoportraits'

The international portrait studio Hey Saturday specializes in dating profile pictures – photographs intended for use in online forums, apps and matchmaking services. Here, Magnum photographer Martin Parr commissioned the company to produce a portrait of himself according to the company's usual practices. Told only to 'smile and look happy', he is shown with hands in the air, leaning gently to one side, standing in front of a restaurant or shop front, a warm globe light in the distance, and the reflection of an onlooking child in the window behind him. The setting is humanizing and approachable, designed to make Parr look sociable and non-threatening.

Unlike an amateur profile portrait, Hey Saturday's picture is studied in its casualness. The awning, the background and the reflection are shown out of focus, while the subject – Parr – is made to look as though the viewer has just met him on the street, and been invited along for a drink. Unlike traditional studio portraits, it is meant to convey spontaneous interaction – the sort of unprompted encounter one might record with a smartphone. It puts the viewer in a position of intimacy, as if in a one-on-one encounter with the subject. Like informal photographs of family and friends, it suggests there is a story behind the picture, even though the situation is orchestrated, and ultimately fictitious.

Right **Alec Soth**
The Curator Fei Dawei being interviewed on multiple streaming apps, n.d.

Below **Susan Meiselas**
Barcelona, Voting Day on Referendum Independence, 2017

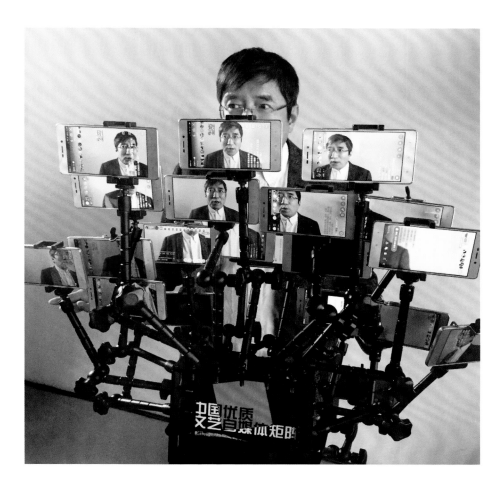

Ian Berry
St Stephans Cathedral, Austria, Vienna, 2019

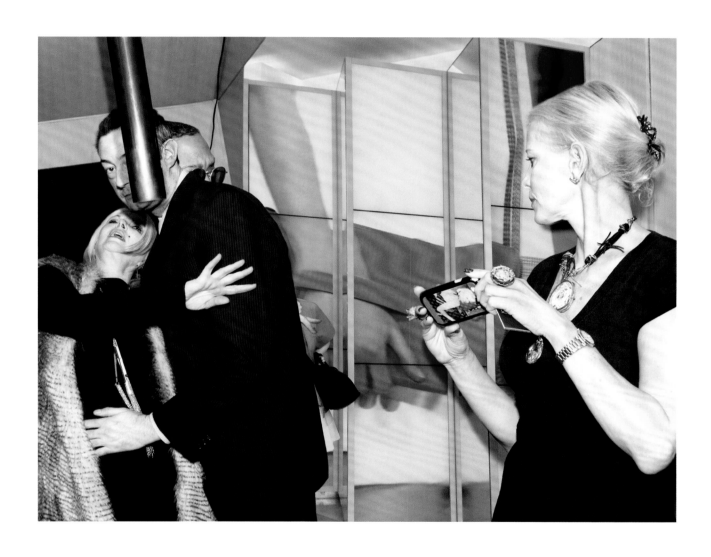

Mónika Sziládi
Untitled (Fall I), 2014–15, from the series
'Claws and Flaws', 2014–15

Anderson & Low
Untitled (The Mighty One), 2009, from the series
'Manga Dreams', 2009

Truth and fiction collide in the series 'Manga Dreams', collaborative portraits that resemble characters in Japanese comics. Inspired by the influence of manga on Tokyo youth fashion, Jonathan Anderson and Edwin Low invited subjects they met on the street to their studio, where they provided hair, makeup and clothing stylists who worked with the sitter to develop an ideal character. The resulting portraits are archetypes (idealized warriors, princesses and villains) based not only on manga conventions, but also on aspects of the subjects' own identities (how individuals perceive themselves, or how

they would like to be seen). As stylized as they may appear, the alternative realities these sitters inhabit reflect a deeper truth that might not be apparent in a more conventional portrait.

Like other pictures in the series, *Untitled (The Mighty One)* combines theatrical artificiality with uncanny realism. This is achieved in part through digital post-production techniques, which enable the artists to add or remove backgrounds, sharpen contours, and intensify lighting effects. At the same time, the intimate detail of the photographic image is retained,

so that every pore, mole and imperfection of the sitter's body is clearly shown.

Well known for their work photographing athletes, the artists would go on to photograph the sets of the James Bond films *Skyfall* (2012) and *Spectre* (2015), and make publicity photographs for *Star Wars: Episode VII – The Force Awakens* (2015). Each of these projects shares an interest in heroism – how heroes are constructed and seen, the reality or unreality of the human body, and what is genuine and substantial about identity and self-belief.

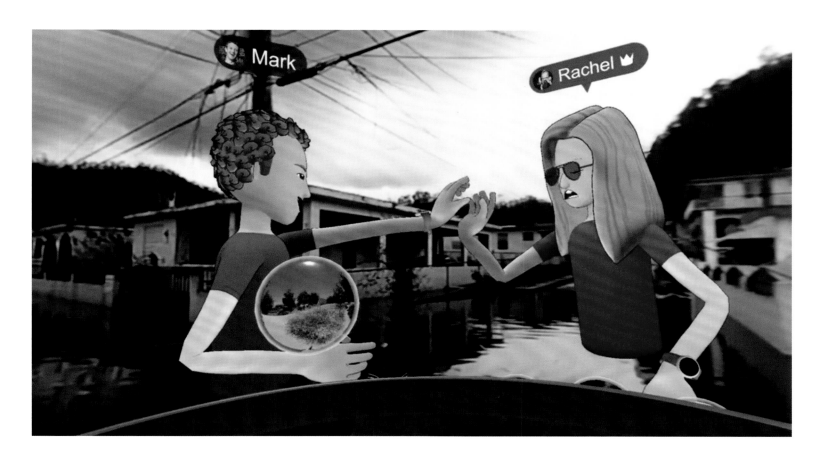

Avatars of Mark Zuckerberg and Rachel Rubin Franklin touring flooding caused by Hurricane Maria, Puerto Rico, 2017

In the aftermath of Hurricane Maria, which devastated Puerto Rico in 2017, Facebook founder Mark Zuckerberg and Rachel Rubin Franklin, the company's then-Head of Social VR (virtual reality), hosted a livestream event in which their avatars toured areas affected by the disaster. Their intent was to announce a new initiative supporting Red Cross relief efforts, while at the same time promoting a new app called Spaces, which enabled visits to faraway places without physically travelling. However, the discordant vision of Zuckerberg and Franklin high-fiving in front of a flooded

street, and cheerfully describing the experience as 'magic', struck many as at best insensitive, and at worst a new and nefarious form of disaster tourism.

At the time of the livestream, nearly half of Puerto Rico's communications infrastructure was no longer functioning. Although Facebook did send employees to help restore telecommunications and later donated cash to the relief effort, the image of Zuckerberg and Franklin transported to a place of genuine human suffering highlighted a shortcoming of virtual experience. Despite

Zuckerberg's claims that 'you can get the feeling that you're really in a place', the virtual visitors' experience of the situation could hardly have been more different from that of Puerto Rican residents, many of whom were left homeless and without power, water or food. Superimposed on photographic imagery of real places, the chosen avatars were strangely apposite – their spotless t-shirts, smart watches and neatly coiffed hair indicative of their true locations inside a California corporate bubble, rather than a disaster zone.

Taryn Simon
An Avatar, 2008

The word 'avatar' is commonly used to mean
a digital stand-in for an individual used in
online simulations and games; its original
meaning was an incarnation of a Hindu deity,
especially Vishnu, protector from cosmic
forces of destruction and chaos. Taryn Simon's
An Avatar is both – a mischievous alter ego
for an unidentified person, and an ironic saviour
of humanity. A Frankenstein's Monster hewn
from controversial political figures, he combines
one shoe of former Hamas leader Nizar Rayan
with an eye of Cuban president Fidel Castro;
an ear, nose and chin derive from former
American Secretary of State, Henry Kissinger.
With remarkable specificity, the constructed
figure borrows suits and ties, beauty marks
and lower eyelid bags from various figures,
but is conspicuously missing a heart and
brain. As potent a mix of personalities as
the avatar represents, he is ultimately a study
in superficiality – a seemingly arbitrary, but
eerily purposeful, assembly of parts.

The resulting avatar is a macabre figure,
clutching a microphone in mid-rhetorical
flourish, levitating against an acrid yellow
background. As a saviour of humankind he is
unlikely in the extreme, a creature more likely
to sow dystopia than restore order, even though
in life, each of the individuals he is built from
advocated solutions to complex problems.
He is, perhaps, the dark side of all of us – a
dysfunctional, self-destructive manifestation
of competing interests.

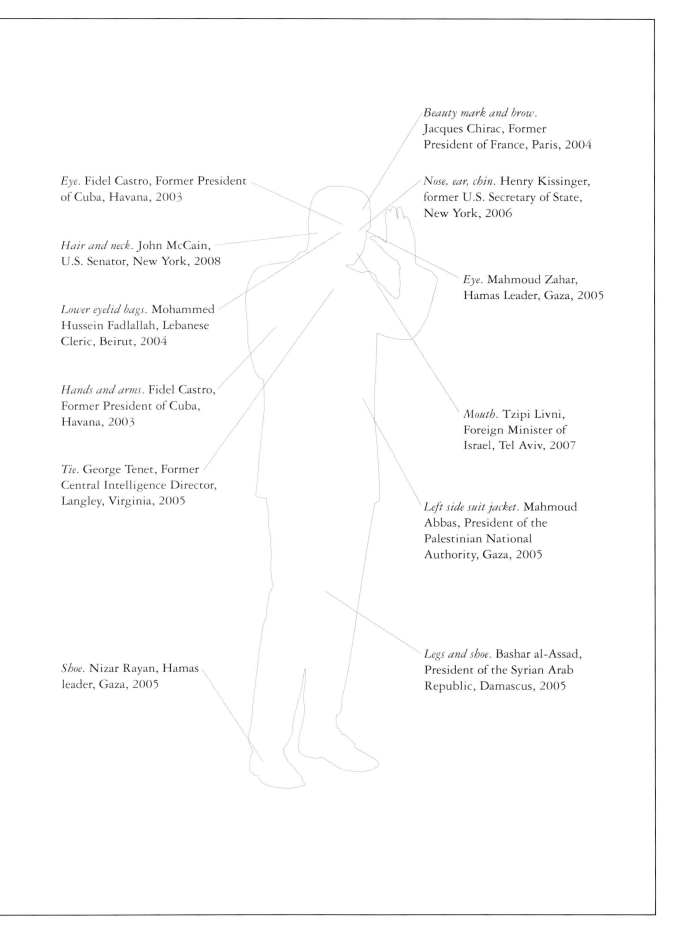

Beauty mark and brow. Jacques Chirac, Former President of France, Paris, 2004

Eye. Fidel Castro, Former President of Cuba, Havana, 2003

Nose, ear, chin. Henry Kissinger, former U.S. Secretary of State, New York, 2006

Hair and neck. John McCain, U.S. Senator, New York, 2008

Eye. Mahmoud Zahar, Hamas Leader, Gaza, 2005

Lower eyelid bags. Mohammed Hussein Fadlallah, Lebanese Cleric, Beirut, 2004

Hands and arms. Fidel Castro, Former President of Cuba, Havana, 2003

Mouth. Tzipi Livni, Foreign Minister of Israel, Tel Aviv, 2007

Tie. George Tenet, Former Central Intelligence Director, Langley, Virginia, 2005

Left side suit jacket. Mahmoud Abbas, President of the Palestinian National Authority, Gaza, 2005

Legs and shoe. Bashar al-Assad, President of the Syrian Arab Republic, Damascus, 2005

Shoe. Nizar Rayan, Hamas leader, Gaza, 2005

Marc Erwin Babej
Dear Pharaoh, 2017, from the series
'Yesterday — Tomorrow', 2017

The invention of photography is sometimes thought of as a natural outgrowth of Renaissance-era single-point perspective, in which three-dimensional space is rendered according to geometric principles, with one point of view and a fixed vanishing point. However, photography has always been capable of representing space in other ways. Depending on design, nineteenth-century view cameras, with their flexible bellows, were capable of tilts, swings, drops and shifts that could contort an image beyond recognition. In addition, wide-angle and telephoto lenses can be used to expand and compress the field of view, making the subject look rounder or flatter than they appear in life. In recent years, digital post-production techniques have increased the ease and variety of manipulations that can be employed, allowing the maker to warp perspective, or piece together imagery taken from more than one source.

Single-point perspective is sometimes described as mimicking how the eye sees, but, traditionally, not all cultures have subscribed to this understanding of how vision works. For example, in ancient Egypt, artists used a privileged point of view allowing them to 'see' the front and side of a sitter at the same time. This approach is sometimes called 'aspective' realism, since it allows the viewer to look clearly at different aspects of the subject simultaneously. Marc Erwin Babej uses digital techniques to reimagine Egyptian carved reliefs using photographs altered according to rules of aspective realism. The project — made in collaboration with leading Egyptologists and experts — not only brings ancient practice alive in new ways, it also challenges usual notions of photographic reality, and the assumptions implicit in viewing a 'conventional' photograph.

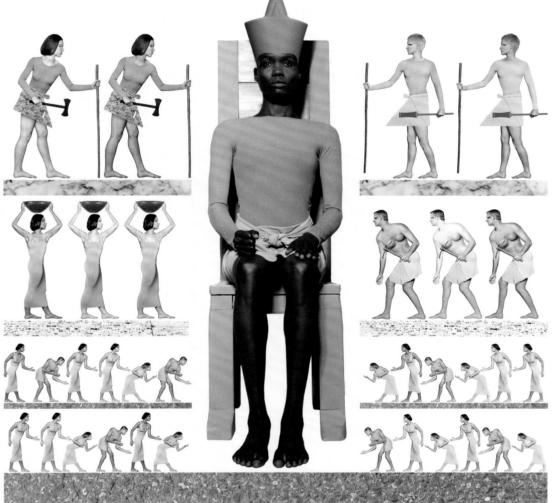

THE IDEOLOGICAL SYSTEM BY WHICH THE WHOLE LEADERSHIP AND PEOPLE ARE FIRMLY ARMED WITH THE IDEOLOGY OF MA'AT AND UNITED SOLIDLY AROUND IT, UNDER THE SOLE LEADERSHIP OF PHARAOH . THREE PRINCIPLES FOR THE ESTABLISHMENT OF THE MONOLITHIC IDEOLOGICAL SYSTEM OF EGYPT:

I . WE MUST ADHERE STRICTLY TO THE PRINCIPLE OF UNCONDITIONAL OBEDIENCE

IN CARRYING OUT PHARAOH'S INSTRUCTIONS 2 . WE MUST ESTABLISH STRONG

ORGANIZATIONAL REGULATIONS SO THAT UPPER AND LOWER EGYPT

MOVE AS ONE UNDER THE ONE AND ONLY LEADERSHIP OF PHARAOH . WE MUST

PASS DOWN THE GREAT ACHIEVEMENT OF PHARAOH FROM GENERATION TO GENERATION 3 . WE MUST

INHERITING AND COMPLETING IT TO THE END

Daniel Mayrit
Comisarios, 2016, from the series
'Authorised Images', 2016

The Spanish *Ley de Seguridad Ciudadana* (Citizen Security Act) came into force in July 2015, specifying a number of infractions that could be enforced directly by the police or Guardia Civil without recourse to a judge. Among these was a provision making it illegal to photograph police officers without explicit permission. One effect of this 'gag law' has been to protect police from being photographed while engaged in questionable acts, such as suppressing political protest. At its worst, it also shields officers engaged in illegal behaviour, such as police brutality.

Daniel Mayrit's photograph was taken from a police archive, since in accordance with the law private individuals are no longer allowed to make and distribute pictures of police. The picture shows the annual convention of the chiefs of National Police, which takes place every year in Madrid. To comply with the new restrictions, the face of every policeman in the picture has been pixellated except for the two people in the centre, who are politicians and therefore exempt from the law. Ironically, both were later prosecuted for corruption perpetrated during their years as heads of police forces.

Armin Smailovic
Witness W132, 2015, from the series
'Testimony Portraits', 2015

generated.photos
Natural front-facing asian black hair long hair
joy female with brown eyes, 2020

The person depicted in this photograph is not real. She is a completely synthetic creation generated by artificial intelligence (AI) software, applying algorithms designed to characterize and replicate human appearance. Although it looks like a photograph, the picture was actually created by entering a series of instructions into the website https://generated.photos, which produced this result. It is one of a large number of websites offering AI-simulated portrait imagery free of copyright and privacy protections. The primary market for such imagery is advertising and fashion illustration; pictures like this enable designers to produce catalogues, reports and advertisements without paying a professional model.

The technology that produced this picture is related to techniques that allow the 'de-ageing' of older actors, the visual resurrection of celebrities who are no longer living, and even the creation of lookalikes who can be made to perform acts a real celebrity never would. Such uses have sometimes caused justifiable alarm. However, manipulation and fakery have always been common in photography: AI technologies have simply made deception more convenient and convincing. Philosophically, digitally derived pictures like this also remind us of the inherent limitations of traditional portrait photography. If the penetrating gaze, arched eyebrows and dimpled cheeks in this picture mean nothing in real life, to what extent can any picture convey a person's true identity?

Maija Tammi
One of Them Is a Human #1,
Erica, 2017

Robert Heinecken
Connie Chung, 1986

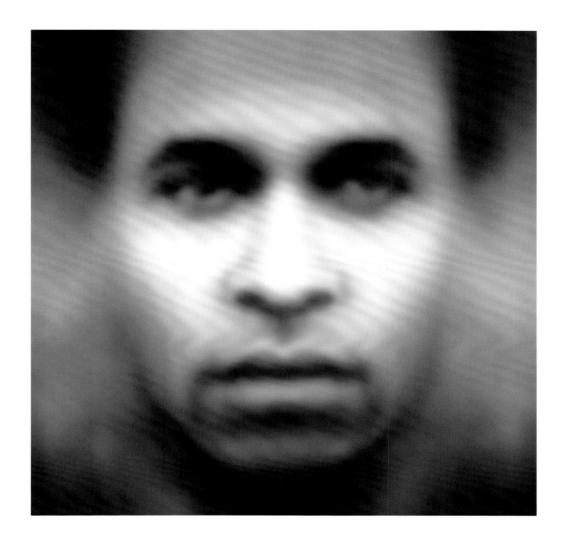

Trevor Paglen
"Fanon" (Even the Dead Are Not Safe)
Eigenface, 2017

This ghostly picture portrays Martinique-born political philosopher Frantz Fanon in the form of an eigenface, a computer model used in facial recognition technology. Fanon was an anti-colonial theorist who argued, among other things, that European language constructs implicitly reinforce false notions of racial difference and white superiority. A strong advocate for the independence of Algeria from France (achieved in 1962), he approached racism as a psychopathology – a culturally imposed, internally perpetuated, white-driven expression of social, political and economic injustice. His writings advocating renewed black consciousness influenced colonial liberation movements internationally, and inspired revolutionary figures including anti-apartheid activist Steve Biko in South Africa, and Malcolm X in the United States. Each advocated the violent overthrow of entrenched power structures, a step Fanon considered largely inevitable.

While resembling an out-of-focus photograph of a human face, this eigenface rendering is not technically a portrait at all, but a mathematical expression of variability within a population. An eigenface maps all known variations in appearance as vector data, allowing a user to detect statistical differences between any given individual and the reference group. Since digital photographs record visual information as pixels, they readily lend themselves to this kind of analysis. The irony of a critic like Fanon being subjected to such treatment, in which racial and ethnic identity become just so many lines of computer data, reminds us of the perils of digital technologies in the representation of identity.

Kazuto Ishikawa
Humanity 23, 2015, from the series 'Humanity',
2015–ongoing

To make the portraits in his 'Humanity' series, Japanese artist Kazuto Ishikawa prints with massive overlays of ink, allowing the original image to disintegrate into pools of colour. As the inks bleed they disrupt the original portrait, rendering it invisible or, as in this image, partially obscured. The artist thinks of this process as a metaphor for identity loss in the digital age, overloading his portraits with colour in the same way information overwhelms individuals through social media and the internet. Since Ishikawa makes his alterations without the sitter's approval or presence, he also sees the distance involved in his process as parallel to the anonymity of digital information and its effects. At the same time, he considers his pictures, which are analogue in construction, as antidotes to the digital sphere.

Like the colours of traditional kimono, the colours of Ishikawa's portraits are meant to convey meaning. Red, which dominates this picture, is among the most complex colours in Japanese symbology, with associations ranging from joy and happiness to death and mourning. Blue is also considered a meaningful colour, suggesting passivity and coolness. Although Ishikawa can control the palette of colours he uses, he does not control the way they flow on paper, which gives each picture an element of chance. Aspects of the portrait may even become strangely dislocated; for example, in this photograph the figure's neckline, hair and left eye are aligned, whereas her right eye repeats faintly, seemingly drifting away from her body.

3 Face to Face

Portrait and Emotion

Facial and body signals can be grouped into two distinct but overlapping systems: body language and expression. Expressions are automatic and autonomic – the lizard part of our brains sending a status report to another person or animal. When we are genuinely alarmed, without thinking, our facial muscles draw our eyes and mouth wide, and we may emit a gasp. When we are angry or provoked, we might bare our teeth in a snarl. When we are deeply in love, we lower our eyelids and relax our facial muscles; we may even blush a little. All of these actions occur involuntarily and below consciousness. If we concentrate, of course, we may be aware of these things happening, and we can even try to suppress them. However, they are biological responses that occur on a primal level, and are difficult to mask. We call them 'expressions' because they are eruptions of our inner feelings, made manifest on our bodies.

Body language – including gestures of the hands, arms and body – comprises a separate but overlapping system that builds off these autonomic responses, but is acculturated like spoken language. Body language may feel automatic, but from a biological perspective it is voluntary, and controlled by a different part of our brains. The distinction between expression and body language can be difficult to establish. In casual conversation we often conflate the two, especially when speaking about the face, where the term 'facial expression' is used to mean both involuntary and voluntary expressions. Gestures of the arms and hands are some of the easiest to identify – in much of Western culture, for example, the palm held outwards at another to signal 'stop', or the shrugging of the shoulders to signal 'I don't know'. Other aspects of body language more closely resemble autonomic expressions. The most famous and beguiling of these is the smile. Smiles can be either expressions or gestures, depending on circumstance. When we are suffused with joy, smiles leap to our faces. That is a smile as expression. At the same time, if we want to signal satisfaction to another nonverbally, we might smile purposefully, using our faces almost like words to tell the story of our happiness.

Expression and gesture are not mutually exclusive. Imagine, for example, someone arriving at a lucky individual's front door to tell them they have just won the lottery. At first the recipient of the good news will smile broadly and genuinely: an autonomic, expressive

Friedl Kubelka vom Gröller
Lisa Crncec, Age 27, Part-Time Bartender, Unmarried –
Thoughts about Sexuality, Innate Femininity, 1985

Guillaume-Benjamin Duchenne de Boulogne
False Laugh: Excitation of the Zygomaticus
Major Muscle, 1852–56, in *Mécanisme de la
physionomie humaine* (1862)

reaction to a happy circumstance. As legions of television cameras arrive and begin to ask questions, the situation is no longer so joyful. Nevertheless, the winner might continue to smile politely, to signal satisfaction and appreciation. That is body language, or gesture. People smile all the time and for counterintuitive reasons. Sometimes they smile when they make a mistake – a kind of non-verbal apology for doing something wrong. Or they may smile while performing a difficult task, like pushing a heavy load. These are considered non-verbal signals of affirmation, in the face of obstacles.

The origins of expression and body language remain somewhat contested in scientific circles, since they have implications for evolution and ethnology. It is generally (but not unanimously) accepted that expressions are universal, while gestures are learned. In other words, in virtually every society on earth, expressions look more or less the same, while body language may vary considerably. For example, in nearly all cultures, sadness is expressed by downturn of the lip muscles and shedding of tears. There may be some communities that encourage individuals to alter or suppress these expressions for cultural reasons, which is one reason why universality of expression is sometimes questioned. On the other hand, body language may be as particular to a culture as words are to a language. An example of this is shaking the head to say 'no'. In most of Europe, Africa, Asia and North and South America, shaking the head from side to side is used to indicate rejection or disagreement. However, in certain parts of Eastern Europe – in Bulgaria and Albania, for example – a headshake has the exact opposite meaning, signalling 'yes' or agreement.

Scientists are increasingly learning how to separate 'real' expressions from 'simulated' body language. In most cases, the muscles involved in displaying an involuntary facial expression differ from those used to make a parallel gesture, even when they involve the same parts of the face. In the case of smiling, this phenomenon has been understood since at least the nineteenth century, when it was first proven photographically. The French scientist Guillaume-Benjamin Duchenne de Boulogne, working at the Salpêtrière hospital and elsewhere in Paris, developed an experimental system for isolating various muscle groups in the 1850s. Using mild electrical probes, he stimulated certain facial muscles to contract. Then, working with the photographer Adrien Tournachon (younger brother of Gaspard-Félix Tournachon, known as Nadar), Duchenne arranged to photograph the result (see left). Working in this way, Duchenne discovered that a 'genuine' smile involves different muscle groups than a simulated one. With probes applied to faces and muscles contracted artificially, the results may look disturbing, but the subjects were not harmed, and the photographs were not intended for public consumption. Duchenne considered them experimental evidence (at that time a novel concept when applied to photographic information), designed to record the results of his research and make it easy to share this with other scientists.

In recent decades, the work Duchenne began has been applied to lie detection techniques, and is now routinely used in customs and border protection, as well as police work. By closely observing facial expressions and other signals under questioning, a trained observer can often judge whether an individual is telling the truth or trying to deceive or conceal their true feelings. The difference may or may not signal a lie, as a person may have perfectly good reasons for concealing their true thoughts. The pre-eminent scholar in this work is the American psychologist Paul Ekman, formerly of the University of California, San Francisco. Ekman has achieved remarkable success using photographs and close observation to examine 'micro expressions' – subtle changes in expression that occur in 500 milliseconds or less, and are frequently missed by the casual observer – to determine if someone is telling the truth, and other intricacies of human expression (see opposite). Photography can be an excellent tool for spotting micro expressions, since these may appear and disappear faster than the naked eye can process. Some of the 'tells' of lying are easy to see without assistance: fidgeting, blinking, aversion of the eyes, and dilation of the pupils. Others require closer scrutiny. Subtle asymmetries of the eyes, brows, head and shoulders may betray falsehoods, but are difficult to see without photography or video.

Among those who took an interest in Duchenne's photographs in the nineteenth century was evolutionist Charles Darwin. Darwin encountered Duchenne's photographs

Mark G. Frank, PhD
A Microexpression of Disgust, February, 2021

in the 1860s, a decade after Duchenne produced them. Nearly thirty years after publishing his account of the *Voyage of the Beagle* (1839), and ten years after *Origin of Species* (1859), Darwin was researching a book on sexual signalling and the place of humans in the evolutionary scheme. In *Origin*, he had carefully avoided placing humans in his theory of evolution by natural selection, the so-called 'survival of the fittest' doctrine.[1] The new book, which would become *Descent of Man* (1871), finally acknowledged what pundits had long assumed – that Darwin's theories implied that humans, too, had evolved from other animals. In humanity's case, he argued, the most immediate ancestors were higher primates.

Along the way, Darwin pioneered what would later be called psychology, but did not then exist as a distinct discipline. In the late 1860s, psychological research was young and unproven, so the work Darwin turned to was decidedly cutting-edge. His own scholarship had become increasingly radical: if humans had evolved from animals, he hypothesized, then human behaviours, including expressions, must have animal origins. Taken to its logical conclusion, this meant that human brains, and with them, thoughts and feelings, have animal progenitors as well. Since expressions were the best available indicators of mental states, he began to compare human expressions with animal ones. And because expressions (particularly the micro expressions Ekman later identified) may change quickly, he used photography to freeze behaviours in time. As this work outgrew its original purpose as a chapter in *Descent*, Darwin published his findings, together with photographs illustrating his work, in another volume, *The Expression of the Emotions in Man and Animals* (1872).

Darwin began his photographic work by shopping for commercially available portraits in London shops and studios, hoping to find pictures including common expressions like crying, laughter and indignation. These, he reasoned, would be more reliable than photographs made to his instructions, since they would represent, if not actual expressions caught midstream, then at least popular conceptions of what expressions look like. Instead, he found that most portraits even at that vintage showed individuals with neutral expressions. The reason for this was partly technical: photographic chemistry was so slow that it was hard to photograph quickly changing things like facial expressions.

In snapshots and social media, English-speaking photographers often direct their subjects to put on a smile (of the gesture type) by asking them to say 'cheese' before making the exposure. Other countries have parallel phrases: in China, the Mandarin word for 'eggplant' (*qié zi*) is used; in Sweden, '*omelett*'. In South America sitters often say 'whiskey', while in Korea sitters are known to say 'kimchi'. These words are meant to be slightly silly in hopes of eliciting genuine smiles, but they also force the lips into a smile-like gesture. Saying 'cheese' in English directs the lips upwards and causes the teeth to bare slightly – a reasonable imitation of a smile. Other phrases have the same effect in other languages.

Coaxed smiles are common in certain categories of formal portraiture – for example, school yearbooks, corporate newsletters, and even driving licences. However, a neutral, comparatively expressionless style prevails in most other forms. Because they carry the burden of personal identity, many formal portraits are vested with gravitas, and a neutral expression is considered serious and appropriate. Conversely, a more light-hearted expression could appear trivial, and as a result, the sitter less consequential. Moreover, a neutral expression is a blank slate, with the potential to go in any direction – happy or sad, angry or determined. Since expressions and gestures are by nature momentary, neutral expressions seem solid and universal by comparison. Like a holotype, or primary specimen of an organism, an expressionless portrait might be deemed 'typical' of that sitter. In other words, rightly or wrongly, if a photographer aims to provide an archetypal representation of an individual, they are likely to pose them with a neutral expression. Neutrality, of course, is a relative term. Often it is the hint of emotion that makes a portrait exceptional – the ever so slight curl of a lip, the glint of an eye, or a gentle tilt of the head.

Darwin failed to find what he needed in commercially available photographs, so he commissioned one of the most innovative portraitists of his time, the Swedish émigré photographer Oscar Rejlander, to photograph himself and others performing specific expressions. Darwin was not as sensitive to the differences between voluntary gestures

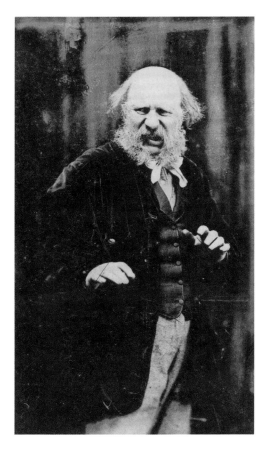

Oscar Gustaf Rejlander
Disgust, c. 1871, from Charles Darwin's
*The Expression of the Emotions in Man
and Animals* (1872)

and involuntary expressions as scholars would later be, in part because he did not fully grasp the cultural differences between forms of body language in various cultures.[2] Nevertheless, the photographs Rejlander made for Darwin would influence generations of scientists and portraitists alike.

At a time when capturing genuine expressions seemed beyond the reach of photographic technology, Rejlander managed to open new conceptual possibilities. His photographs for Darwin read like episodes from a Victorian melodrama – mini narratives in which Rejlander enacts surprise, disgust, indignation and indifference. Not only were these pictures a technical tour de force, Rejlander also managed to produce striking self-portraits capturing his personal eccentricity and charm. In *Disgust*, for example, he appears as two characters in an existential play, reacting to himself as if in a mirror (see above). In one picture his jaw opens slightly askew, his bald pate illuminated by bright light from above, a cravat looped round his neck, and the buttons of his vest straining to cover his girth. In the companion picture Rejlander appears once more, again in disgust, but this time wearing a felt hat, his velvet

artist's jacket belted at the waist, its gaping pockets seemingly full of supplies, and his eyes looking sidelong at his doppelgänger. Indeed, the regard between the two portraits reveals itself to be mutual disgust – the artist disapproving of himself in the third person, trapped in an endless feedback loop. Rejlander produced numerous self-portraits over the course of his career, and frequently posed as a model in his pictures, performing popular roles. Yet in no other photographs does one see so fully into Rejlander's life and disposition than in the 'non-portraits' he made for Darwin.

The question of expression and portraiture arises periodically in the history of photography. Pictorial photographers working at the turn of the twentieth century coined the term 'psychological portraiture' to describe photographs in which the sitter visibly displays emotion (see also p. 90). This idea resurfaced after the Second World War among a small group of portraitists and photojournalists who advocated a new kind of portraiture. Among these were the Latvian-born American photographer Philippe Halsman, and the Hungarian-American Marcel Sternberger. Sternberger was an especially vocal exponent of psychological portraiture, delivering an influential series of lectures on the subject at New York University in 1940. Although his reputation dwindled after his death and he is only now beginning to be rediscovered, during his heyday Sternberger held a client list that was the envy of his peers, producing portraits of Einstein, Franklin D. Roosevelt, H. G. Wells, Indira Gandhi and Sigmund Freud, to name just a few – his portrait of Roosevelt was the model for the American dime. The presence of Freud on Sternberger's list of 'psychological' sitters is ironic, not just because of Freud's contributions to the field of psychology, but also because Freud shared a direct lineage with Duchenne and his photographic experiments of the 1850s. Freud was a student at the Salpêtrière under the prodigious clinician Jean-Martin Charcot, who used the hospital's new Photographic Service to study patients with hysteria. Charcot, in turn, had been a student of Duchenne.

Sternberger's photograph of Frida Kahlo, taken during a joint session with Diego Rivera in 1952, illustrates his approach (see opposite). Sternberger invited sitters to freely express themselves for the camera, encouraging them

to laugh, smile and joke around. In his portrait of Kahlo, the artist looks down and away from the camera, her brow gently furrowed. It appears to show Kahlo genuinely lost in thought, her attention elsewhere. Sternberger embraced this momentary quality in his portraits, which other photographers avoided, because he believed understanding could be found in authentic unguarded moments. However, for Sternberger, 'psychological' did not just mean the sitter was caught in an act of candid expressiveness. He also devised an elaborate and carefully controlled system of chiaroscuro lighting to conjure and intensify mood.

Increasingly, contemporary photographers have investigated emotional expression as an aspect of portraiture. Yet it is not always clear what constitutes expression, nor indeed how any given expression ought to be interpreted. In the 1980s, for example, the Austrian photographer Friedl Kubelka vom Gröller produced a series of emotional grids in which a sitter was photographed while thinking about intimate experiences. In *Lisa Crncec, Age 27*, she asked an unmarried part-time bartender (the relevance of these traits is not immediately apparent) to recall her early sexual experiences, while considering her innate femininity (see p. 81). After reading the handwritten captions, viewing of the photographs operates on two levels. Since the subject is sexual, it places the viewer in the role of voyeur. At the same time, one struggles to imagine what is crossing the woman's mind from frame to frame. In most, she holds her head at an angle, but in the second frame over and third down, her head engages the camera squarely. Is this a moment of significance, or the random wobble of her head as she considers something insignificant? Is she recalling a lost love, an unsatisfying experience, confusion or a violent assault? Each is a plausible explanation, and the photographs themselves offer few clear answers.

The impulse to map emotions on the face and body results from the recognition that individuals are not defined by physical appearance alone. To dig deeper, to understand what lies beneath the skin, requires the artist to search for thought and feeling. Photography is exceptionally good at capturing the superficial topography of the bodies we inhabit, but less adept at conveying particular states of mind. For that, photographers have frequently turned to expression and body language as indicators of what lies within. Ethereal, ineffable, they are like smoke signals sent from our inner selves.

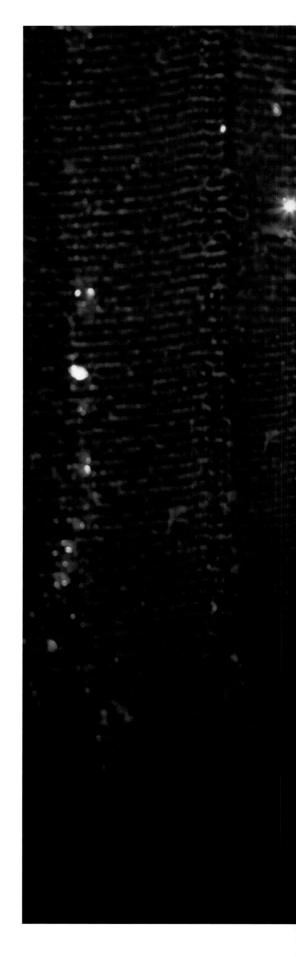

Newsha Tavakolian
Portrait of Mahsa Vahdat, 2010, from the series
'Listen', 2010–11

Iranian artist Newsha Tavakolian was born
two years after the Islamic Revolution of 1979,
which resulted in severe restrictions on women's
freedoms, expanded by regimes that followed.
Among the prohibitions was a ban on female
singers performing solo or on stage. As a result,
like all Iranians of her generation, Tavakolian
was prevented from hearing professional women
singers publicly, growing up.

In 2010, after lengthy private negotiations
with the sitters, who feared repercussions for
the project, she arranged for six professional,
or formerly professional, singers to perform for
the camera. This resulted in a video and a series
of still photographs, including this one. The video
showed the women singing in a Tehran studio;
however, in compliance with post-revolutionary
rules, Tavakolian removed the soundtrack, so

the women's voices could not be heard. In the
photographs, made during the same sessions,
each is shown with eyes closed and lips parted,
as if captured in a poignant moment from
a soulful ballad. They seem to have retreated
to an invisible inner life, beyond the reach of
political interference.

The singers were told to imagine performing
on a stage in front of a large audience, the
sparkly sequinned curtain suggesting a pre-
revolutionary television studio. As part of the
process of making the pictures, the artist
created empty CD cases; her pictures might
be thought of as album covers for recordings
yet to be made. For now they remain empty,
their voices – representative of countless other
Iranian women – heard only in pictures.

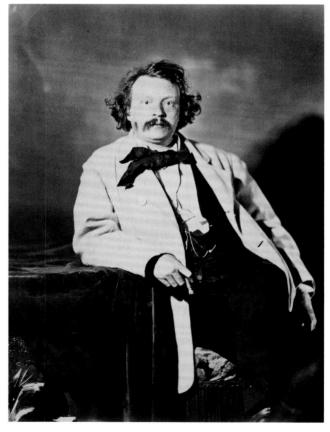

Opposite **Henry Peach Robinson**
Fear, c. 1860

Above **Adrien Constant de Rebecque**
Man in Chainmail Tunic Posing as a Dying Soldier, c. 1863

Right **Félix Nadar**
Autoportrait à la lumière électrique [Self-portrait
in electric light], c. 1860

Heinrich Kuehn
Frau Ingenieur Richter [Engineer's Richter's Wife],
c. 1913

Heinrich Kuehn's portrait of 'Engineer Richter's Wife' — her head tilted back, teeth bared, and eyes averted from the viewer — bristles with energy, while the 'V' of her neckline points to a bouquet of roses, giving the picture erotic charge. In fin-de-siècle Vienna, where this photograph was made, intellectuals sought to restore unbridled human emotion to what they saw as the staid forces of modern post-industrial culture. In this picture, Kuehn (or Kühn) shows the partner to progress — the unnamed wife of an engineer — as an irrepressible sexual being, literally married to science.

In the Vienna of Sigmund Freud, Robert Musil and Arnold Schoenberg, discontent with traditional arts organizations led to a series of secession movements, including most famously the so-called Vienna Secession led by the painter Gustav Klimt, the designer Koloman Moser, and others. A similar dynamic played out in photographic circles, with Kuehn forming a small photographers' collective called 'Das Kleeblatt', or 'The Clover Leaf', with partners Hans Watzek and Hugo Henneberg.

Kuehn was an advocate of Pictorial photography — an international movement that sought to demonstrate photography's artistic potential by making pictures resembling prints, drawings, and even paintings. The reddish-orange tint of this photograph was made by mixing pigments into a handmade photosensitive gum solution, which was then brushed on paper and developed with water. By manipulating the fragile emulsion during development, Kuehn was able to intensify elements of the picture while erasing sections such as the background completely.

Josef Breitenbach
Jeune fille en Deuil [Young Girl in Mourning]
(Actress Edith Schultze-Westrum), 1932

Winifred Casson
Accident, 1935

F. Holland Day

The Seven Words, 1898

Working from his home in Dedham, Massachusetts, F. Holland Day produced some 250 'sacred pictures' of scenes from the life of Christ, in which he frequently posed himself as Jesus. He made the extraordinary self-portrait sequence shown here just prior to a detailed re-enactment of the Passion, in which he submitted to a mock execution staged by neighbours whom he enlisted to portray Roman soldiers. To prepare, Day fasted, grew his beard long, and imported authentic wood and cloth from Syria. The resulting images show Day, as Christ, in the throes of agony yet suffused with inner peace, in accordance with the New Testament account. The central photograph, slightly elevated in relation to the others, shows him casting his eyes to heaven and exclaiming, 'my God, my God, why hast thou forsaken me?' before succumbing in the final three frames.

This rare example, for the time, of a photographic story told in sequence recalls the proto-cinematic motion-study experiments of Eadweard Muybridge and Thomas Eakins at the University of Pennsylvania in the mid-1880s. Eakins had painted his own version of the Crucifixion in 1880, using a student suspended from a cross as a model. However, Day's carefully orchestrated photographs also parallel developments in dramatic theatre. As co-owner of the publishers Copeland and Day, he was among the first to distribute Oscar Wilde's plays in America, and was aware of evolving ideas about dramatic representation. The nascent movement that would become Method Acting, in which a performer attempts to put themselves in the mind of a character in order to portray them more convincingly, would soon coalesce in the teachings of Russian theatre director Konstantin Stanislavski.

Daniela Rossell
Untitled, 2001, from the series 'Ricas y Famosas'
[Rich and Famous], 1994–2002

Alec Soth
Mary, Milwaukee, WI, 2014

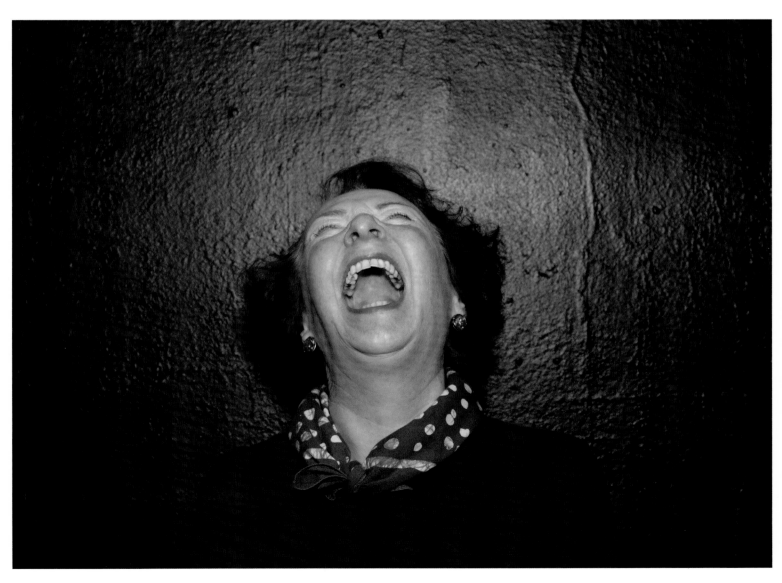

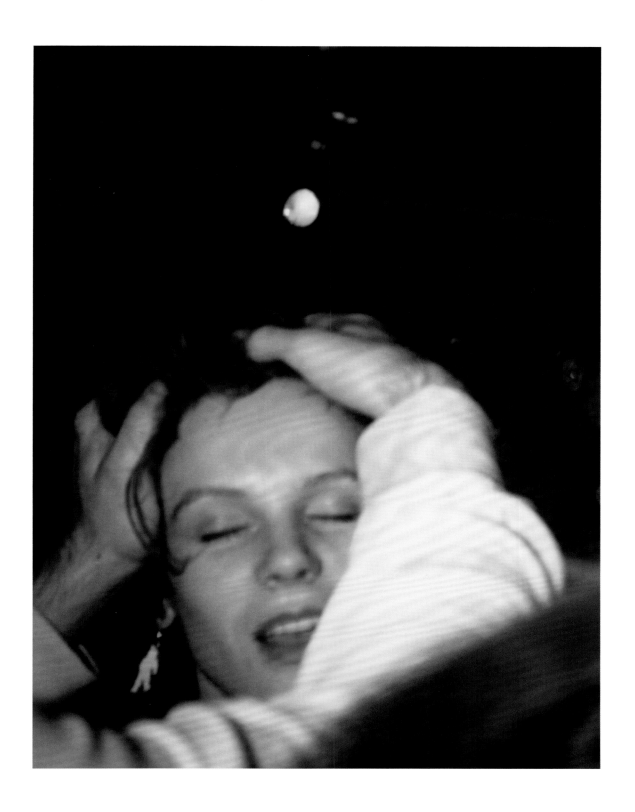

Wolfgang Tillmans
Love (hands in hair), 1989

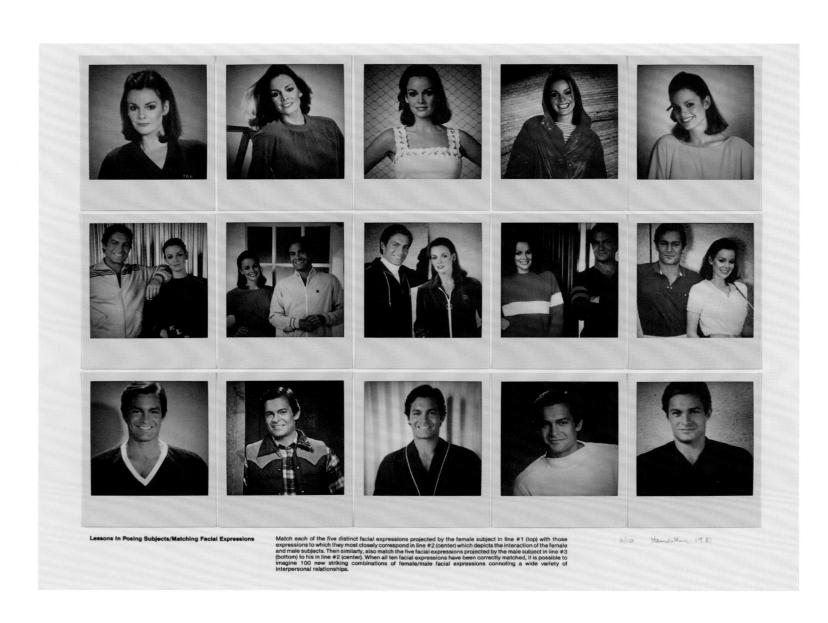

Lessons In Posing Subjects/Matching Facial Expressions

Match each of the five distinct facial expressions projected by the female subject in line #1 (top) with those expressions to which they most closely correspond in line #2 (center) which depicts the interaction of the female and male subjects. Then similarly, also match the five facial expressions projected by the male subject in line #3 (bottom) to his in line #2 (center). When all ten facial expressions have been correctly matched, it is possible to imagine 100 new striking combinations of female/male facial expressions connoting a wide variety of interpersonal relationships.

6/10 Heinecken 1981

Robert Heinecken

Matching Facial Expressions, 1981, from the
series 'Lessons in Posing Subjects', 1981–82

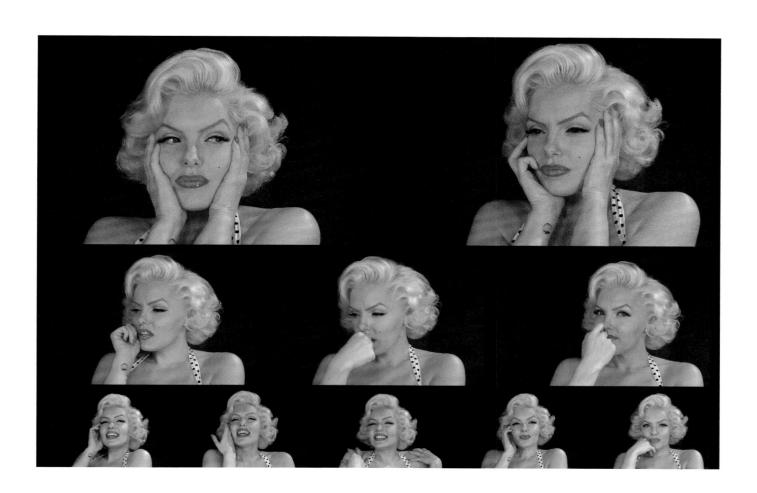

Mary McCartney
Marilyn Saved My Life, London, 2012

4 The Studio

Formal Portraiture from the 19th Century to the Present

In 1891, the pioneering English photographer Henry Peach Robinson published a manual, *The Studio, and What to Do in It*. The title was not just facetious; many photographers at the time lacked a basic understanding of studio design and practice. While painters' portrait studios had existed for centuries, photographic studios were still a new phenomenon, and opinions differed on how they might best be built and used. A veteran of the wet-plate collodion era, Robinson had been forced to give up his London studio in 1864, due to the damaging effects of photographic chemicals on his health. Four years later he had recovered sufficiently to open a new one, this time with business partner Nelson King Cherrill, in affluent Tunbridge Wells.[1] The second studio prospered, but the experience of opening two studios in succession stayed with him. As Robinson explained in the book:

> For in-door work a studio is essential. There have been so many different forms of studios invented, designed, or modified from others, that when a photographer wishes to build a studio, and turns to the authorities for information and guidance, he finds something very like chaos, for in the multitude of councillors there is—confusion.[2]

A seemingly endless variety of designs was tried and tested, several of which Robinson described in his book: the 'lean-to', the 'ridge roof', and the 'tunnel', all with different dimensions, roof angles, baffles, blinds, reflectors, screens and backdrops, and each meant to accommodate specific cameras and obtain particular visual effects. With so many different approaches available and no single path to success, the potential for failure was omnipresent. Yet legions of photographers built studios anyway, because the studio offered a prize that no other working method could – control.

Studios enable photographers to set the circumstances of their photographs in advance. The position of the sitter, as well as the manner of dress, makeup, props and background, can be precisely arranged; in addition, the number, intensity and angle of lights and reflectors can be carefully thought through. In the Victorian era, studios were provisioned with essential facilities, such as darkrooms

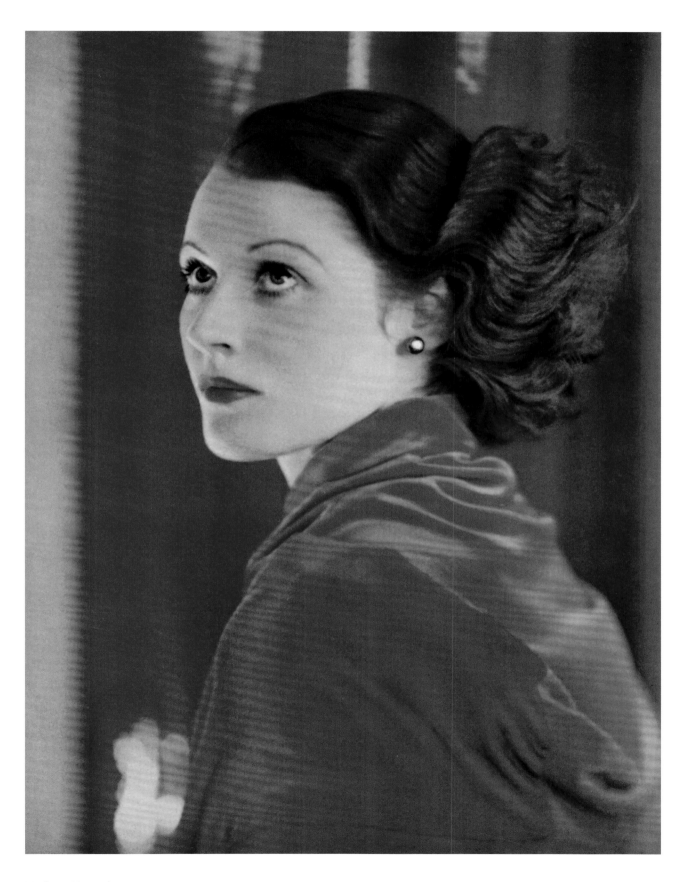

Madame Yevonde
Joan Maude, 1932

for coating wet-plate negatives and printing, as well as retouching and hand-colouring equipment. As technology improved in the twentieth century, and particularly with the advent of colour photography, the studio also allowed photographers to control colour temperature and balance. Recently, power film winders, flash and strobe lights have given way to high-definition video capture and high-lux LED lamps, but the goal since Robinson's day remains essentially unchanged. The studio is a place where the photographer can shape the way portraits look.

If the portrait studio is a stage, then poses are performances. The studio is a transactional space, where photographer and sitter may collaborate, compete and challenge each other. Like the director of a play, the photographer arranges the sitter before the camera, sets the mood, and determines the arrangement of lighting, set and costume. She or he may try to coax certain responses out of the sitter, but the sitter – as actor – is the one who must ultimately face the audience. The tone of a sitting may be formal or relaxed, but only in the studio does the photographer have such a conscious ability to shape the appearance of the picture to interpret the subject. Conversely, it is only in the studio that the sitter is so cognizant of being observed, of every pore of appearance being explored and inspected. In such a heightened environment, subtle nuances of gesture and expression may acquire unexpected significance.

In Madame Yevonde's portrait of Joan Maude, for example, the ambiguity of the sitter's expression adds to its psychological impact (see p. 101). With Maude's shoulders facing away from the viewer, head turned back and eyes directed upwards, Yevonde gives the picture a feeling of spontaneity – of time arrested. Swept backwards, Maude's ginger hair seems to levitate off the back of her head, while a single button earring all but glows on her earlobe. Clad in red and set against a vibrant red backdrop, she sports glossy lipstick, eyeliner, mascara and pencilled eyebrows that accentuate the illusory quality of the scene. In Yevonde's hands, Maude is at once eminently real and larger than life – part human, part goddess.

Some photographers draw up elaborate plans in advance of a studio setting, mapping out the elements of a picture in extraordinary detail. Many also keep detailed journals in which they record angles, heights and distances of sitter, cameras, lights and reflectors, as well as colour temperatures, scrim and paint colours, lens selection, aperture and exposure time. Having a plan is essential when working with clients whose time is always precious and frequently expensive. Moreover, precise records enable the photographer to repeat or extend a session on another day without guesswork, and provide priceless information for arranging similar sittings with other subjects. Photographers may also record personal details in their journals, such as sitters' likes and dislikes, useful topics of conversation, and matters best avoided.

To a layperson, it can be surprising to see how meticulously engineered many studio portraits are. However, being in control does not mean eliminating the element of chance entirely. Julia Margaret Cameron, for example, embraced the unplanned effects she obtained in her 'glass house', the studio she made from a glazed chicken house at her home on the Isle of Wight sometime between 1864 and 1866. 'I longed to arrest all beauty that came before me', she wrote; for her, this meant allowing the qualities of the subject to express themselves.[3] In *The Mountain Nymph, Sweet Liberty* (see opposite), Cameron orchestrated the 'Rembrandt style' lighting grazing the sitter's left side, as well as the deep chiaroscuro surrounding the figure. The depth of focus would have been largely visible to her on the ground glass. However, when she inserted the plate holder and uncapped the lens to make the exposure, she could not see exactly where the riotous curls of out-of-focus hair cascading from the top of the figure's head and down her neck would fall, nor could she see the intensity of her probing stare. It is the combination of these elements, anticipated and accidental, that makes the portrait so compelling. Cameron created the circumstances within which her portraits could come alive, without attempting to control every aspect of their production.

From their earliest days, photography studios have been expensive to build and operate. In the nineteenth century, as Robinson pointed out in *The Studio*, in addition to the studio room itself, the photographer had to provide changing rooms and waiting areas, sets and props, and a darkroom for processing

Julia Margaret Cameron
The Mountain Nymph, Sweet Liberty, 1866

the results. The real estate required was costly, particularly in the fashionable addresses where the most popular studios were found. And since early studios also required reliable sunlight to expose their pictures, most needed substantial architectural adaptations, building roofs and walls out of glass. Urban studios frequently had to be positioned on the tops of multi-storey buildings, where they would receive as much sunlight as possible, but this meant that supplies, equipment, and sometimes even water had to be carried by hand up flights of stairs. Ventilation of chemicals was vital if often neglected, as Robinson learned to his cost. In short, running a studio was a logistical and economic nightmare.

In spite of all this, photographic studios flourished for most of the nineteenth century – just as they continue to be an important form of portrait practice in the digital age. In London, for example, a dramatic rise in the number of studios occurred shortly after the expiration of the patents for William Henry Fox Talbot's calotype process (1851) and Louis Daguerre's daguerreotype (1853), enabling photographers to practise without paying a licence fee to the inventors. What had been fewer than a dozen professional studios in 1850 increased by roughly 1500% to nearly 175 by 1860; in 1870, the ranks had swelled another 57% to approximately 275.[4] These numbers were to stay more or less constant until the turn of the century, and would continue to rise again until the outbreak of the First World War.

Early photographers faced two fundamental problems that rendered studio photography especially difficult. The first was available light. Although systems of artificial lighting did exist, these generally involved the use of highly combustible chemicals and gases. The 'limelight' used by theatres and dance halls, for example, required blowing an oxyhydrogen flame (an early form of welding torch) over quicklime; this was superseded later in the century by electric arc lamps, which created light by sending a charge of direct current between two electrodes in a sealed gas tube (modern fluorescent lights are a kind of arc light). Although these technologies were used in other contexts – most notably in the projection of magic lantern slides – they were dangerous, expensive, and hard to manage in the studio. It was not until the commercialization of incandescent lights at the turn of the century that photographers were able to use artificial lighting consistently. Before then, most studio photographs were made with sunlight.

The second challenge faced by early studio photographers was the nature of photographic materials themselves. Chemistry and optics were so slow that photographs frequently had to be taken outdoors where light was full and bright. Many photographers resorted to creating makeshift *plein air* studios, particularly when working far from home. Stories abound of improvised 'studio' settings in patios and courtyards, where cloth screens, carpets and furniture were arranged outdoors to provide the illusion of an indoor setting. To negate the angular shadows that unfiltered sunlight can create, photographers improvised from available materials. The French photographer and sea captain Paul Miot, for example, photographed Tahitian natives on the deck of his ship, where he could use the sail as a solar reflector (see p. 144).

Victorian photographers viewed portraiture as an 'instantaneous' subject, meaning one in which the sitter might move during exposure, causing indistinctness and blur. Everyday things such as a crashing wave at the beach, a horse-drawn carriage in motion, or the leaves of a tree moving in the wind proved elusive to early photographers, since they occurred too quickly to be captured by slow emulsions. Portraits were a special case, since individuals could be asked to hold a pose long enough to register clearly in a photograph; for those who could not, a variety of rests and clamps could be positioned out of camera view to add extra stability. Nevertheless, fidgeting, shifting weight and repositioning of the hands were common, and may occasionally be glimpsed in early studio portraits. Long exposures also made smiles and other lively expressions hard to capture. For this reason, the faces in many nineteenth-century studio portraits look blank. This artificial deadening of expression can be a barrier to appreciating early studio portraits, even though the sitters were obviously every bit as vital and alive as people are today.

Some of the most transporting portraits of the 1850s are stereo daguerreotypes – a process that enjoyed a vogue in English studio photography after the patent on the process expired (see also p. 107). The daguerreotype was sharper and in most cases faster than the

Thomas Richard Williams
Princess Victoria, 21 November 1856

To render age less garrulous; make beauty more lovely; to impart an expression of intelligence where nature has not been over bountiful; to light up the intellect, and to impart the quality of power in those heads on which she has lavished her most precious gifts; in short, to present human nature in its best form, by aid of a camera and a properly-lighted room.[5]

In the case of celebrities, the stakes could hardly be higher. The studio is a place where image is distilled and persona refined. Yet the principles are the same regardless of who is being photographed. Whether it is a businessperson posing for the company newsletter or a family sitting for a dime-store portrait, the subjects always want to look their best.

The artful manipulation this sometimes entails makes the studio one of the most challenging and rewarding places to make a picture. Since so much of studio practice is planned, if a sitter is unhappy with their portrait then the photographer is taken to task: unfairly, perhaps, the onus is on the photographer, rather than the sitter, to achieve good results. Alterations and effects can be made digitally in post-production. Still, the studio provides creative opportunities that would be hard to obtain in any other way. As artificial as such arrangements can be, a successful studio session is an eddy in the current of daily life, where the visual noise of the outside world can be excluded and social expectations reset.

alternatives, enabling portraitists to make pictures with remarkable precision and warmth. Using good lenses, a professional daguerreotypist could obtain photographs that, if not truly instantaneous, provided the illusion of scenes from real life. T. R. Williams's portrait of Queen Victoria's eldest daughter Victoria at age sixteen, for example, captures the young Princess Royal in gentle contrapposto, leaning back and turning her head away and out of the frame (see above and left). The picture combines stately authority with youthful uncertainty, as the princess's eyes gaze wistfully into the distance. The restrained subtlety of her expression is framed by the extraordinary complexity of her jewelry and dress, as well as the intricate screen and curtain behind her. The masterful application of hand colouring, particularly on the figure's head and neckline, further brings the subject to life.

Hand colouring may seem contrived to contemporary viewers, but studio portraits are by nature artificial. The ubiquitous eye of the camera, the glare of lights and reflectors, the unfamiliar clothing and furnishings are usually remote from daily experience and often uncomfortable, as is the relentless attention of the photographer. To extract something genuine from such a situation is an extraordinary feat, particularly as the sitter wants to be cast in the most flattering light possible. As the Philadelphia- and London-based photographer John Jabez Edwin Mayall (see p. 106) put it, the real purpose of a studio photograph is:

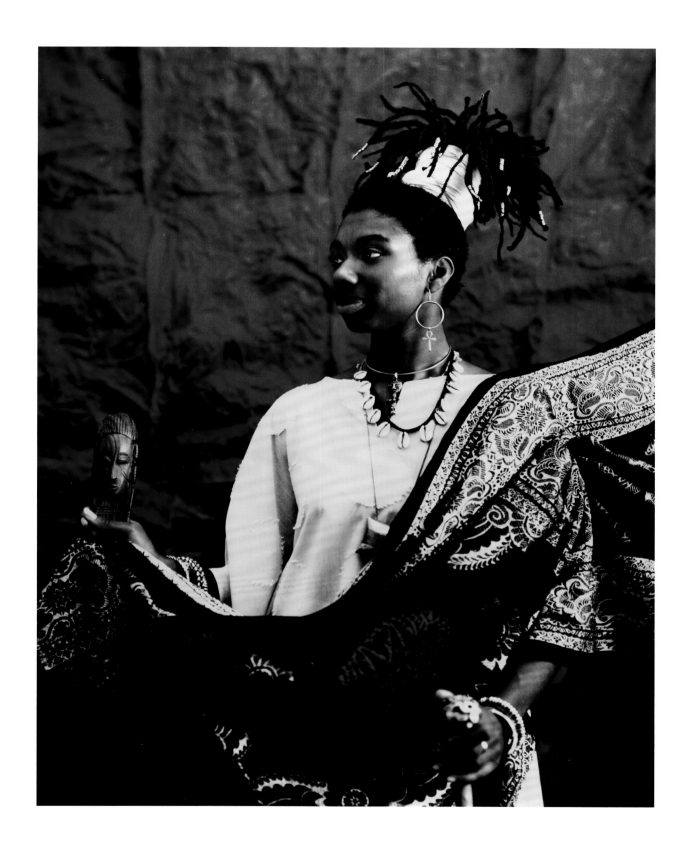

Maud Sulter
Clio (Portrait of Dorothea Smartt), 1989

Below **John Jabez Edwin Mayall**
Portrait of Three Girls, 1850s

Opposite below **Warren T. Thompson**
Portrait of a Girl, 1853–59

Left William Edward Kilburn
Portrait of Two Women, 1850s

From his premises on fashionable Regent Street in London, William Edward Kilburn became known for exquisite hand-coloured daguerreotypes like this one. He was particularly noted for the skies he added to his portraits, rendered in azure and purple, and filled with puffy clouds. The two women in this portrait seem to be perched on a mountaintop or hovering in space – angelic figures transcending the daily reality of city life. In fact, the clouds were an act of pure invention. Not only do Kilburn clouds vary from portrait to portrait, but in stereo portraits like this one, they do not quite match left to right. It is not clear why Kilburn and his colourists chose the particular cloud patterns they used, but they may have been designed in part to reflect the personalities of the sitters.

Stereoscopy was a 3D technology that pre-dated the invention of photography. Stereo portraits like this one were made using a special twin-lens camera that replicated the inter-ocular distance of human eyes; when seen through a stereo viewer this produces the illusion of three dimensions. The English scientist Charles Wheatstone devised the stereoscope in 1832, using prisms, mirrors and drawn pictures, but it was the Scottish inventor David Brewster who adapted the idea to photography in 1849. Stereo photographs could be made using nearly any photographic process, including, as in this case, daguerreotypes. In the early to mid-1850s, when this portrait was probably made, daguerreotypes were prized for their sharpness and comparatively short exposure times, making them capable of producing images of remarkable human presence.

Michel Kameni
Untitled (Bride), 1970

Oscar Gustaf Rejlander
Unknown Young Woman, 1863–66

In 1857, Oscar Rejlander debuted his ambitious composite print, *The Two Ways of Life*, at the Manchester Art Treasures Exhibition. Composed of some thirty-two separate negatives (depending on the version), the picture drew widespread criticism for its extreme artificiality, building an imagined scene from assembled photographic parts. Even though Queen Victoria bought three copies of the print – one a gift for Albert, the Prince Consort – critics seized on the use of nudes as indecent, and accused Rejlander of hiring prostitutes to make the picture. Much of this, in retrospect, was a smokescreen. At a

time when the meaning of photographic reality was still in flux, his real transgression was the appropriation of photographic imagery to create a new, synthetic composition drawn from his imagination.

The backlash from *Two Ways* was so severe that Rejlander swore he would never make another composite picture. Although he broke that promise on numerous occasions, in the 1860s he focused on unmanipulated, naturalistic portraiture like this, becoming one of the most accomplished portraitists of his age. Using specially designed 'tunnel studios' made of glass

and capable of intensifying natural light, he made images that seemed to freeze the sitter in time. Spontaneous, ephemeral and genuine, pictures like this led Julia Margaret Cameron and Lewis Carroll to seek his counsel, and caused Charles Darwin to commission him to produce pictures of emotional expressions for his research.

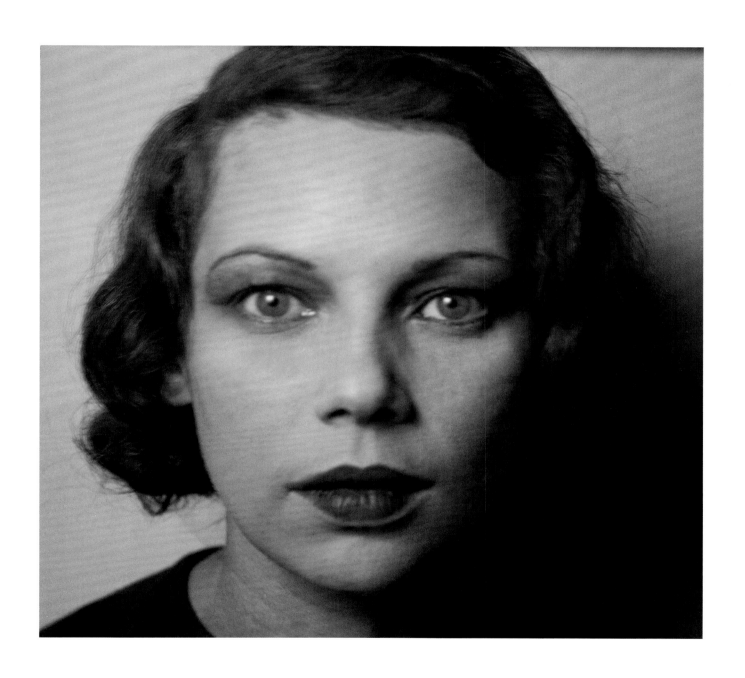

E. O. Hoppé
Tilly Losch, 1928

Lee Miller
Self Portrait, 1932

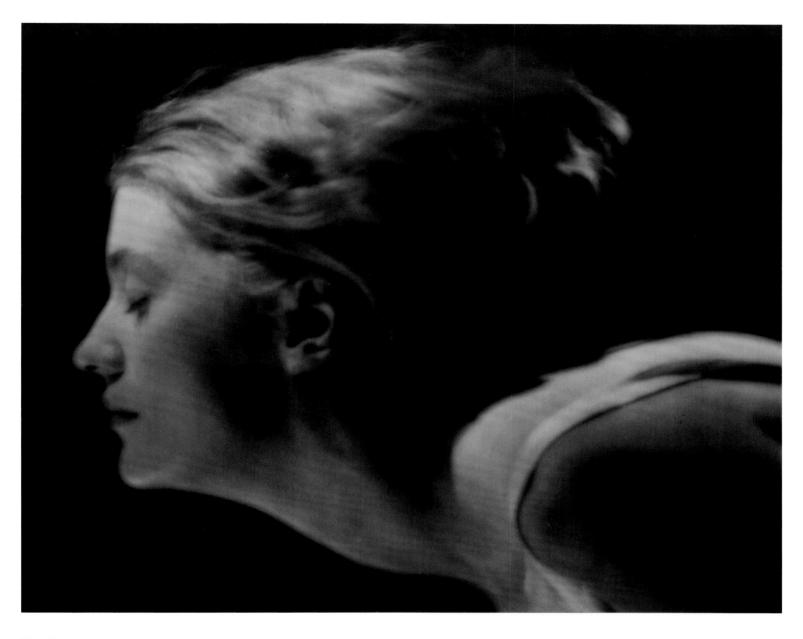

Man Ray
Lee Miller, 1929

Man Ray fell deeply in love with his student, model, assistant and collaborator Lee Miller, who came to Paris seeking his tutelage in 1929. In this portrait taken early in their time together, Man Ray presents her as a mercurial, mysterious figure hurtling headlong into an unseen future. Eyes closed, neck extended forward, and hair seemingly lifting in the breeze, she appears to be flying – an angel, perhaps, or a ship's figurehead. In fact, the picture is a characteristic example of surrealist sleight of hand. Photographed on level ground, it actually shows Miller standing with her neck craned backwards. To achieve the effect in this picture, Man Ray simply turned the image on its side.

Miller and Man Ray became lovers, but their romance did not last. Surrealist men preached free and open sexual relationships, but backtracked when women exercised the same liberties they claimed for themselves. Man Ray became jealous of the time Miller spent with others, no matter how innocent. Although they would eventually become lifelong friends, in 1932 Miller, feeling smothered, severed ties, leaving Paris for New York to open her own studio. Man Ray never got over her. His revision of an earlier piece, *Object of Destruction*, a metronome ticking back and forth with Miller's eye attached, was one of many despondent works he made in the wake of her departure. In spite of this, the extraordinary creative energy of their time together would prove formative to them both. Like Man Ray's portrait, it was elusive, transient and intense.

André Hachette
Sarah Liévine, c. 1907–45

Opposite **Paul Burty Haviland**
Florence Peterson, c. 1910

Below **Simon Frederick**
Naomi Campbell, 2016

Opposite **Philippe Halsman**
Märta Torén, 1949

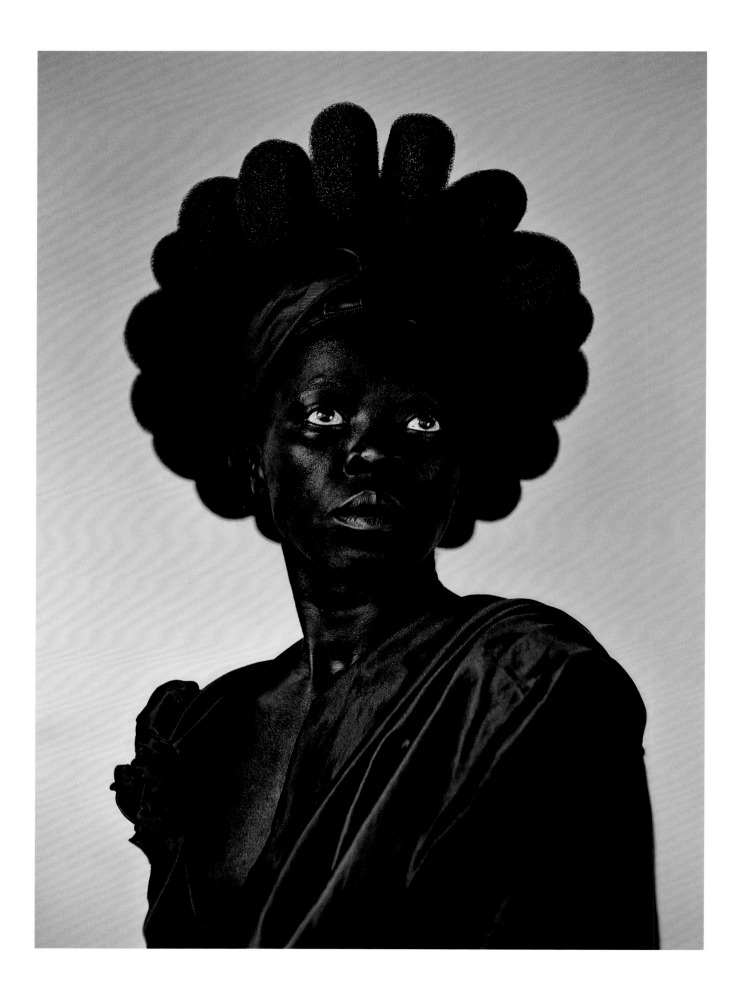

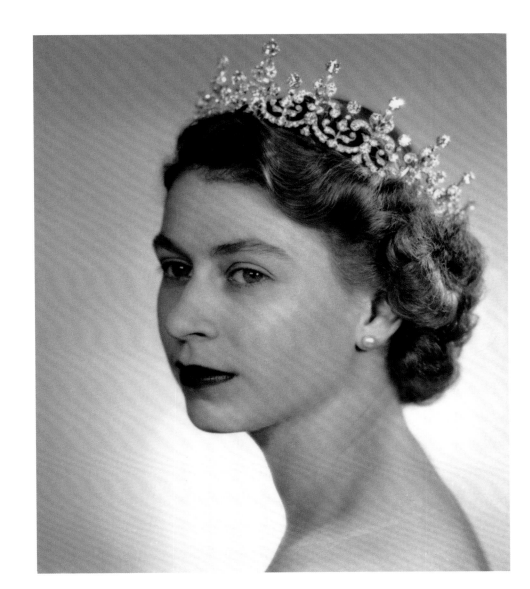

Opposite **Zanele Muholi**
Ntozakhe II, Parktown, 2016, from the series
'Somnyama Ngonyama' [Hail the Dark Lioness],
2015–16

A ring of scouring pads crowning the artist's
head to resemble the Statue of Liberty or some
lost Greek god, Zanele Muholi's self-portrait is
layered with meaning, reflecting the artist's own
resolute self-determination and the desire to
create dignity and safe community for lesbians
and gender-expansive individuals in South Africa
and beyond. It is also a picture about labour,
oppression and black African identity; about
family and self, pride and beauty. The artist's
eyes glow against resplendent black skin and are
raised to the heavens, looking self-confidently
out and beyond the frame. By heightening
contrast in post-production, the skin and clothes
have been intensified, darkened; the shimmering,
silky lustre of their blackness contributing to
the portrait's noble, determined air.

Ntozakhe II, Parktown, 2016 is arguably
the most famous of a series of defiant
self-portraits Muholi began in 2012, called
'Somnyama Ngonyama' in isiZulu, or 'Hail the
Dark Lioness'. At once playful and searingly
critical, these pictures evoke and question
colonial-era ethnographic portraiture, fashion
imagery, and even classical painting. Many
are dedicated to the artist's mother, Bester,
who spent forty years as a domestic worker.
The props used to construct these portraits
are a mix of found objects, machine parts and
household implements, including latex gloves,
vacuum hoses, clothes pegs and, in this case,
scouring pads. Transformed to make portraits
of regal presence, these humble objects become
symbols of lives spent in the service of others –
and transcendence.

Dorothy Wilding
Queen Elizabeth II, 1952

Nadav Kander

Barack Obama III, Washington DC, USA, 2012

In 2009, Israeli-born photographer Nadav Kander was commissioned by the *New York Times* to produce a series of fifty-three portraits of key figures in the Obama administration, from then-Vice President Joe Biden and Secretary of State Hillary Clinton to President Obama himself. Loosely based on Richard Avedon's 1976 project for *Rolling Stone*, 'The Family', in which Avedon produced sixty-nine photographs of members of the American political and corporate elite in his trademark minimalist style, Kander positioned his subjects against a neutral background in the manner of a typological survey, three-quarters-length. The success of that project led rival magazine *Time* to invite Kander to photograph Obama again three years later, this time for the cover of their 2012 'Person of the Year' issue. Here, Kander's portrait of the American president, fresh from re-election, is intimate, yet statesmanlike.

In the 2012 portrait, the president is shown in profile, head lowered, in a pose that calls to mind the formality of numismatic portraits and postage stamps. Nevertheless, the viewer feels Obama's unmistakable presence. His eyes seemingly lost in thought, his expression neutral but determined, and his head slightly tilted, he seems to have been caught at a genuine moment of introspection. Light shines brightly on the president's forehead, symbolically highlighting his intellect; his ear, prominent, listening. Far from celebratory, the sombre tone of the portrait shows a president facing grave and uncertain challenges. A reverse halo surrounds his head and torso. Set against a neutral, dark background, the halo gives the portrait energy and depth, while also lending the president an otherworldly quality.

Joseph Albert
Fairy tale ball participants from the Künstlergesellschaft
Jung-München artists association, unidentified member
and sculptor Hermann Oehlmann, portraying the race
between the hare and the hedgehog, Munich, 1862

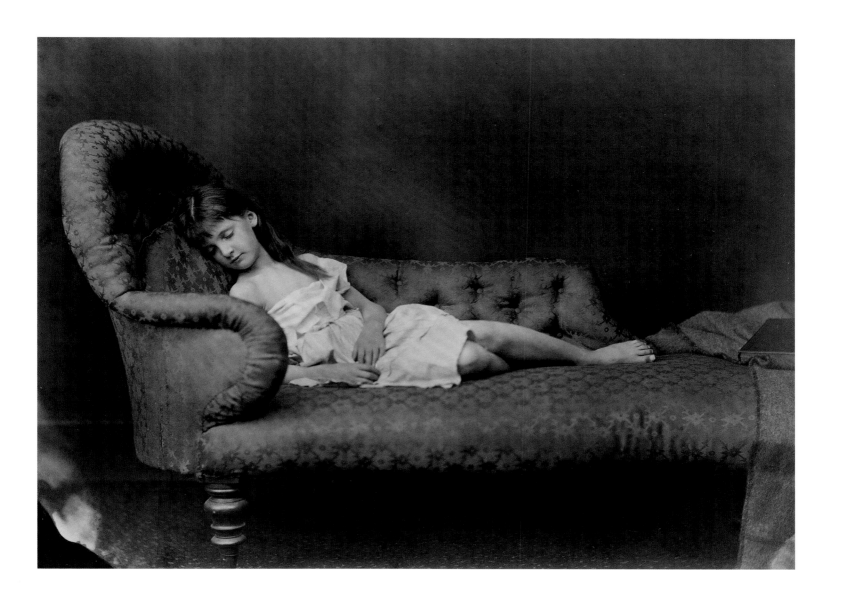

Lewis Carroll
Xie Kitchin, 1873

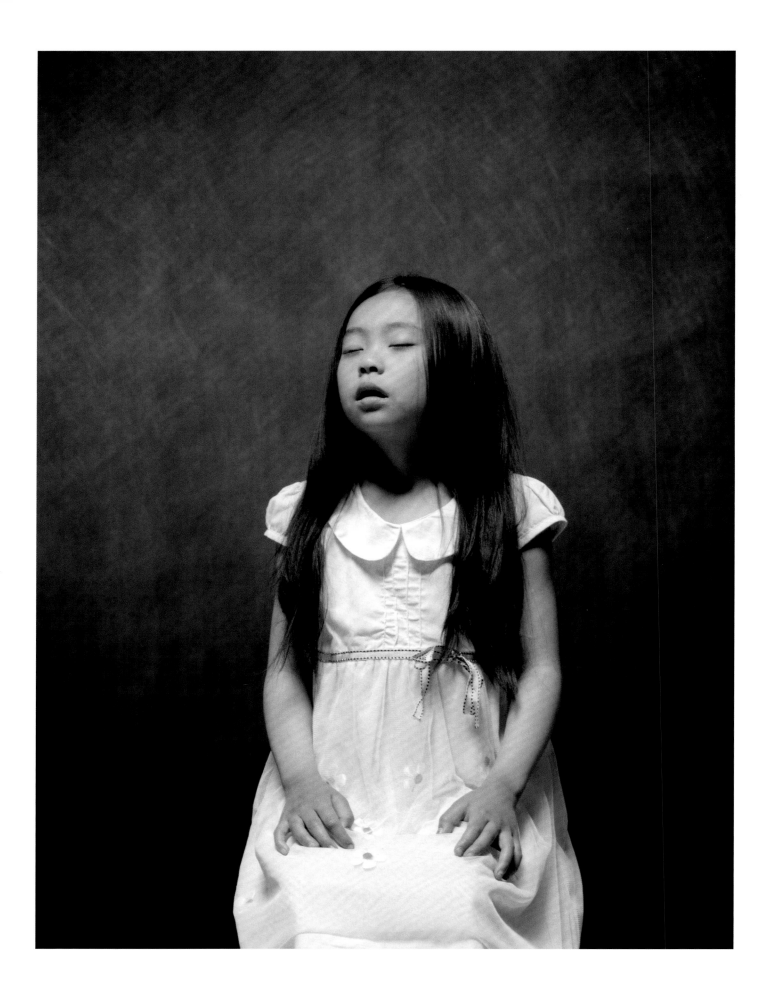

Opposite **Wang Ningde**
No. 58, 2009, from the series 'Some Days',
1999–2009

Below **Paul Outerbridge**
Melba, Nyack, New York, c. 1936

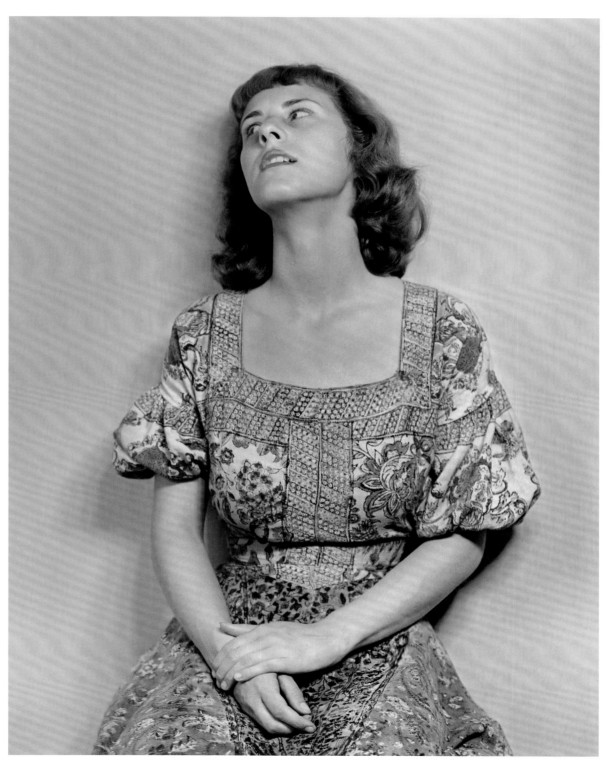

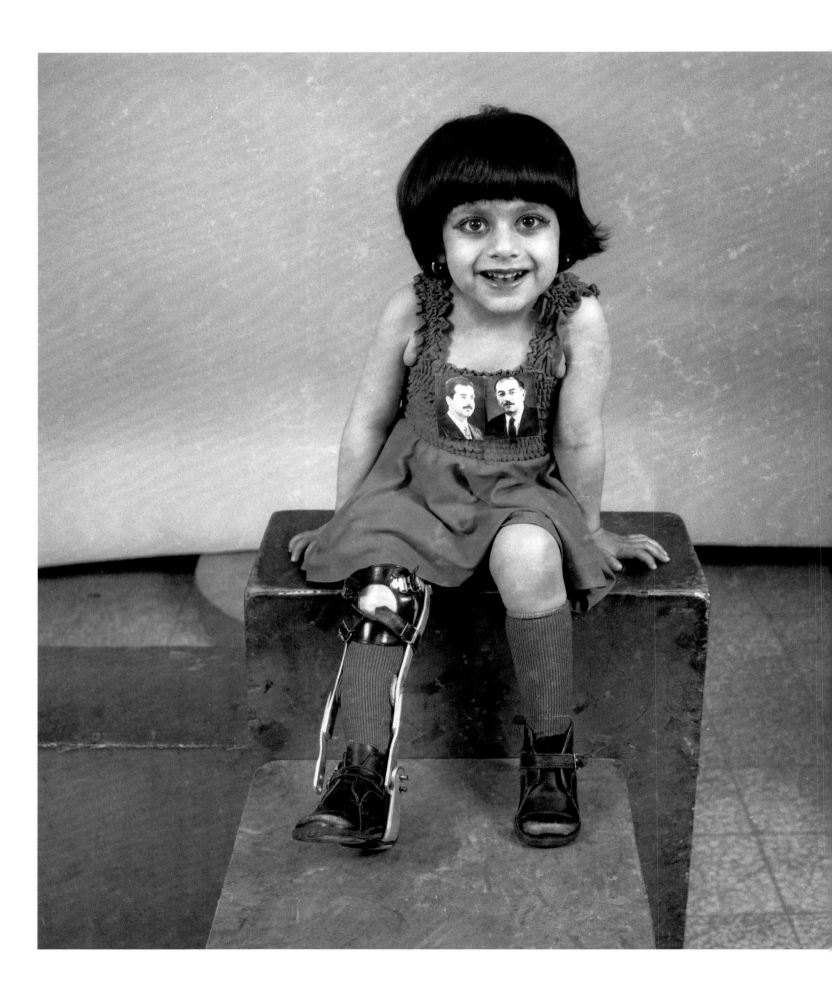

Akram Zaatari

Excerpt from 'Hashem el-Madani: Studio Practices', 2006

Lebanese artist Akram Zaatari is a co-founder of the Arab Image Foundation (AIF), an artist-run organization dedicated to collecting, exhibiting and researching photography of North Africa and the Middle East. However, the foundation does not operate merely as a library of specific images, the way a traditional photographic archive would. The AIF began as a research institute where individuals deposited carefully chosen photographic collections. Given the complexity of this material and the questions it raised, Zaatari's interests evolved from individual pictures and their stories to larger questions of how studios operate over time, and how commercial portraitists interact with the communities in which they operate. For this reason, after years of studying family albums, Zaatari decided to focus on the archive of self-taught photographer Hashem el-Madani and his Studio Shehrazade, which allowed him to explore studio methods and practices, in addition to their social context, including the ways in which clients were welcomed to the studio, stylistic approaches employed by the photographer, and even the nature of economic transactions conducted there. Founded in a living room in Saida, Lebanon, in 1948, Studio Shehrazade had grown to become the city's pre-eminent portrait studio.

Recently, Zaatari's work on the nature of photographic archives has intensified. In 2019, he left the AIF to focus on his own personal archive. The project to which this image belongs (photographed 1980–82) was initially produced under licence, with Zaatari acting as artist using and studying materials produced by the photographer Madani; however, in 2016 Zaatari took full ownership of Madani's copyrights and integrated what was left of this historical archive into his own.

Because social conditions and photographic practice are continuously changing, Zaatari is able to explore how personal narratives meet historical moments. And since the region has often been at war, evidence of conflict recurs in photographic collections. This picture of a girl with a prosthetic leg belongs to a series Zaatari has titled 'Studio Practices'. Two pro-Iraqi propaganda portraits are pinned to the girl's dress – former President Saddam Hussein, and his predecessor, Ba'athist leader Ahmed Hassan al-Bakr. It is unclear whether the girl is Iraqi, Lebanese, or another nationality. The Iraqi Ba'ath party was active in Lebanon from the early 1970s until 1982; its following, some of whom were armed, included Lebanese citizens.

Irving Penn
Truman Capote, New York, 1948, from the series
'Corner Portraits', 1947–48

Hands stuffed in his oversized herringbone jacket with upturned collar, kneeling sideways on a worn wooden chair, and with his hair neatly pomaded and head tilted downwards, American author Truman Capote found comfort in the awkwardness of Irving Penn's unusual set. Capote was well-known for his high-pitched voice and offbeat mannerisms, echoed in this eccentric pose. Best-known at the time as a prolific short story writer, in 1948 Capote published his first novel, *Other Voices, Other Rooms*, a semi-autobiographical story of a boy's horrific journey to accepting his homosexuality in the American south. Frank in his own sexuality, he encouraged others to be open about theirs.

This photograph is from a series of 'Corner Portraits' Penn began in 1947 for *Vogue* magazine. The idea was to show the thriving cultural community in New York, enriched after the Second World War by émigrés from Europe and around the world. Before the war, Penn had worked as art director for Saks Fifth Avenue; here, he adapted the diorama-like artificial space of a department store window display for studio portraiture. The pared-down set, a marked break from the stylized portraiture of the interwar period, is comprised of a single V-flat (a portable folding scrim used in studio photography) placed at an acute angle, with minimal furniture and directed light, mimicking sunlight. This intense, claustrophobic and unforgiving environment was at once an existential space seemingly lifted from a Brecht play; at the same time it was a pure, uncluttered, and even welcoming platform for sitters to express their true character.

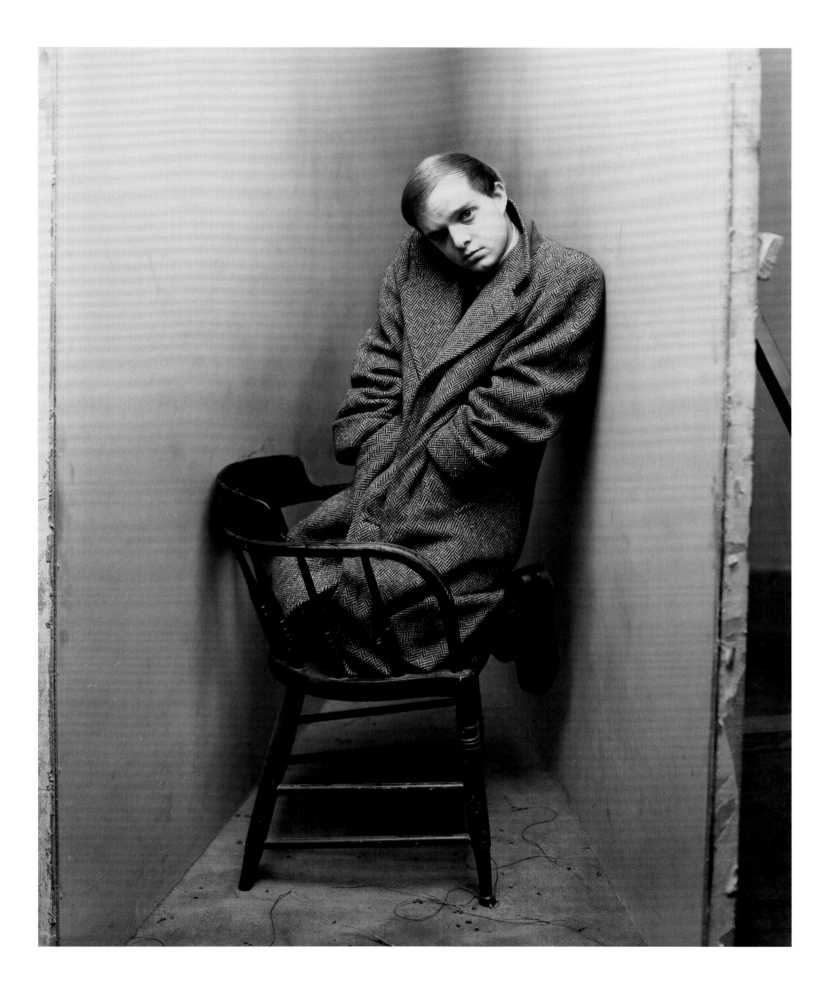

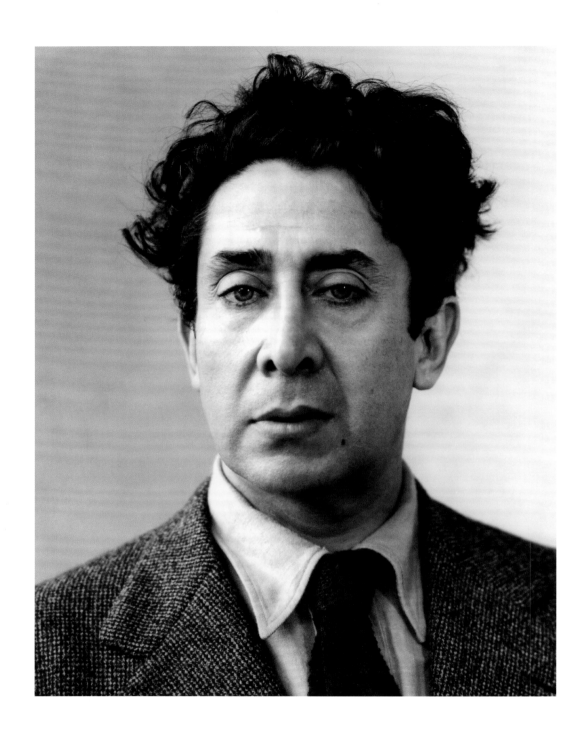

Above **Guillermo Zamora**
David Alfaro Siqueiros, 1946

Opposite **Rashid Johnson**
*The New Negro Escapist Social and Athletic
Club (Dr. Minton)*, 2010

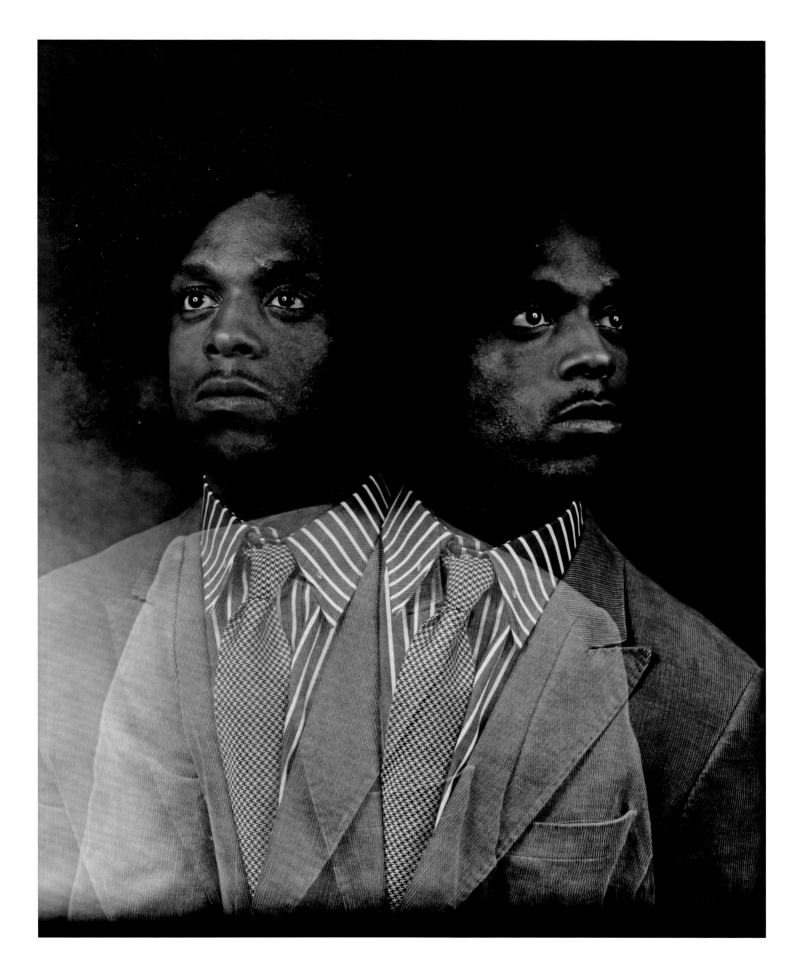

Lai Fong
A Chinese Merchant in Full Dress, c. 1870

Opposite **Martin Parr**
To Sang Fotostudio, Amsterdam, Holland, 2000,
from the series 'Autoportraits'

Martin Parr's long-standing interest in popular
photographic practice propels his ongoing series
of 'Autoportraits', performative pictures in
which he poses in other photographers' studios.
The artist is particularly attracted to studios
catering to distinctive regional tastes or the
tourist trade, since the props and backdrops
they use may be highly stylized, or digitally
altered to reflect local preferences. A celebrity
of his own creation, over time Parr has appeared
practising karate with Vladimir Putin and on
the football pitch with Lionel Messi; he has
banged a drum at a luau, stood under the flight
path of a superjumbo jet, shown off his impressive
muscles as a bodybuilder, and emerged from
the mouth of a shark.

Through it all, Parr has maintained the
same neutral, disaffected expression, as though
swept unwittingly from one extraordinary event
to another, despite the supposed excitement
of the situations in which he has found himself.
In this picture, he appears in Hawaiian shirt
and khakis between a colonnaded fern and an
elaborate flower arrangement, framed by a
festooned orange curtain – the national colour
of Holland. Pictures such as this celebrate
the creativity of the journeymen and women
portraitists responsible for huge volumes of
photographs, bought and cherished by their
owners, yet largely ignored by critics. At the
same time, they raise deeper questions about
identity and self. By tirelessly shoehorning
himself into an endless string of unlikely
scenarios, the artist's personality gradually
erodes, becoming subordinate to the uniquely
photographic worlds he enters.

Right **Thomas Child**
Bride and Bridegroom, 1870s

Below **Malick Sidibé**
Un jeune gentleman [A young gentleman], 1978

Camille Silvy

James Pinson Labulo Davies and Sarah Forbes Bonetta (Sarah Davies), 15 September 1862

Posing in the artist Camille Silvy's fashionable studios in Bayswater, London, Sarah Forbes Bonetta, born Omoba Aina, and her husband Captain James Davies are portrayed against a verdant painted backdrop in the European style. The occasion for the portrait may have been the couple's recent wedding, since the two had been married the previous month. With a watch fob dangling from his vest, and hand tucked confidently in his trouser pocket, Davies looks the picture of a wealthy British industrialist; Bonetta, shown here only nineteen years of age, appears holding a book in a frilly Victorian dress, in a typical aristocratic pose.

One of several pictures Silvy made of the couple during this session, it belies the extraordinary biographies of both sitters. Bonetta was born a princess of the Yoruba people in what is now Nigeria. Orphaned and enslaved at age five during a war with the neighbouring kingdom of Dahomey, she was released during an otherwise unsuccessful British diplomatic mission to end the kingdom's complicity in the Atlantic slave trade. Introduced to Queen Victoria, she quickly became a court favourite and was named the Queen's goddaughter. Also of Yoruba ancestry, Davies was born in Sierra Leone to parents who had been freed by the Royal Navy's West Africa Squadron, charged with patrolling the coast to intercept slave ships and liberate those imprisoned on them. Returning to Lagos with Bonetta, he established a vast, successful agricultural operation and is credited with bringing cocoa farming to the region. Bonetta's life was cruelly short; she died of tuberculosis at thirty-eight.

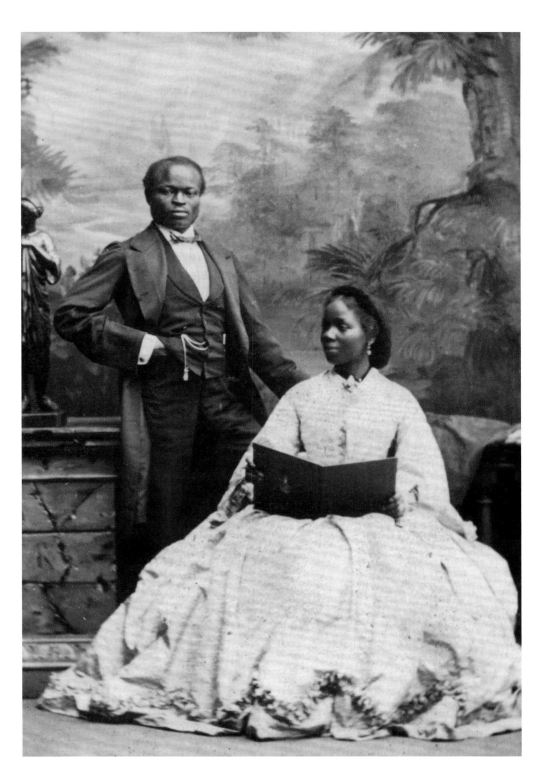

5 Pleased to Meet Me

Photography, Exploration and Type

Of the thirty-six photographs John William Lindt made of inhabitants of Clarence Valley, on the north coast of New South Wales, the most famous is a portrait of a woman with short hair, bare from the waist up, wearing only a dingo-fur headdress and snake necklace (see opposite). With her beautiful features and strong jawline, even now she is a striking presence. In keeping with the nineteenth-century conception of 'types', Lindt left her nameless, describing her merely as an 'Aboriginal woman'. Yet the picture became so popular that viewers were not content for her to remain anonymous. Soon she became known as 'Mary-Ann of Ulmarra', after the small town on the banks of the Clarence River where she was believed to live. As a result of this tiny fragment of imagined biography, the picture took on added dimensions. Now a named individual, she became a character, a hero – a relatable person, and not just a representative of a people or culture. Her real life story was

lost, but viewers imagined who she was from their scant knowledge of Aboriginal culture and colonial practices. It was not until some 140 years later, in 2015, that researchers and descendants of Mary-Ann discovered the full story.[1] Her pseudonym had some basis in fact: her name was indeed Mary-Ann and she did live in the region, but not in Ulmarra; she and her husband, a British immigrant named Cowan, ran a livestock farm there.

In light of this new information, the National Gallery of Australia now describes Lindt's portrait as that of Mary-Ann Cowan. However, the photograph has not changed. It was the same when she was known as Mary-Ann of Ulmarra, and before that when she was simply an 'Aboriginal woman'. Her ethnicity never really defined who she was, and while we may suppose we know her better now that we know something of her story, as viewers our understanding will never be complete. Posing his sitter in the studio against

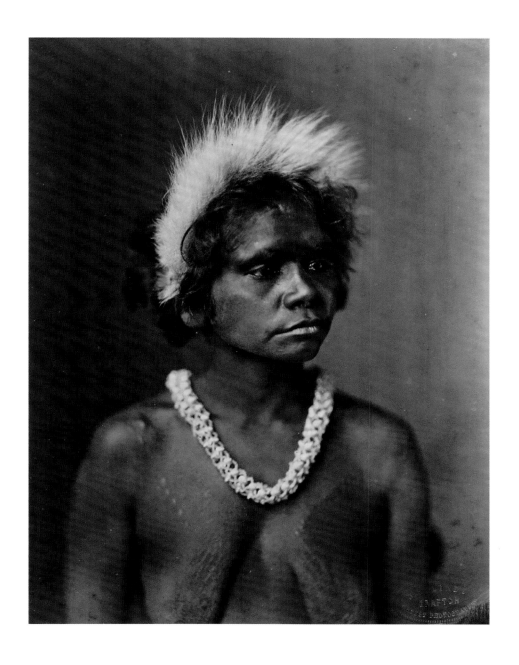

John William Lindt

Mary-Ann Cowan, also known as *Mary-Ann of Ulmarra*, or *Aboriginal Woman*, 1873

Francis Galton
2 sons, 2 daughters, father and mother, c. 1883

a neutral backdrop, biography expunged, Lindt attempted to erase all evidence of Mary-Ann's personal circumstances. Yet her character – those ineffable qualities that made her uniquely who she was – never left the portrait. This, in the end, may be the lesson of all photographic surveys. Despite the maker's intentions, personality often tends to bubble to the surface.

The impulse to classify and categorize has a long and eventful history in Western culture. During the seventeenth and eighteenth centuries, this manifested in the spectacular *Wunderkammer*, or Curiosity Cabinets, favoured by aristocracy, in which natural history, historical and ethnographic artefacts were combined: coconuts, stuffed birds, eggs and seashells presented side by side with crystals, geodes, Polynesian battle clubs, Pre-Columbian sculpture and unicorn horns, for example.[2] Such collections were designed to amaze and inspire the owner and to impress visitors; the more worldly and eclectic the specimens, the higher the status of the collection. The pious saw such collections as evidence of the divine wisdom of God. With the publication of Carl Linnaeus's *Systema Naturae* in 1735, the activity took on an added dimension.

Classification systems of various types now pervade our social and economic systems, from National Insurance and Social Security numbers to telephone area codes, and from QR codes to the Dewey Decimal System. Museums, too, the origins of which may be traced to Baroque and Enlightenment *Wunderkammer*, are usually organized according to taxonomic hierarchies. Nineteenth-century French paintings are classified separately from contemporary African photographs, for instance, and each example is assigned a discrete accession number. Depending on how they are conceived, museum collections may even be thought of as 'surveys' in their own right. National portrait galleries, for example, exist to collect pictures of certain categories of people, produced according to agreed standards.

When in earlier times this same concept was applied to actual human beings, the results quickly became more complicated. After all, the same conveniences that made photography useful in the analysis of lab specimens could also be extended to the study of people – the potential to share imagery without transporting the subjects themselves, and to generate quantitative data that could be shared with colleagues. The only problem is: people are not artefacts. We are living, changing, thinking beings, whose sensibility and mood may vary from one moment to the next. Equal parts creatures of habit and response, we learn, adapt, and feel things.

Survey photographs are mediated encounters. They exist to create a window for the viewer to see and study people they do not know. The 'otherness' this implies has long been a subject of critical discourse in photographic theory. The essence of this discourse is the acknowledgment that, regardless of the creator's intentions, photographs are never truly neutral. At one end of the spectrum, they may simply betray implicit assumptions of the maker, accidentally absorbed from cultural standards. At the other, they may reveal consciously held racial, colonial, gender and class prejudice.

It is easy to see why photography was chosen for the many survey projects conducted in the nineteenth and twentieth centuries. As a quick and accurate visual recording device, the camera is unrivalled; moreover, photography's capacity for verisimilitude enables it to record the appearance of things in exquisite detail. In the case of portrait surveys, this is a double-edged sword. Surveys are devised to draw broad conclusions from specific observations. No matter how much a maker may wish their photographs to speak in generalizations, they always deliver specifics. They excel at recording idiosyncrasies – people and their peculiarities, warts and all. A hunch of the shoulders, the way a person holds their head, the scars from an old injury, or the hereditary curve of their ears: those things that physically distinguish individual human beings may be clearly shown in a photograph under a specific set of conditions – at one moment, at an agreed location, and at a particular time and date.

In 1878, Charles Darwin's cousin Francis Galton attempted to address this problem by creating 'generalized' portraits made up of multiple pictures (Galton proposed using both photographs and drawings) composited together in the camera (see above left). By pinning these portraits up and rephotographing them one on top of another in alignment, he hoped to reveal commonalities between people of different types. His combination portraits of categories including criminals, the mentally

Circle of Thomas Henry Huxley
Frontal and profile photographs of a female
and male subject, 1868

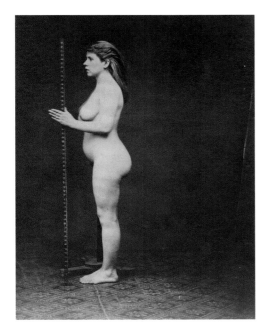

ill, scientists and Westminster schoolboys,[3] for example, would, he hoped, 'create a portrait of a type and not an individual'.[4]

Where features repeated, Galton surmised, exposure would be darker, indicating a commonality. Where they were outliers not broadly shared in the population, they would be comparatively faint, indicating an idiosyncrasy that could be discarded. As scientific data, Galton's composites had numerous problems, not least of which was his organizational structure: he made little distinction between social and behavioural tendencies and racial and ethnic origins. Nevertheless, in recent years Galton's work has become increasingly relevant as the basis for artificial intelligence systems designed to recognize human faces by plotting them against mathematical composites, called eigenfaces (see p. 77).

Perhaps the most ambitious portrait survey ever undertaken was launched in 1868, under the patronage of the British government. Working with the Colonial Secretary, George Leveson-Gower, the second Earl Granville, Charles Darwin's close friend and advocate Thomas Henry Huxley attempted to produce a photographic atlas of peoples of the British Empire for use in anthropological research.[5] A man of formidable intelligence and humane instincts, Huxley complained about the large numbers of photographs that were being produced of peoples around the world without a plan. Such pictures, he argued, were of little use scientifically because they could not be compared or reliably measured. The seemingly arbitrary decisions individual photographers made when producing their pictures – whether to shoot close up or far away, full-figure or face only, with a short or long lens, in profile or head on, for example – had knock-on effects not only on what could be seen in the frame, but also on the mathematical perspective with which the person was rendered.

Huxley and Granville aimed to document as many different racial and ethnic 'types' as possible within the Empire (and beyond, if it could be arranged) to facilitate research on common ancestries revealed by physical factors such as skull size and shape. Supposing that government representatives throughout the Empire were in a unique position to order photographs to be made for the project, the two sent letters to all corners of the globe, requesting governors, regional administrators, prison wardens, missionaries and others to arrange for photographs to be produced and sent back to London for study. The letters included Huxley's instructions for how the photographs should be made:

> [T]he right arm should be stretched out horizontally – the hand being fully open with the fingers & thumb extended, and the palm turned forwards. The feet should be parallel and with the ankles fairly touching one another. The arm will need a rod to prevent it from trembling and a measuring rod divided in feet and inches may either be fixed to this rod or otherwise included in the plane of the body so as to present a scale. In the profile view, the left side should be turned to the eye of the photographer; and the left arm bent at the elbow and so disposed as not to interfere with the outline of the pectoral region. The back of the hand should be turned toward the photographer and the fingers & thumb extended.[6]

Huxley even arranged for representative photographs to be taken in London according to these instructions, which could be sent to correspondents as samples (see left). With the imprimatur of the Colonial Secretariat behind them, the letters were duly sent, but the hoped-for standard survey of peoples of the Empire never materialized.

To judge from the results preserved in the Huxley Archive in London, the photographs Huxley and Lord Granville received were not only thin in number, they were also of mixed quality. What Huxley had perceived as chaos in the photographic community prior to launching his scheme was impossible to fix; the chaos he perceived was actually fundamental to the enterprise. Photographers had to be creative, skilled and adaptable to obtain pictures of people in the different places they travelled. They had to get to know the people they met, and devise effective ways to interact with them. Their diverse strategies may have exasperated Huxley, but they were the product of many minds negotiating different problems using the resources they had in varying circumstances. In other words, photography was an inherently human undertaking, and the results could not be fully controlled, any more than people themselves can be.

Walter Stoneman
Rudyard Kipling, photograph for the National Photographic Record, 1924

A generation later, the British government lent its weight to another photographic survey, this time with the lens aimed at the British people themselves. From 1917 to 1958, photographer Walter Stoneman produced more than ten thousand individual portraits of eminent Britons made according to loosely applied rules, in a project that became known as the National Photographic Record (NPR).[7] Selected individuals were invited to Stoneman's studio, where they had their portraits made for free. In order to maintain a neutral point of view, Stoneman photographed them from the waist or shoulders up, facing the camera directly or in partial profile against a plain, usually black, background. Facial expressions were kept to a minimum. Hats were discouraged but judges were permitted to keep their powdered wigs, clerics could wear ecclesiastical gowns, and military leaders could display their medals and regalia. Most other sitters dressed semi-formally, in suits and ties, and were allowed to keep their eyeglasses on, if they used them.

The resulting photographs were seldom exhibited and never sold, but maintained as a Who's Who of British achievement. Relatively few women were initially included, although this situation improved somewhat as the project wore on. The professions represented include military and political figures, authors, artists, scientists, business people, civil servants, colonial administrators and governors, among others. As impressive as many of these people were, they reflected an early twentieth-century view of meritorious professions. To contemporary eyes they form a strikingly homogenous group, with persons of colour hardly represented.

Stoneman's portrait of Rudyard Kipling is arguably the best-known example of his NPR work, and reveals some of the project's more troublesome aspects. It shows the author and poet in subdued light against a neutral backdrop, the camera positioned slightly above the sitter's sightline (see above left). The illumination is full but targeted, the left side of his face falling into partial shadow, reflections glinting from the rims of his spectacles, and catchlight (stray light from studio lamps) visible in his eyes, off centre. He faces the camera squarely, revealing both ears, but his torso is turned slightly so that his left shoulder is closest to the camera. Unusually for a 'record' photograph, the focus is soft and flattering, with shallow

depth of field. The picture is expertly made but conventional – virtually indistinguishable from thousands of other routine early twentieth-century photographic portraits. Which is, ironically, the point. The NPR was not a place for dramatic poses or exaggerated effects. In keeping with the weight of the enterprise, Stoneman's portrait of Kipling is restrained and dignified, just as he intended it to be.

Those looking for insight into Kipling's character in Stoneman's portrait will search in vain. Unlike Lindt's portrait of Mary-Ann Cowan, were Kipling not such a recognizable figure, he might easily be mistaken for a member of another profession entirely: a banker, perhaps, or a physician. The picture contains no hint of his creativity, his controversial imperialist views, or his incendiary arrogance. The writings that had come to define him, from *The Jungle Book* and *Kim* to 'White Man's Burden', are not in evidence. Nor do we see the tragedy of his beloved son John, killed at the Battle of Loos when Kipling himself pulled strings to help him enlist, after he was rejected on grounds of poor eyesight. The picture tells us nothing about the sitter's mental state, motivations or concerns. By the time Stoneman's portrait was made, Kipling had become a staunch anti-communist, an advocate for the defence of Armenia, and a passionate opponent of the fascist Oswald Mosley. He was a flawed and complex person living in a turbulent time. Yet Stoneman's picture conveys none of that. The value of such a portrait – ambivalent, detached, and stubbornly unrevealing – is unclear.

Stoneman began his work some six years after the German photographer August Sander embarked on his own celebrated photographic survey, *Menschen des 20. Jahrhunderts*, or *People of the Twentieth Century*. Sander, too, was extraordinarily dedicated to his task, and although his efforts were cut short in 1936, when his book *Face of Our Time* was confiscated by the Nazi regime, he spent more than forty years producing work for the series. Unlike Stoneman, Sander was not interested in a single social stratum; he aimed to characterize German society as a whole by presenting people engaged in different occupations and epitomizing various social classes. While the logic of his groupings was somewhat fraught – 'women', for example, were given equivalent status to 'farmers' – the framework was designed to reflect the interconnectedness

August Sander
Boxers, 1929

of seemingly disparate roles. While Sander photographed some of the same categories of people as Stoneman, in seeking to understand the totality of German social structure he cast a wider net, including manual workers such as bricklayers, a pastry cook, and boxers, for example.

Although *People of the Twentieth Century* was typological in theory, in practice Sander embraced the individualism of his subjects. His *Boxers, 1929*, for instance, included in his section on sport (a subset of 'Farmers'), is playful in tone, juxtaposing two men of different physique and temperament (see left). Paul Röderstein, on the left (tall, blond, gangly and long-legged), stands next to Hein Hesse on the right (shorter, stockier, and broad-shouldered, with a tuft of curly hair on his head). Hesse smiles broadly into the camera, his eyes squinched into a smile, while Röderstein stands solemnly, standing upright with near military poise. The difference between the two men is evident even in their feet: Röderstein, his tightly bound shoes almost at right angles, ankles touching; Hesse, feet spread comfortably, laces looped loosely.

Taken full-figure, bathed in natural light and sharply focused, the photograph not only conveys what the sitters looked like, but invites the viewer into their presence, and provides a glimpse of their personalities. The portrayals are intimate and personal. As if to concede that no single boxer would suffice to represent the profession, Sander instead gave us two – a universe of two boxers, representing two potential manifestations of the sport. Separately, they represent two known individuals. Together, in Sander's judgment, they define a type.

Richard Daintree and Antoine Fauchery
Aboriginal Man Ornamented for a Corroboree,
c. 1858

Opposite **Edward S. Curtis**
Haschelti – Yeibichai (Navajo), 1904

Standing bolt upright, feet parallel and centred almost perfectly left to right, the figure in *Haschelti – Yeibichai* confronts the viewer head on, as if an extension of the canyon wall behind him. The picture is organized around graphic forms – the striated diagonal of the rock face, the bands of light and dark formed by dirt and stone, and the patterning on the subject's mask, vest and headdress. The sharp focus and frank, proto-Modern stillness of the composition are interrupted only by the blur of the hare in his left hand. To non-native Americans, this was a portrait filled with otherness – the geology of a southwest landscape, the manner of dress and its cultural context. To Native Americans, it was a work of almost pure fiction.

Edward S. Curtis was determined to show Navajo (Diné) people participating in a Yeibichai healing ceremony, also called Nightway, for his encyclopaedic survey of Native American peoples, *The North American Indian* (1907–30). He made two visits to Navajo Nation, in 1904 and 1906, each time encountering resistance. The picture is meant to represent Haschelti, sometimes referred to in English as the Talking God. Since a Yeibichai is sacred, it was forbidden to photograph, especially by a non-native such as Curtis. Almost certainly, the sitter for this portrait was a non-native impersonator; the most likely candidates are Charlie or Sam Day, local traders who served as Curtis's guides. Their attire is also probably not the same as that used in a real ceremony, but a copy made specifically for the purpose. It has been suggested that Curtis was not even present for the photograph. Both Sam and Charlie were photographers; Charlie sometimes photographed Sam posing, and vice versa.

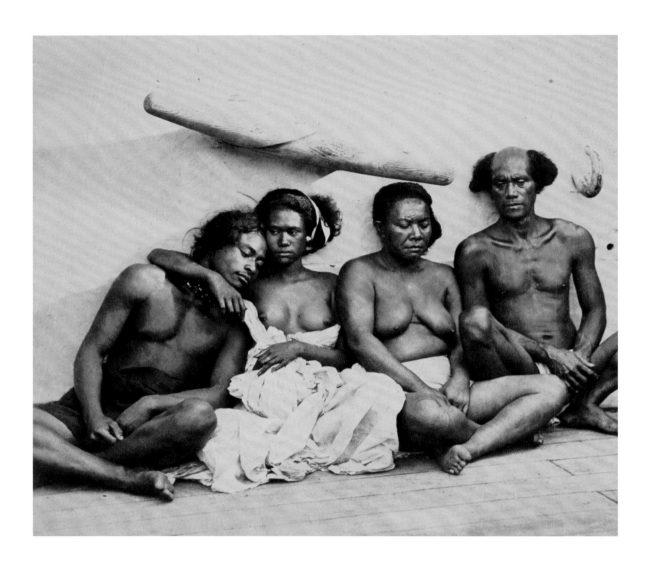

Paul Émile Miot

The King of Vaitahu and his Family, 1870

This complex portrait shows members of a Marquesan royal family seated on the deck of Paul Émile Miot's ship, the *Astrée*, in 1870. The precise identity of the figures is not entirely clear; however, in other photographs, the young man on the left is identified as the King. Uniquely among royal portraits, he is not only positioned off centre, but presented with eyes closed, resting his head on the shoulder of a woman – presumably the Queen – who looks away out of the frame. The older woman in the centre also closes her eyes in sleep or meditation, while the man on the right squats, knees spread, chest muscles tense, and brow furrowed. The family neither directly engage with the camera nor each other; rather, they make up four separate psychologically charged portrait vignettes, connected by the clever interplay of torsos, arms and legs, arranged as in a bas relief.

A French naval officer, Miot photographed people he encountered during his voyages. Posing the Vaitahu royal family on the deck of his ship not only provided easy access to his travelling darkroom, it also enabled him to use the side of the ship as a backdrop, complete with the otherworldly cleat on the wall behind them. It would also have enabled him to use sailcloth as a solar reflector, reducing exposure times and producing the full, even light that illuminates the figures.

The painter Paul Gauguin, who may have seen this and other photographs by Miot, travelled to Tahiti in 1891, two decades after this picture was made. He would later relocate to the Marquesas, where he died in 1903. Resembling a lost Gauguin masterpiece, Miot's photograph invites the viewer to push beyond superficial appearances and recognize the sitters as feeling, thinking individuals.

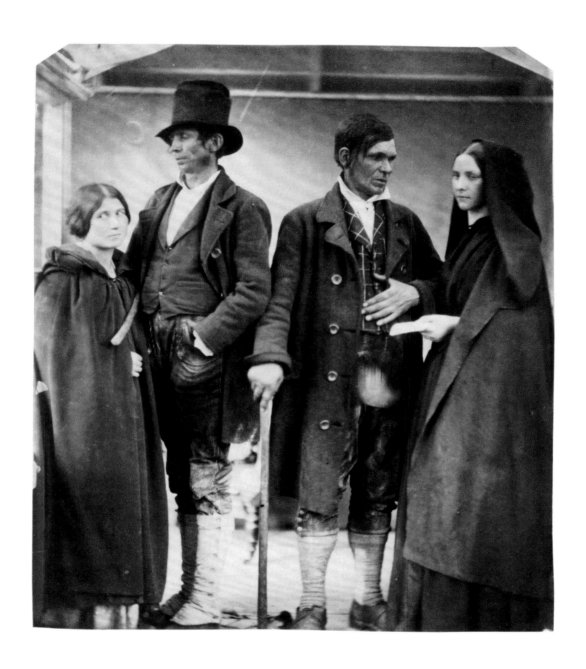

John Gregory Crace
Irish Peasantry, 1853

Francis Galton and unknown photographer
Family photograph, c. 1883

To make his archetypal composite photographs of groupings such as criminals, consumptives and Royal Engineers (see p. 138), Francis Galton superimposed the faces of individuals one on top of the other in perfect registration. In order to obtain the images he needed for these experiments, he sometimes commissioned new photography, even enlisting the help of the renowned photographer Henry Peach Robinson (see p. 88). Otherwise, he worked with existing photographs, as appears to have been the case here. For Galton's method to work properly, the subjects had to be photographed at the same scale. A family portrait like this one was ideal source material, since it was clear all the sitters had been photographed with the same camera and lens, and from the same distance.

The white rectangles mark where Galton neatly cut out the faces of each of the sitters in this family portrait. He then rephotographed the excised faces, combining them into a meta-portrait intended to reveal common features. Galton was not familiar with the idea of Mendelian genetics, which would only become widely known in the early twentieth century; however, he was interested in the inheritance of physical traits. Consequently, he created two different kinds of family portraits – some in which all the sitters were blood relatives, creating what he believed to be a combined portrait of that bloodline, and others in which the sitters were related by both blood and marriage, resulting in what he thought familial offspring might look like. It is unclear which type this was. As creative and visually impressive as Galton's research was, it was ultimately of limited scientific value.

THE BELLE OF THE YAKIMAS

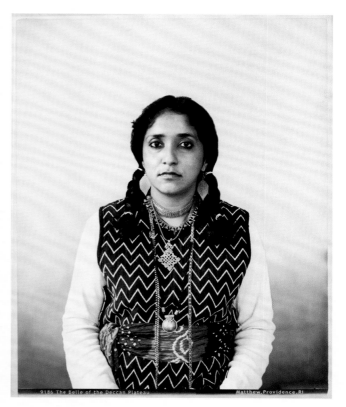

THE BELLE OF THE DECCAN PLATEAU

Annu Palakunnathu Matthew
Belles, 2001, from the series 'An Indian from
India', 2001–9

Frederick S. Rankins
Theophilus Brackett (1839–1912), from the series
'Old Swampscott Fisherman', *c.* 1906

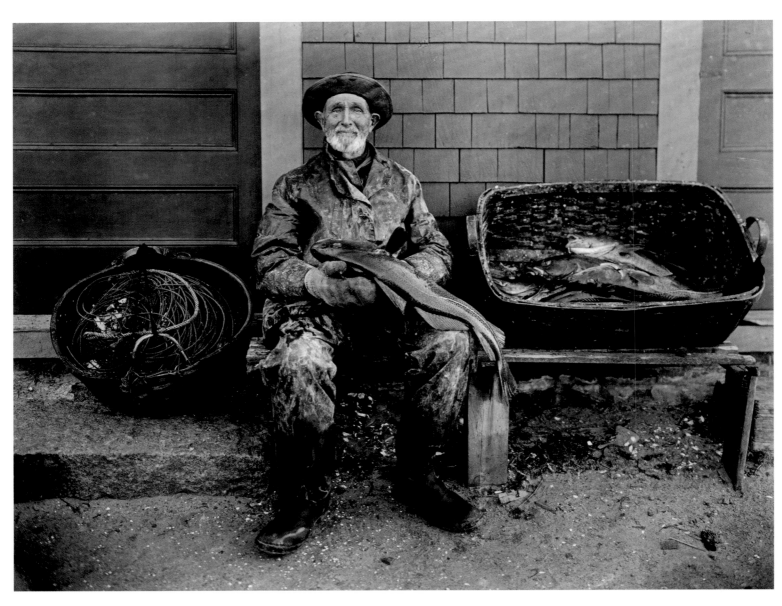

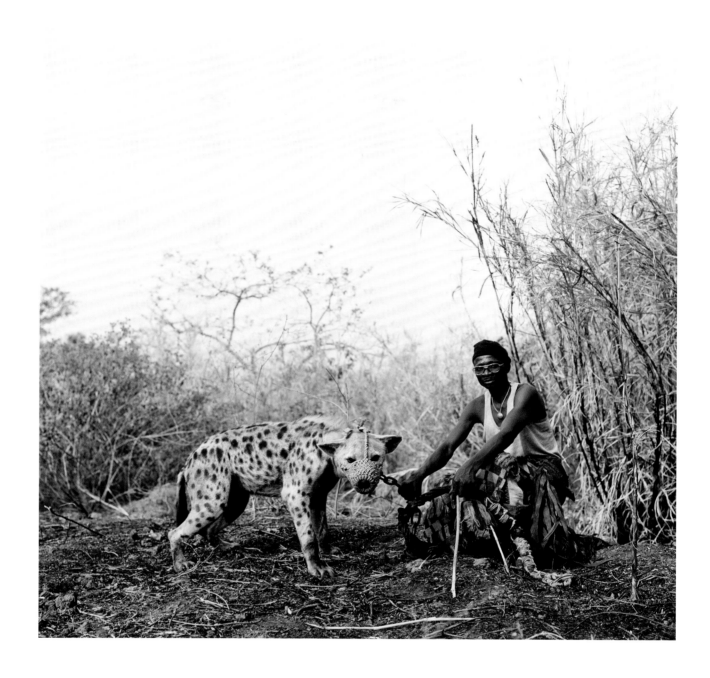

Pieter Hugo
Mallam Galadima Ahmadu with Jamis, Nigeria,
2005, from the series 'The Hyena and Other
Men', 2005–7

Nigeria's hyena men are a band of itinerant
street artists who make their living travelling
from town to town in West Africa performing
stunt shows with trained animals, including
baboons, pythons and the hyenas which are
their namesake. During these shows, trainers
remove the animals' restraints, seemingly
defying death by placing their hands, arms and
even heads inside their jaws. Audiences pay for
the entertainment, and are encouraged to buy
the charms and potions the performers use to
protect themselves from harm. It is hard and

dangerous work, and the hyena men bear the
scars of the bites and scratches that are an
inevitable consequence of their trade.

In *Mallam Galadima Ahmadu with Jamis,
Nigeria*, trainer and hyena face the camera with
parallel expressions, the characteristic arch of
the hyena's back reflecting the slightly hunched
posture of the crouching man. The hyena's rope
muzzle is intricately, almost lovingly woven, its
tender appearance negated only by the heavy
steel chain Ahmadu uses to secure it. He wears
an amulet around his neck, presumably one

of the charms he uses to ensure the hyena's
obedience. By positioning the animal's head
in the centre of the composition, Pieter Hugo
underscores its formidable presence. However,
the intimacy shared by trainer and animal
suggests a more nuanced relationship. Their
lives are interwoven; separate, but together,
travelling, but at home. Hyena and hyena man
are bound in a mutual dependency neither can
or would shake.

Hugh Welch Diamond
Patient, Surrey County Lunatic Asylum, 1850–58

Posed against a neutral backdrop, her right arm hooked around the back of a chair, Hugh Welch Diamond's *Patient, Surrey County Lunatic Asylum* looks back at the viewer with a playful smile, her long hair tumbling over one shoulder, and a flap of her blouse folded under at the second button from the top. Diamond was both a pioneering photographer and the first in a series of psychiatric practitioners who attempted to use photography as a therapeutic tool; others, such as Henry Hering, at Bethlem Royal Hospital, and James Crichton-Browne, at West Riding Asylum, would similarly use photography to treat patients in their care. Yet none managed to convey the transporting intimacy of portraits such as this one, which seems less a medical document than an absorbing portrait of a friend or loved one.

Diamond worked at a time of comprehensive reform in mental health care, when physicians began to rethink the traditional view of asylums as prison-like enclosures, instead creating educational initiatives and rehabilitation programmes. Although these efforts met with some success, the reasons for being committed in the first place remained discriminatory by contemporary standards, and particularly prejudicial against women. Hysteria and erotomania were common diagnoses. Although the circumstances behind this particular portrait are unclear, Diamond and others used photographs to study and classify ailments. They also experimented with showing patients their portraits, in order to dispossess them of self-delusions and restore their self-esteem. Although the asylum system as a whole did improve during these years, there is little evidence that cures of the kind envisaged by Diamond had any significant effect.

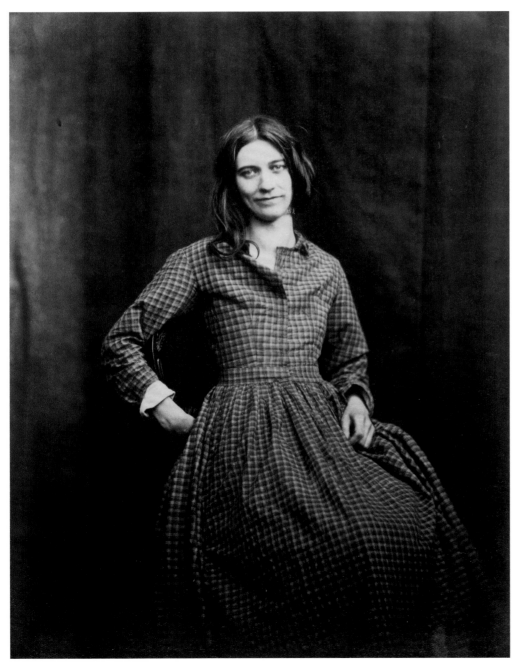

Madhuban Mitra and Manas Bhattacharya
Untitled, 2013, from the series 'Mount Analogue', 2013

This anonymous portrait was one of a number of colour negatives found in India's first and only still-camera factory, National Instruments Ltd in Jadavpur, Kolkata. Its signature product, the National 35, is no longer produced. The company struggled to make a profit, and was shut down in the 1980s after only a few years in operation. In 2009, the site was acquired by Jadavpur University, which invited the artists Madhuban Mitra and Manas Bhattacharya to document and explore the ruins, which had been untouched for nearly thirty years. Among the debris the artists found broken cameras and machine parts, posters and personal possessions of the former workers, including articles of clothing, combs, and even a love letter.

The artists discovered a group of colour negatives, including this one, in a rubbish bin. It is unclear whether the images they contain were of personal importance to factory workers or merely tests of film and equipment; the identity of the sitters is lost to time. Rather than print the negatives conventionally, the artists decided to rephotograph them preserving the eerie red, green and blue palette of the unprinted negatives, and leaving scratches, cracks and discolouration much as they were. The girl in this picture lies on the ground in a colourful skirt and blouse, head propped up in one hand. Yet her ghostly form is barely recognizable – a faded memory from another time.

Arnold Genthe
Merchant and Body Guard, Old Chinatown,
San Francisco, c. 1895–1906

Lewis Wickes Hine
Young Millworker, c. 1904

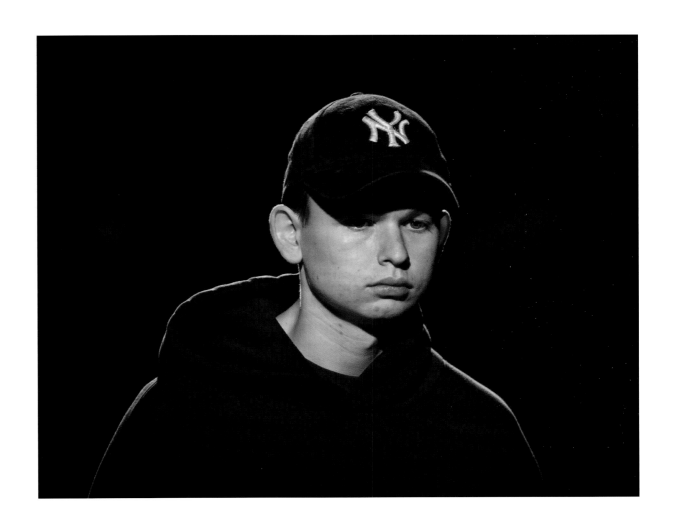

Philip-Lorca diCorcia
Head #10, 2000, from the series 'Heads',
1999–2001

Above and opposite **Allan Sekula**
Portraits of Salespeople, 1973

Joni Sternbach

08.07.04 #1 Abbey, 2008, from the series
'Surfland', 2006–20

Her body curved in a sinuous 'S', feet buried in wet sand and one arm reached behind to hold her surfboard, Abbey is portrayed as an elemental being, emerging from a murky background where there is no clear demarcation between earth, water and sky. Joni Sternbach produced this picture in Montauk, Long Island, as part of a series depicting surfers with their boards. The artist views surfers not just as athletes, but as voyagers, attempting to connect with the raw forces of nature. She views the size and shape of the boards, the way they are decorated and

weathered, and, critically, how her subjects hold them as revealing of character. Abbey's board is simple, minimal. She stands in front, holding it at an angle – seemingly without effort.

Sternbach uses a nineteenth-century process known as tintype, or ferrotype. Each tintype is unique, and must be handmade on the spot. They are similar to wet-plate collodion negatives, a common process of the 1850s–70s; however, instead of glass, tintypes are made on thin sheets of metal painted with black lacquer, and the picture is mirror-reversed. Dark areas

of the photograph are where the photosensitive emulsion received less exposure, so the black of the plate shines through. Sternbach uses this material for its extraordinary beauty, to slow down interactions with her sitters, and because the exposure times are shorter than with comparable wet-plate collodion negatives. In addition, in the nineteenth century, people frequently carried tintypes with them as companions and talismans – in much the same way as surfers hold their boards.

Detlef Orlopp
Helga N. 5.4., 1969, from the series 'Heads',
1958–2014

6 Sell Yourself
Fashion and Portraiture

Fashion photography carries the cachet of glamour – of stars and supermodels, *Vogue*, *Harper's Bazaar* and *Vanity Fair* covers, catwalks and galas, innovation, style and fine design. Yet for every yard of silk and every braid of hair, a phalanx of photographers stands at the ready to publicize, promote and celebrate the people who wear and make fashion goods. Photography is now so thoroughly ensconced with fashion that it is hard to imagine the industry without it. From haute couture to luxury lifestyles, for one hundred years or more, the way we have learned about the most up-to-the-minute fashions is through photographs. And since fashion is always changing, fashion photography is always changing too.

Fashion portraiture is among the most vital forms of expression in photography. It is no coincidence that Andy Warhol began his career as an illustrator for the fashion magazine *Glamour*. As a breeding ground for popular culture, it is a place where popular personas are born – a cultural crossroads where image meets identity. Without fashion photography we might never have encountered such larger-than-life personalities as Naomi Campbell or Kate Moss, Alexander McQueen or Coco Chanel. Many fashion photographers, too,

are sources of fascination in their own right. Helmut Newton, Annie Leibovitz and Irving Penn became household names through their work in fashion. Michelangelo Antonioni's legendary film *Blow-Up* (1966) was inspired by British fashion photographer David Bailey; likewise, Stanley Donen's *Funny Face* (1957) was based on Richard Avedon. Other celebrated photographers spent significant parts of their career working in fashion, or went back and forth from fashion to other arenas: Edward Steichen, Man Ray and Bruce Weber, for example.

Fashion photography is aspirational. It is an extension of the collective mood – an indicator of who we are at any point in time, socially and culturally. This connection is so pronounced that during the Second World War, the British Ministry of Information identified fashion magazines (or, as they were then, 'women's magazines') as vital to national morale. As Audrey Withers, editor of British *Vogue*, would later recount:

[T]he way to catch women's attention was through the pages of magazines which, in total, were read by almost every woman in the country. So a group of editors were

Norman Parkinson
Nena von Schlebrügge, Informal, in the Forest
(First Test Shots), 1955

Craig McDean
Wonder Woman, Portrait of PJ Harvey, 1995

frequently invited to briefings by ministries that wanted to get across information and advice on health, food, clothing and so on. And they sought advice from us too – telling us what they wanted to achieve and asking how best to achieve it. We were even appealed to on fashion grounds. The current vogue was for shoulder-length hair. Girls working in factories refused to wear the ugly caps provided, with the result that their hair caught in machines and there were horrible scalping accidents. Could we persuade girls that short hair was chic? We thought we could, and featured the trim heads of the actresses Deborah Kerr and Coral Browne to prove it. But what about also designing more attractive caps?[1]

While fashion magazines may no longer have the influence they once did in reaching women or any other segment of the population, the industry remains an important proving ground for new ideas and trends. It is a bellwether not just of who we are, but who we want to be.

In its purest sense, fashion refers to periodic changes in popular taste for consumer items and services, such as clothing, shoes, makeup, hairstyle and accessories. Fashion photography fuels and records these changes. It may be aimed at any audience, but for a variety of (generally not very good) cultural reasons it is most often aimed at girls and women. The term is usually understood also to include pictures used to illustrate essays and interviews published in fashion magazines, even when those pictures are not tied to a particular product. Since many artfully designed goods are presented and sold as fashion objects, and often come with celebrity endorsements – cigarettes and alcoholic drinks, for example, or luggage, cars and home decor – the lines between fashion and 'advertising' photography are blurred, especially in contemporary photography where there are no set rules, and pictorial strategies frequently overlap.

Because television and film programmes are marketed seasonally, much as clothes and accessories are, and since pictures of celebrities have long been a staple of fashion and lifestyle magazines, these are generally included in the fashion category. Ultimately such designations are largely semantic, and opinions as to what constitutes a 'real' fashion

photograph, or indeed whether fashion photography makes any sense at all as a catchall term, will differ. Many photographers bristle at the designation, since historically fashion has been seen as more frankly commercial, and therefore somehow less artistic, than photography explicitly made to be shown in museums and galleries. In any case, the distinction is somewhat artificial, since nearly all professional photography has a commercial aspect.

Most fashion portraiture falls into two main categories. In the first, the individual depicted is closely connected with the creation of a product: for example, when a musician or actor is shown publicizing a recording, performance, film or personal brand, as with Craig McDean's portrait of PJ Harvey, which appeared in the September 1995 issue of *i-D* magazine (see left). A second category is more loosely associative, as when a model or celebrity is shown wearing or using a product when they have no direct relationship with it except by affiliation, as in Juergen Teller's photograph of Kirsten Dunst wearing a Chloé bikini in Los Angeles (see opposite, above).

Fashion photographers are researchers in the laboratory of public opinion. Their relationship with the viewer is urgent and direct: the economic consequences of a failed image or campaign may be felt quickly, particularly when distributed through social media or other digital channels. Moreover, consumers are fickle, and even a great idea may not find an audience if it is ill timed or clumsily distributed. Ultimately, the fashion photographer's goal is to connect with viewers and raise awareness of a person or product, with the eventual aim of encouraging them to spend money. Thus a successful fashion photographer must produce work that is not only artistically successful, it must also be memorable, appealing, and psychologically resonant.

Unfortunately, fashion photography also capitalizes on our collective insecurities. And since the majority of fashion photographs are aimed at women, industry practices raise serious questions about gender identity and disenfranchisement. Undoubtedly, fashion photography is an arena in which cultural conventions are sometimes challenged for the better. However, it may also reinforce unhealthy cultural messages about gender roles, private and occupational relationships, sexual expectations and body image, and has

Above **Juergen Teller**
Kirsten Dunst No.4, Los Angeles, 2013

Below **Cecil Beaton**
From Charwoman to Dowager, 1930s

been implicated in devastating mental illnesses including bulimia, anorexia nervosa, body dysmorphic disorder and clinical depression, to name just four examples. This is a matter of life and death: such serious conditions have resulted in terminal illness and suicide among adults and teenagers alike. Under pressure from advocacy groups and in response to legal judgments, the industry has attempted to modify some of its worst practices, but efforts have been largely incremental. Until fashion photography becomes truly inclusive, gender-balanced and positive, it will remain a contested domain.

Fashion photographs are frequently altered prior to publication to change body shape, minimize blemishes and reduce signs of ageing. It is widely understood that in the age of Photoshop and other digital post-production software, it is easy to erase wrinkles, crow's feet or stretch marks from a picture, to reduce or enlarge breasts, thighs or buttocks, or to change skin tone. Less well-known is the extent of the manipulations sometimes employed, and the long history of such alterations in photography.

In the 1930s, photographer Cecil Beaton created a presentation piece, *From Charwoman to Dowager,* illustrating how a photograph could be fundamentally transformed in the darkroom using then-common printing techniques (see below). In the first frame, the photograph was printed unaltered, as it was captured in the camera. In the second, Beaton revealed instructions to the printer, including extensive trimming around the

figure, and written notations requesting the subject's hairline to be lowered and lightened, her eyebrows to be thinned, and a necklace and earring to be added. The final picture shows the result of these changes. Having lost several dress sizes and with her double chin removed, the subject looks lean and glamorous. Beaton's demonstration may be extreme, but it is hardly exceptional: 'improvements' of the kind Beaton requested were common in fashion photography throughout the twentieth century, long before the invention of digital retouching. As a result, the ideals to which women in particular have been held over time are frequently not only unattainable, in some cases they are physically impossible – products of artistry and imagination, rather than biological reality.

Editing is also an important part of the fashion process. Picture editors usually choose the photographs they use from options presented digitally, or, in the film era, from contact sheets; depending on their status, photographers are not, as a rule, allowed to choose the specific images used in a campaign, a magazine spread, or online. Norman Parkinson was one of the select few who was permitted to choose his own photographs. His portrait of the Swedish model (and mother of actress Uma Thurman) Nena von Schlebrügge in a woodland setting was chosen from at least twelve alternatives (see p. 161). The contact sheet shows Parkinson experimenting with different angles and lighting effects, directing von Schlebrügge to tilt her head in various

directions and hold her hand to her face. The image he ultimately chose, marked in red ink on the contact sheet, presents her from a slight angle looking down at the viewer, eyebrows gently raised, the dappled light behind her dissolving into radiant splashes (see above). It is the look of one lover approaching another, her attention seemingly fixed on the viewer with intimate awareness – a fictional moment in a story never written.

Fashion photography drives consumption, the social and environmental implications of which are open to question. An economist might argue that advertising results in a net social good, since it helps connect consumers with the products from which they will derive the most utility. However, the luxury goods associated with fashion are frequently of notional benefit. No one would deny the advantages of making well designed, expertly crafted and fairly priced products. A handmade watch is a thing of beauty, for example, but should one buy six or seven of them? And what if only a small percentage of the population can afford them? By their very definition, luxury goods are predicated on exclusivity and status. This alone may be socially divisive, but what are the long-term psychosocial, environmental and economic impacts of artificially stimulated overconsumption? And how is this filtered through the lens of racial, ethnic and religious disparity?

To exacerbate the problem, endless seasonal or annual fashion cycles result in products that are prematurely valueless. A beautifully constructed haute-couture dress might last for years as a durable garment, but may be mothballed in weeks or months simply because it is 'out of fashion'. Worse still, some garments and accessories, including those purchased for weddings, quinceañeras, debutante balls and proms, are specifically designed to be worn for just one occasion. In recent years, there has been a movement among women in the film industry to reuse showy gowns used at public events, such as Oscar night (men, of course, held to a different standard, have long been in the habit of reusing their tuxedoes). But this is just the tip of the iceberg. Fashion is regularly sold for one-off or limited use. Indeed, the industry depends on the obsolescence of last year's fashion to encourage consumers to renew their investment in a company's products year on year. The expenditure of resources this entails, many of which are rare and environmentally precious, is a matter of abiding concern. So too is the waste generated.

The vast majority of fashion photographers understand the dangers and limitations of the industry in which they are engaged. Moreover, as the numbers of women and people of colour working in fashion grow, they bring with them refreshing new attitudes about what constitutes effective and responsible visual representation. At the same time, ironic and self-aware fashion photographs have flourished as photographers assimilate criticisms levelled against the industry, and consumers become cynical about hackneyed tropes.

Voluptuous Attentions, David LaChapelle's well-known photograph of his friend Pamela Anderson, is an example of this self-critical approach (see opposite). It shows the actress lying on a beach with her head propped on one arm, nude but for high-heeled leather boots, on an orange 'Baywatch'-style towel. She is surrounded by men with cameras, aimed at her from crotch height like extensions of their genitals, the figures themselves anonymous and their faces cut off by the frame. Anderson cranes her head backwards to see them, eyeing the group warily, but knowingly. As viewers, we are left to contemplate Anderson's agency – whether she is victim, perpetrator, or something in-between. Is she the pursuer or the pursued? The photograph is taken at her eye level, rendering her sympathetic and the men imposing, even predatory. The only

David LaChapelle
Voluptuous Attentions (Pamela Anderson), 2001

other object visible in the scene is an old transistor radio – an item of retro cool, but also a fashion object that might otherwise have been discarded long ago. LaChapelle's photograph is cautionary about the fashion industry itself, but it is also an attempt to excavate Anderson's true identity. The raw sexuality of the picture is unmistakable; her personality is inscrutable. In LaChapelle's picture, she has become 'a bride stripped bare by her bachelors', to borrow Marcel Duchamp's storied phrase.

At its best, fashion photography is one of the most dynamic and inventive forms of picture making – a crucible in which dramatic new ideas are forged and fresh pictorial strategies developed. Historically, photographers in other fields have often taken cues from fashion photographers, so that innovative approaches have frequently become established in fashion photography before they were taken up in other

realms. Since the fashion industry is driven by change, and since in order to succeed their work must stand out and attract consumer attention, fashion photographers are under constant pressure to reinvent themselves. This makes fashion photography a difficult and sometimes cut-throat occupation, but it also inspires like no other, since it is forever at the cutting edge of photographic practice.

Yousuf Karsh
Princess Grace, 1956

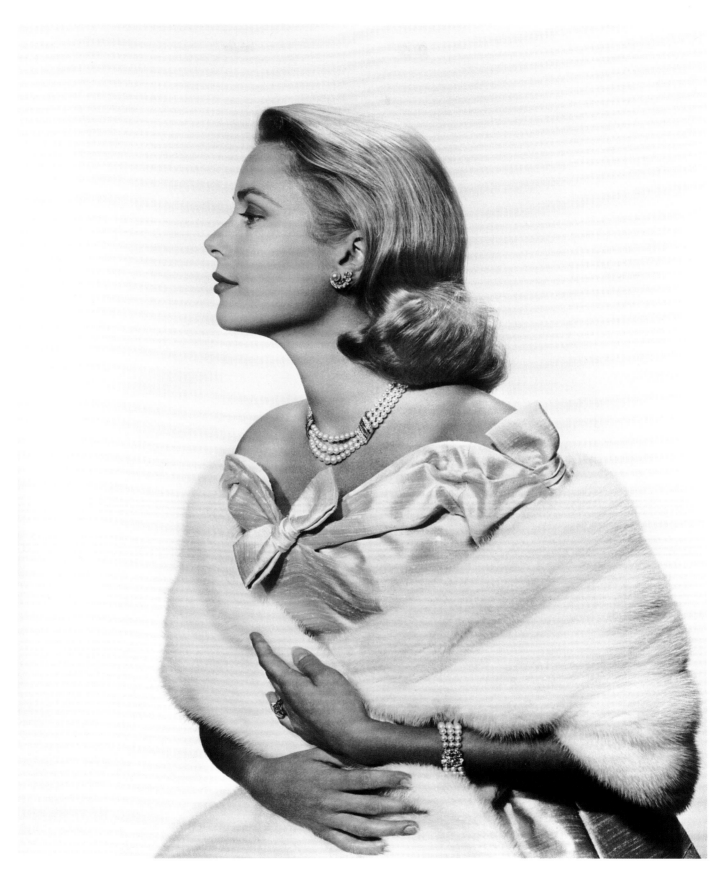

Richard Avedon
Marilyn Monroe, actress, New York, May 6, 1957

In this famous photograph, Marilyn Monroe is seemingly trapped in amber, frozen between fatigue and sadness. With her eyes averted, head angled slightly and lips gently parted, she seems almost about to speak. Glamorously dressed, through Richard Avedon's lens she has become a fallen angel: melancholy, even absent; contemplative, yet drained. Outwardly, she remains recognizable, her swooping curls of blonde hair pulled back to reveal her widow's peak, pencilled eyebrows and dark mascara, legendary mole visible on her left cheek, and glossy lipsticked lips pursed slightly to reveal two barely perceptible buckteeth. The sequins at her breast dissolve into circles of light, echoing the circles of her eyes.

Still only thirty years of age, Monroe visited Avedon's Madison Avenue studios to pose for photographs to publicize her new romantic comedy, *The Prince and the Showgirl*. It was the last film developed by the production company she and the photographer Milton Greene had founded three years earlier, Marilyn Monroe Productions, and the experience had been draining: the partnership with Greene had soured, and the company found itself under severe financial pressure. Towards the end of the sitting, Monroe's energy abated, but Avedon continued to photograph her and managed to produce this portrait. It captured an instant in which Monroe had seemingly dropped her guard, providing a window into the circumstances of her life and the woman behind the public image. The viewer senses that the real Monroe is stronger, deeper and fuller than her physical presence, yet her emotional state is unclear. Was she simply tired out, or was she trapped in some existential labyrinth?

Thomas Ruff
press++33.16, 2016, from the series 'press++',
2015–ongoing

George Hoyningen-Huene
Model wearing pale crepe romain pyjamas
by Vionnet, 1931

Edward Steichen
Greta Garbo, 1928

Greta Garbo is shown here at the height of her silent film stardom, during a break in the filming of *A Woman of Affairs*. Edward Steichen described the best photographs from their brief session, squeezed in between takes, as 'like the sun coming out from behind dark clouds'. Photographed from below, the actress is shown in partial silhouette, her head crowning the shadowy forms of her dark blouse and the back of a chair draped with a camera-focusing cloth. Studio lights shine from overhead, directed at either side of her forehead. The angled lines of the backdrop reinforce the effect, giving the

picture a distinctly glamorous air, as though she has been caught on stage between two crossing beams of theatrical lighting. At the same time, with her hair pulled back and head held in her hands, it depicts a moment of shared intimacy, in contrast to her public fame.

As chief photographer for Condé Nast magazines *Vogue* and *Vanity Fair*, Steichen would shape the careers of countless celebrities. Trained as a lithographer, and an avid painter, Steichen was a leader of photographic Pictorialism, the fin-de-siècle movement that coalesced around Alfred Stieglitz and his

Photo-Secessionist journal *Camera Work* early in the twentieth century. Steichen reinvented himself several times over the course of his career, first as a pre-eminent fashion photographer, later as a horticulturalist, and ultimately as the influential head of the photography department of New York's Museum of Modern Art. 'The Family of Man', which he curated, was one of the best-attended photographic exhibitions ever produced, and is still on display in his native Luxembourg.

Angus McBean
Audrey Hepburn, October 1950

Above **Jillian Edelstein**
Miranda Richardson, 2014

Opposite **Kadara Enyeasi**
Madonna III, 2018, from the series 'L'Ouverture',
2015—ongoing

Tracey Moffatt
Self Portrait, 1999/2005

Kourtney Roy
Holly Rose, Printed Jersey Dress, Pleated Wool Skirt, and Leather Bag by Prada, from 'Champ de courses' [Race Course] for *Numéro* magazine, 2014

Above **Miles Aldridge**
Cara Delevingne (The Red Lion #1), from 'The Red
Lion' for *Numéro* magazine, 2012

Opposite **Martyn Ewoma**
*Mlungisi Wears Stylist's Suit, Daily Paper Jersey,
Calvin Klein Belt, Devil's Advocate Shoes*, from
'Elegant People' for *Nataal* magazine, 2020

7 You Ought to Be in Pictures

Narrative Portraiture and Cinematic Style

In 1956, the Canadian sociologist Erving Goffman quoted Shakespeare's *As You Like It*: 'All the world's a stage,' he reminded us, 'and all the men and women merely players.' Goffman's seminal book *The Presentation of Self in Everyday Life* likened social interactions to theatrical performances.[1] If Goffman was right, then portrait photographs are the play-bills of our lives; expressions, both publicly and privately, of who we think we are, and how others view us. Whether a rock star or a poet, a farmer or a politician, knowingly or unwittingly each of us adopts a guise when we sit for a photograph. Photographers, for their part, are trained to tease out those traits that characterize and distinguish us, capturing those elements of style, biology or demeanour that set us apart from others. Consequently, every portrait photograph contains an aspect of role-play. This can be as simple as combing our hair and saying 'cheese' when the camera clicks, or as elaborate as creating a purpose-built world in which to be seen, complete with set, props and costume.

Roles define and constrain; they set social expectations and determine how others perceive us. Gender, ethnicity, age, body type, religious belief, disability, sexual orientation and socio-economic status are just a few of the roles we may choose, or may find ourselves in, each of which carries with it inference and prejudice, affirmation and judgment. Moreover, the quotidian roles we take on in family and professional life, on our own and at leisure, alternately shape and define us. Our actions and preferences define us, too: a hero or a liar, an optimist or a jerk. Or perhaps, even, all of these things.

Although we would like to believe there are certain innate qualities within each of us, in reality we are shaped by our biochemical makeup and the countless events, large and small, which we experience over time. Our identities shift from year to year and day to

Elina Brotherus
Der Wanderer 2, 2004, from the series
'The New Painting', 2000–4

Hippolyte Bayard
Self Portrait as a Drowned Man, 1840

day; in addition, we may appear as a certain kind of person to one individual, and someone else entirely to another. Our identities are like diamonds made of plasticine: faceted, yet amorphous, malleable yet resilient. The theorist Susan Sontag described the roles we perform in life as masks we put on – screens that obscure the true identity at our core. But the notion that identity is some sort of pure, steady essence separate and distinct from how we appear to others is strangely romantic. Our careers, our meaningful relationships and our interactions with strangers are not adornments that can be taken on and off at will. Roles envelop us. They *are* us. The best a portrait photographer can do is triangulate on an elusive centre that is forever changing and endlessly out of reach.

Narrative portraiture is a way of temporarily sidestepping expected roles, to force the viewer to see the sitter in new ways. Figurative pictures that reference religious, literary or historical themes have a long tradition in the history of art. Nor are they unique to photography: paintings in which recognizable figures pose in narrative compositions are known in Western art from at least the time of the Renaissance. Shortly after its founding in the seventeenth century, the Royal Academy of Painting and Sculpture in Paris endorsed a formal hierarchy of arts that listed at its pinnacle the 'grand manner', defined as arts with symbolic narrative designed to inspire personal improvement. Although in theory this might be interpreted to mean any picture with strong moral themes (and would eventually be applied within the portrait genre), the grand manner became closely associated with history paintings – frequently elaborate compositions illustrating brief narratives from sources such as the Bible, the Apocrypha, and Greco-Roman mythology and literature. In nineteenth-century Scandinavia and Germany, these historic sources would grow to include Norse and Teutonic myth; in England, it would come to encompass Arthurian legend, Milton's *Paradise Lost* and Shakespearean drama. In the contemporary arena, narrative subject matter has come to include everything from internet memes and passages from television and cinema to pastiches of famous works of art, such as Elina Brotherus's self-portrait reimagining of Caspar David Friedrich's *c.* 1818 masterpiece *Wanderer above the Sea of Fog* (see p. 181).

Role-play has been an integral part of photography since the medium's invention. In 1840, just one year after Louis Daguerre and William Henry Fox Talbot were separately credited with the invention of photography, another of its pioneers created his celebrated *Self Portrait as a Drowned Man* to protest unfair treatment by the French establishment (see left). Although the Academy of Sciences had received notice that Hippolyte Bayard had invented a direct-positive photographic process on paper at nearly the same time as Daguerre, the Academician François Arago, who happened to be an associate of Daguerre's, deceived Bayard by persuading him to postpone his claim while formally announcing Daguerre's invention to the Academy, with no mention of Bayard's alternative process. Bayard was devastated, and in response produced one of the most haunting self-portraits in photographic history. It portrayed Bayard as a victim of suicide, his body resting seated, naked from the waist up, a blanket for a shroud. On the back of the photograph, now in the collection of the Société Française de Photographie, Bayard famously inscribed:

The corpse which you see here is that of M. Bayard, inventor of the process that has just been shown to you, or the wonderful results of which you will soon see. As far as I know this indefatigable experimenter has been occupied for about three years with his discovery.

The Academy, the King, and all those who have seen his pictures admired them as you do at this very moment, although he himself considers them still imperfect. This has brought him much honour but not a single sou. The Government, which has supported Monsieur Daguerre more than necessary, declared itself unable to do anything for Monsieur Bayard, and the unhappy man has thrown himself into the water in despair! Oh human fickleness! For a long time artists, scientists and the press took an interest in him, but now that he has been lying in the morgue for days, no-one has recognized or claimed him!

Ladies and gentlemen, let's talk of something else so your sense of smell is not upset, for as you have probably noticed, the face and hands have already started to decompose.

H.B. 18 October 1840[2]

Although the image is not tied to a particular literary or historical reference – it bears some superficial resemblance to Jacques-Louis David's *Death of Marat* (1793) – Bayard has provided his own, detailed backstory. The viewer imagines the downcast Bayard hurtling himself off a bridge into the Seine, his lifeless body lifted from the flotsam by a mournful *gendarme*. From there, the dreary journey to the morgue in a wooden cart; the grim search for identification; the logging of the discovery into a ledger. All the while, the hapless inventor mouldering in place, his hands and face the first to decay, as evidenced by their darkened appearance. Bayard would later explain that the effect was unintentional; by coincidence his hands and face had been sunburnt, so they registered as darker in the picture.

As a portrait, Bayard's photograph is arguably more effective than any conventional head-and-shoulders portrait ever could have been. It highlights his achievement and disappointment, while portraying him as a sympathetic, if macabre, character. His head resting securely and with one hand gently clasping his wrist, Bayard is transformed into an angelic presence, the light of his body glowing insistently against the darkened background. Remarkably, Bayard signed the epitaph himself, making clear that he was not, in fact, dead, but at the same time granting himself the omniscience to see himself and his predicament from afar. Like an out-of-body experience, the picture allows Bayard to observe himself in the third person, lamenting his failures while at the same time demonstrating his virtuosity as a photographer – the very medium which was his supposed downfall.

Drowned Man hinted at conceptual possibilities that later photographers would fully embrace. In the 1850s and 1860s, in particular, a minor vogue developed for photographs of subjects posed in tableaux.[3] This paralleled a fashion for theatrical 'tableaux vivants', in which models enacted famous scenes from religious texts, literature and art history, complete with historically accurate costume and elaborate backdrops for the entertainment of a live audience. Viewers understood and accepted this sort of in-person transformation, but some blanched at photographs made the same way.

One of the most provocative of these photographers was the English pioneer William Lake Price, who produced carefully constructed photographic compositions in the 1850s depicting famous fictional characters as they might have appeared in life, such as Daniel Defoe's Robinson Crusoe. Price produced a sequence of four pictures of Crusoe, which he exhibited at the London Photographic Society in 1858. These photographs were not based on specific passages from the novel but synthesized from his imagination and details in the text. The four pictures show a progression as the adventurer gradually comes to grips with his situation, transforming from victim of a shipwreck to master of his own domain. In the most famous of these, Price showed Crusoe seated at a table, his foot propped on a block and tackle, attended by his native assistant Friday (see left). Numerous animals rest at their feet, including a goat and two kids, as well as Crusoe's trusty unnamed dog. A string of game is tied to the leg of the table, and a crab rests on a tray, while the rest of the scene is filled with nautical salvage, pottery and weapons. A verdant grape arbour surrounds the scene.

At first, viewers struggled to understand Price's photograph and others like it. Since photography excels at recording likeness, the figures in Price's photograph seemed to defy

Helmar Lerski
Junger Bettler (Young Beggar), c. 1930,
from the series 'Everyday Heads', 1928–31

logic. They clearly did not really depict Crusoe and Friday, since those were fictional characters from a book published nearly a century and a half earlier. Nor were they purely fictional renditions of the characters, in the way people were accustomed. Here were flesh and blood people, the identity of whom would be clear to anyone who knew them. Notwithstanding the carefully arranged scene and the costumes made of animal skins, this Crusoe was a pale-faced Victorian, his shaggy beard too tidy for a castaway, his hair brushed and his skin soapy clean. Consequently, the picture seemed to be stuck in conceptual limbo. Was it a portrait of the sitter as Crusoe, or a portrait of Crusoe as the sitter? Or perhaps the specific identity was irrelevant? Maybe Price conceived of Crusoe as a kind of English everyman, and the picture a sly social commentary on technology and possessions in the industrial age.

With the advent of cinema, narrative structure in photography took on added dimensions. Cinema's invention was intimately entwined with developments in still photography: increasingly rapid exposure times, combined with the invention of roll film on a flexible nitrocellulose base (a marked improvement over the wet-plate collodion emulsions employed by Victorian photographers), meant that for the first time amateurs could make photographs without specialist training. Previously, practitioners needed to know how to work in the darkroom, or at least had to pay skilled assistants to perform darkroom work for them. In fact, up until the invention of gelatin dry plates in the 1870s (George Eastman got his start making such plates), photographers also needed to be able to make their own wet-plate negatives on the spot, and use them before they dried. The new ready-to-use film was commercialized by various manufacturers at the turn of the twentieth century, most notably the Eastman Kodak Company, which released its first Kodak camera commercially in 1888. This alone would become a landmark in portrait history, since it enabled photographers to take up to one hundred exposures at a clip before returning the film, camera and all, to the company to be developed, printed and reloaded. A flood of photographs resulted, chronicling the lives of ordinary people.

Since motion-picture technologies depended on the same flexible film and fast emulsions that made the Kodak camera possible, it was not long after these vital components became available that motion-picture photography was invented. Like still photography, the invention of cinema was anticipated in the work of numerous experimenters, including several who might reasonably be credited with having invented processes of their own, including Eadweard Muybridge, Ottomar Anschütz, William K. L. Dickson (working for the Edison Company), Louis Le Prince and William Friese-Greene, to name the most prominent. The Lumière brothers were the first to screen films in a recognizably modern style, which they did in Paris, in 1895. By the early twentieth century, the silent film era was fully under way, and with it cinema's first major movement – Expressionism.

The term 'Expressionism' in cinema was borrowed from other art forms – painting, literature, and, perhaps most apposite, theatre. Expressionist works are usually characterized by a focus on individual experience and emotion, and a tendency towards symbolism and exaggerated effects. The movement was particularly important in Germany, where it gave rise to a generation of influential directors, such as Fritz Lang (*Metropolis*, 1927), F. W. Murnau (*Nosferatu*, 1922) and Robert Wiene (*The Cabinet of Dr Caligari*, 1920). Each used dramatic lighting and dark shadowy backgrounds, acute angles of view and intense facial expressions to tell angst-ridden stories. Their work would have a lasting effect on the filmmakers who would follow, including Ingmar Bergman and Alfred Hitchcock, towering influences in their own right.

Although Expressionism did not exist as a coherent movement in still photography, its effects were nevertheless extensive. The portraitist Helmar Lerski was among those who absorbed its lessons to create a new form of portraiture based on Expressionist cinema. Born in Alsace and working in Switzerland, the United States and British Palestine, Lerski was a special effects advisor on *Metropolis* under Lang. Lerski's own photographs show a parallel sensibility: close-cropped, shot from below, with bright directed light (sometimes achieved with mirrors) on oiled skin, Lerski's subjects are simultaneously present and absent (see above left). The psychological intimacy and penetrating gaze conjured by Lerski create an unavoidable, almost confrontational presence,

while the intense artificial lighting and the otherworldly texture of skin and hair render them unreal. Lerski's figures look like actors in an unnamed Expressionist film. Narratives are suggested but never resolved; instead, Lerski's portraits become isolated frames of mysterious cinematic stories, trapped heroically in time.

Fragmented and incomplete narratives have become an integral part of the vocabulary of contemporary photography, suggesting stories but never explaining or completing them. Raymonde April's portrait, *Adrienne*, for example, shows a girl leaning against a door in the hallway of an apartment building, eavesdropping on some unknown sound or conversation (see below). Whether the scene was set up by the artist and sitter or observed without direction is left ambiguous, as is the nature of the situation. Under these circumstances, the gesture of the girl's left arm, held upwards in an 'L' as if about to flee, becomes especially significant. Is she hearing something she is not supposed to? And, if so, is it something trivial or important? As viewers we are unsure whether the picture is grave or lighthearted, playful or intense. This in turn leaves the viewer uncertain about the circumstances of the girl's life, or how as viewers we are meant to think about her. It becomes a portrait of her in the present, and potentially the future. As

viewers, we are invited to contemplate different outcomes.

Such portraits employ photography's central paradox – its ability to show exactly how things look at a particular moment, while at the same time offering no more than a brief, finite window. The 'pictus interruptus' of a narrative begun but never completed can be more affecting than a portrait with a clear message. Incomplete narratives invite us in, but ask us to complete the story. Still photographs have an intractable temporal determinacy that is at once thrilling and frustrating. Popular cinema, by contrast, usually has a clear 'before' and 'after'. Still photographers have learned to exploit this language, provoking thought but offering no easy outcomes.

Sarah Dobai
Mike, 1997

Opposite **Tom Hunter**
Woman Reading a Possession Order, 1997,
from the series 'Persons Unknown', 1997

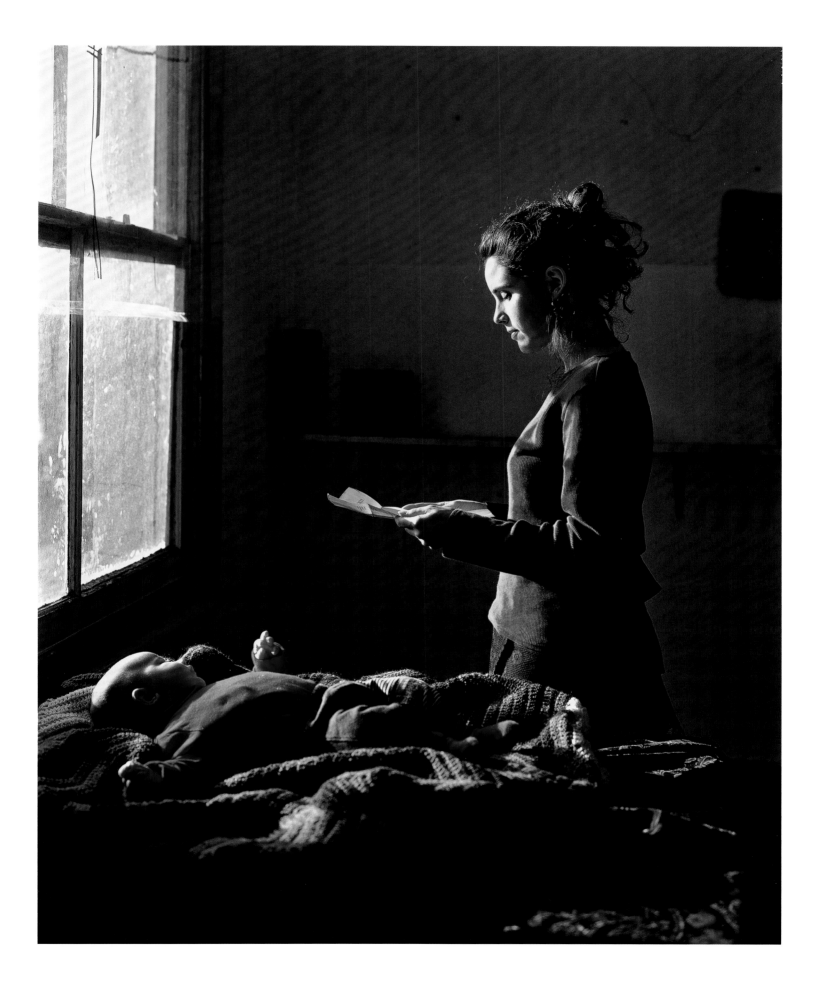

Tseng Kwong Chi

Self Portrait, Cape Canaveral, Florida, 1985,
from the self-portrait series 'East Meets West',
1979–89

Self-portraiture has been a vital part of photographic practice throughout the medium's history, but it was not until the late 1970s that the Hong Kong-born photographer Tseng Kwong Chi began his most famous body of work, 'East Meets West', a series of travel portraits directly anticipating the rise of selfies decades later. Dressed as a Chinese Communist Party apparatchik, Tseng posed at landmarks around the world, pretending to be a visiting dignitary.

The incongruity of his appearance at popular locations such as Cape Canaveral highlighted the disparate expectations of Chinese and American citizens at the time. The freedom of movement promised by the thaw in relations between the United States and China that had begun during the Nixon administration had not yet materialized, and few but the most privileged Chinese nationals could travel for sightseeing, especially by themselves.

Tseng's photographs are part political performance, part mischievous send-up of tourist photography. Yet it is the loneliness of the figure that endures; the poignant sense that the traveller should be enjoying himself but is instead engaged in some sort of soulless, programmed exercise. Tseng's Mao-suited tourist comes across as a sympathetic, even heroic, figure.

Samuel Fosso
Self-Portrait (Angela Davis), 2008,
from the series 'African Spirits', 2008

Bill Henson

Untitled 2000-01

A teenage girl casts her eyes downwards in contemplation, raking light gently caressing her face, while suburban streetlamps glow like jewels in the background. To her, her situation is emotional and serious. As viewers we do not know her story, yet we admit ourselves to her world, where the anguish of love and loss mix freely with the electricity of newness and discovery. Bill Henson's teen subjects travel by night, negotiating the liminal space of darkness even as they emerge, cocoon-like, from child to adult. Operatic in their intensity, they are curiously weightless, unfettered; seekers not yet beset by the deeper cares of adulthood.

Henson's teen portraits explore adolescence as a window in time, when feelings are raw and uncorrupted. The inky landscape is sensual and enveloping, a physical complement to the psychological state of the figures. Though evocative of cinema, the images also call to mind the deep chiaroscuro and expressive intensity of Baroque painting. Ultimately, they are not so much portraits of individuals so much as they are meditations on the human condition; portraits of us all, at a time of growth and change.

Above **Alex Prager**
Marilyn, 2010, from the series 'The Long
Weekend', 2010

Right **Tania Franco Klein**
Plane (self-portrait), 2018, from the series
'Proceed to the Route', 2018–ongoing

Below **Yang Fudong**
International Hotel 6, 2010

Opposite **Stan Douglas**
Malabar People: Dancer, 1951, 2011

Sunil Gupta
Untitled #3, 1988, from the series
'"Pretended" Family Relationships', 1988

First out of sleep,
Don't go, you say;
I know, I

echo into morning

THIS PHOTOGRAPH IS MY PROOF

This photograph is my proof. There was that afternoon, when things were still good between us, and she embraced me, and we were so happy. It had happened. She did love me. Look, see for yourself!

Duane Michals
This Photograph is My Proof, 1967–74

Sarah Jones
The Dining Room (Francis Place) I, 1997

It is tempting when looking at one of Sarah Jones's photographs to weave narratives around the details – the prominent form of a blue and white ceramic soup tureen, the regular arrangement of clock, bottle, candle and plates, or the playful asymmetry of the figures, their position balanced against a lacquered sideboard. A patrician figure presides over the scene from above the fireplace, painted dimly on canvas, and bracketed by two framed prints of a foxhunt. Yet it is the exquisite fact of things that prevails in Jones's Francis Place portraits, the elevation of the inconsequential in a meticulously crafted

scene. Shadows projected on the wall by studio lights, reflections on a polished table, the sumptuous modulations of the blue wall: these acutely observed details, resolutely photographic, provide breath and resonance – an expertly wrought stage, rather than a performance.

Only the standing figure engages the camera directly, betraying no emotion; she may be eyeing the photographer with familiar disinterest, or ennui. The girls are positioned like pieces in a puzzle, each inhabiting their own vignette of space, distinct from the others. At right, a girl wearing a blue jacket props her

head up with one arm, looking across the table, the object of her regard unclear. Meanwhile, a third girl lowers her head in her hands in fatigue or exasperation, her hair cascading down to meet its own reflection. The relentless fixity of Jones's picture, and its stubborn unwillingness to allow the viewer beneath the surface, is a reminder of what photography does well, and what it refuses to do.

Lise Sarfati
Sloane # 34, Oakland, CA, 2003, from the series
'The New Life', 2003

Todd Hido

#10473-b, 2011, from the series 'Excerpts from Silver Meadows', 1995–2012

The idea that a photograph should be self-contained – telling a story on its own, without explanation or context – is based on historical conventions in painting. Beginning in the 1970s, artists began to experiment with other forms of expression based on popular commercial photography such as drugstore prints, Polaroid and point-and-shoot cameras, travel snapshots, yearbooks and home movies. These influences, combined with the enduring allure of cinema, introduced a new vocabulary into art photography, in which fragmentary, incomplete imagery, uncanny colour palettes, seemingly spontaneous points of view, and soft focus were embraced

as authentic representations of contemporary experience. This, in turn, resulted in a growing interest in visual syntax as a way of understanding pictures – how the pictures that appear before and after a picture in sequence can shape meaning. Photo books and exhibitions provide opportunities for artists to shape understanding based on this kind of controlled encounter.

In 2013, Todd Hido published *Excerpts from Silver Meadows*, a semi-autobiographical, semi-fictional account of his childhood growing up in Kent, Ohio. The project combined suburban landscapes and interiors photographed by Hido with found imagery, personal photographs of

friends and family, and staged portraits of women. Hido's favoured model Khrystyna, shown here, performs in various roles. In *#10473-b* she appears as if from another time in a vintage green jacket, diaphanous scarf and pearls; her brooding stare, shot from slightly below, commands the viewer's attention. Her relationship to the artist is unclear. She could be a girlfriend, a mother, a stranger, or a manifestation of Hido's desires and insecurities – a hallucination, or a flash of memory.

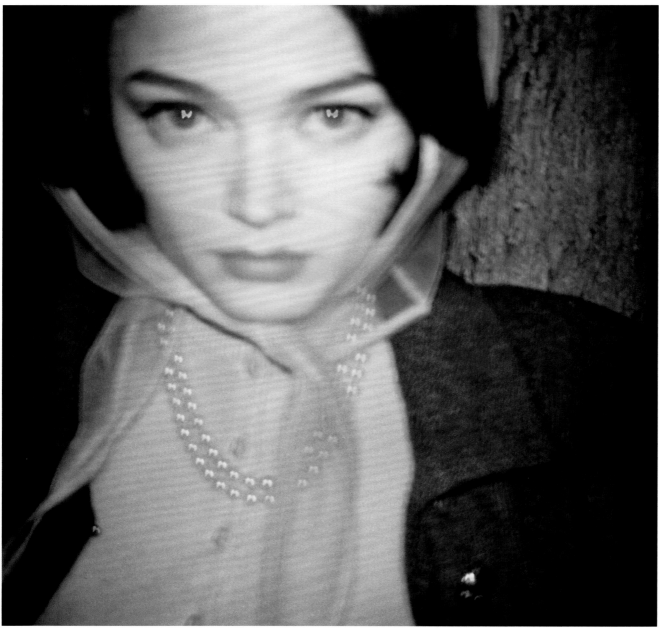

Mark Neven DuMont
Patricia, c. 1930

Cindy Sherman
Untitled Film Still #10, 1978

A torn bag of groceries at her feet, Cindy Sherman scowls at an unseen presence, a carton of eggs clutched in one hand. Like all of the seventy self-portraits in the celebrated 'Film Stills', the picture appears without explanation or context, as though torn from a narrative with no beginning, middle or end. Nevertheless, stereotypical notions of women's identity quickly become apparent: the loving housewife, naïve innocent, seductress, or working girl. B-movies and film noir traded on such well-worn tropes – uni-dimensional expressions of feminine agency. Sherman responded in kind, appropriating not just the style of commercial film stills, but their vocabulary too.

As a critique of popular portrayals of women, the Film Stills are scathingly effective. However, it is the way they reflect Sherman's own identity that makes them so enduringly magnetic. While the situations depicted may be remote from Sherman's actual experience, in adopting the personas of seventy problematic characters, she assumes their shortcomings, abilities and predicaments. Seen this way, the Film Stills are more than just a challenge to Hollywood and its biases, but a complex and nuanced exploration of potentialities; aspects of Sherman's character to be understood, examined and marshalled. By staging the scenes herself, she took charge of the multifarious situations in which women find themselves. The stories may be familiar, but the artist owns them.

Grete Stern
Sueño n.28, Amor sin Ilusión [Dream no.28,
Love without Illusion], *c.* 1951

Sally Mann
Emmett, Jessie and Virginia, 1989

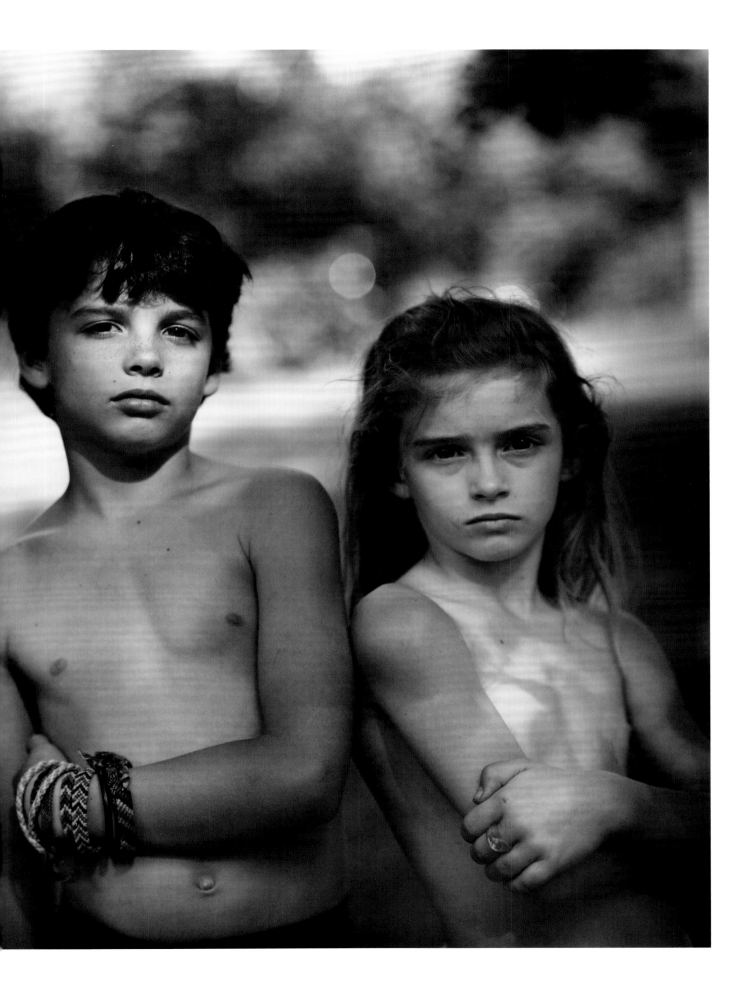

Vasantha Yogananthan
Enjoy Today, Tomorrow May Never Come,
Sonepur Odisha, India, 2017, from the book
Dandaka, 2018

Jeff Wall
Young man wet with rain, 2011

8 Social Circles

From Family Albums to Street Portraiture

Far from the art capitals of Western Europe, Asia and the Americas – some 500 miles east of Moscow – villagers in rural Tatarstan have attracted the attention of scholars for the unusual way they use family photographs. In these communities, pictures are assembled into folios and albums, lovingly wrapped in cloth and stored, shrine-like, in boxes or wooden chests (see p. 208). There they remain, hidden away until special occasions, when they are taken out by elders and viewed with ceremonial care. Since they are rarely seen, it is the presence of these pictures in the home, more than what they depict, that gives them meaning. Tattered and faded, they verify the network of relationships, through blood and marriage, on which the family is built.[1] Like family albums elsewhere, Tatar albums contain stories about the family and its history. Yet in these communities they have taken on another dimension – a devotional, almost mythical aspect. Their mere existence is evidence of the legitimacy, continuity and renewal of the family unit.

The example of Tatar family albums suggests ways of looking at photographs beyond the usual considerations of visual and historic meaning. An anthropologist might think of them as cultural currency; communal glue that can be shared and exchanged to cement or define relationships. Every portrait represents an encounter in which social connections may be established, altered or clarified. By design or by accident, they place maker, subject and viewer in context, locating them in a social web. Some are intimate and knowing, as with a portrait of a friend or loved one. Others are distant and undetermined, as in a picture of an anonymous person on the street, or the victims of a news event.

While Tatar albums may represent an extreme, many families will recognize aspects of Tatar customs in their own practices. Most family albums live in cupboards or closets, only to be taken out on holidays or when relatives come over. Their keepers are usually, but not always, older members of the family who have enough knowledge of family lore to identify the people they show and explain the relationships between them. While they may not have the same precious quality as Tatar albums, family albums worldwide chronicle family histories, and serve as reminders of key events and anecdotes.

Mari Katayama
shell, 2016

Photo albums have existed since at least the late 1860s, when expensive first-generation processes like daguerrotype gave way to alternatives within reach of middle-class families, including the pocket-sized albumen carte-de-visite (literally, 'visiting card') format, and the ambrotype (wet-plate collodion emulsion on glass). In the United States, this same democratizing spirit led to a vogue for tintype portraiture – collodion on thin sheets of lacquered metal – which thrived during the Civil War and Reconstruction (1860s–80s). Lightweight, portable and cheap to make, tintypes enabled soldiers to carry portraits of their loved ones into battle, where they were both talismans and companions. Like albumen prints mounted on card, they could also be inserted into albums, many of which were designed with pre-cut slots to enable pictures to be easily slid in and out of their pages.

With the commercialization of the Kodak camera in 1887, ordinary people were suddenly able to photograph themselves without hiring a professional photographer, making family photographs more intimate and abundant. Just as Polaroid and drugstore prints from colour negatives (colour coupler, or Kodak Type-C prints) came to replace earlier technologies, so too did vinyl, polyester and 'magnetic' sticky-page albums supplant previous designs.

Although the concept of the family album survives in the twenty-first century, it is rapidly being replaced by digital forms. Web-based software and apps that enable photographs to be sorted into virtual albums, combined with sharing platforms including social media, have rendered physical albums increasingly obsolete. Few societies are immune: even in Tatarstan, younger generations are gradually abandoning historical practice in favour of digital alternatives. Concerned that local communities may be losing touch with their family histories, researchers at Kazan Federal University and the State Museum of Fine Arts have organized workshops to encourage engagement with family photographs, as a means to preserve the region's unique culture.[2]

It is widely accepted that photographs contain memories – a truism reinforced by generations of industry-led marketing campaigns. In reality, the relationship between the flat, fixed, rectangular view afforded by a photograph and the imperfect, personal and ever-shifting perception of the past, created and maintained in our minds, is unsteady at best. Memory is a dimension of consciousness, whereas photographs are artefacts, the truth and substance of which may or may not be immediately apparent to the viewer. Human memories are immersive and particular to the person who holds them; they may also contain elements of sound, smell, touch and taste, and are imprinted with the holder's thoughts and feelings. As in Akira Kurosawa's famous *Rashomon*, no two memories are alike, even of the same events. Details remembered by one person may be forgotten by another, escape attention, or occur beyond the reach of their senses. In addition, since memories are rationalized, revisited and reinterpreted, over time they may become corrupted, or simply forgotten.

These principles apply equally to all photographs in the social sphere, from traditional family albums to Instagram feeds. Photographs have fixity, but the meanings we attach to them are fluid. Because the camera mimics the way the eye sees, it is easy to mistake photographs for stand-ins of real-life events. But they are not memories. Rather, they are mnemonics; prompts to enable us to recall people, places and things, or to map our own memories to the experience of others. While the content of any given photograph is more or less unchanging, what it means to the viewer is slippery and subjective. The share and exchange of photographs enables us to seek common ground

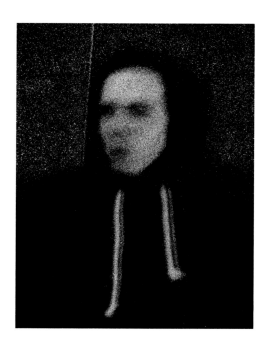

Trent Parke
*No. 178 Candid Portrait of a Man on a
Street Corner, Adelaide*, 2013, from the
series 'The Camera is God', 2013

with our fellow humans and explore differences, even though the way we see, think and feel about pictures is indefinable, mutable and complex. Humans do not just see with their eyes, they perceive with their brains. The camera has no such ability.

In the 1920s, the pioneering sociologist Ernest Burgess proposed a way of analysing societies based on concentric circular zones.[3] In his *Introduction to the Science of Sociology*, he argued that social interactions could be organized according to the closeness of the relationship to the individual. The innermost circle, he explained, was reserved for personal relationships. The next ring was political: areas of formal social control such as laws, social customs, and employment. The outermost ring Burgess reserved for commerce, since the buying and selling of things requires little interpersonal intimacy. He concluded:

> The individual's self consciousness—his conception of his rôle in society, his 'self', in short—while not identical with his personality is an essential element in it. The individual's conception of himself, however, is based on his status in the social group or groups of which he is a member. The individual whose conception of himself does not conform to his status is an isolated individual. The completely isolated individual, whose conception of himself is in no sense an adequate reflection of his status, is probably insane.[4]

If we think of portrait photographs in simple concentric terms, we can organize them based on the strength of the relationship to the maker. In the innermost ring we might place self-portraiture – intimate examinations of personal identity. Further out sit family photographs – pictures of those closest and dearest to us. Photographs of friends and acquaintances inhabit another ring, while studio portraits and commissions lie further out. Further still are photographs made in familiar locales, or of people whose roles are well known to us. In this group we might include pictures made according to certain themes or categories – bodybuilders, grandmothers, prisoners, or Europeans, for example. In the outermost ring are perfect strangers – individuals whose biographies are all but unknown to the photographer. Here we might include reportage,

in which the maker may still portray the sitter with compassion and insight, but with no direct personal relationship.

Viewed this way, portrait photographs form a continuum of intimacy from self to stranger. Self-portraits such as Mari Katayama's *shell* are by nature introspective (see p. 207).[5] Born with severe congenital abnormalities, Katayama opted to have her left leg and right foot amputated at age nine. In the picture, with her prosthetic aids lying before her, she is surrounded by objects she has sewn herself, which she incorporates into installations. The artist describes these objects – resembling mannequins, toys and human body parts – as tools for communication. Meticulously arranged seashells rest on the floor, while specimen jars sit on shelves behind her, alongside upside-down packets of Haribo candy. Stocking-like material stuffed with what appear to be curls of hair festoon the scene, while long strands of unwrapped hair form curtains behind her. Katayama herself, her face strikingly made up and her body clad in lingerie, glares at the viewer. She holds a cable release conspicuously in her hand, leaving unclear whether she is photographing the viewer, herself, or both.

At the other end of the intimacy spectrum, Trent Parke's 'Candid Portraits' provide such sparing detail that the subjects are reduced to patterns of light and dark. In *No. 178 Candid Portrait of a Man on a Street Corner, Adelaide*, for example, little can be gleaned of the subject's appearance (see above left). The figure's head and upper torso are visible, yet the picture is so grainy that his facial features and expression are totally clouded. Instead, his head hovers ghost-like in a dark hoodie, an apparition made barely human by two pull cords dangling unevenly below his neck. Through Parke's lens he becomes a Grim Reaper of anonymity; a presence manifested below conscious vision. By excising nearly all expected information in the portrait, Parke confronts the viewer with their own prejudices. Is an anonymous figure in a hoodie a criminal – a figure to be feared – or, just as likely, a student on a field trip? Moreover, what is it about a conventional, detailed portrait that makes us think we know any more about the individual than what we might surmise from Parke's minimalist ones?

Parke's photograph challenges the notion of the 'social documentary', the meaning of which has a long and fraught history in

Chauncey Hare
Standard Oil Company of California, 1976–77

countries, from Afghanistan to Chile. Comprised of 503 photographs in its fullest version, the exhibition represented an alternative to factionalism and conflict – a shared vision of the best in humanity. Produced in the wake of the Korean War (notably the exhibition was not shown in China), it was conceived as a utopian 'family album' of the world and its people, designed to develop bonds between disparate populations, in much the same way a home family album might.

Appreciation and understanding of postwar humanist photography has changed markedly over time: the Vietnam War, in particular, made 'The Family of Man' seem hopelessly naïve for many viewers. However, the movement did give rise to picture agencies and cooperatives such as Magnum, which have continued to explore and redefine what social documentary photography can be (Trent Parke, for example, is a member). Moreover, the absorption of street photography and reportage into the fine art canon and marketplace marked an important conceptual shift. Charged with emotional content and striving for understanding, the best of this work is portraiture in the truest sense – not just pictures of people, but explorations of identity and the human condition.

Photographers such as Chauncey Hare would return to these ideas in an effort to examine the social construct itself. His *Standard Oil Company of California*, for example, shows an office worker sitting at his desk, the refinery he works for a distant vision out of the window (see above left). The fruit of his labour – sustaining the factory – is not his daily reality. Rather, he is surrounded by paperwork, coffee cup at hand, and a telephone ready to call him to action. His neatly pressed short-sleeve shirt, tightly wound tie and stylish moustache bely his role; he is divorced not only from oil production itself but also from its inevitable consequences – air and water pollution. It is a portrait of a man who is hermetically sealed from the fruits of his labour, yet has carved out a fundamentally human space for himself.

For Stephen Shore, the stakes of human interaction extend to the process of photographing itself. His *Clovis, New Mexico, June 1972* portrays two nametag-bearing conventioneers caught in the ungainly flash of an instant camera, one smiling wide for the camera, the

photography. The term itself is controversial, since by definition to document something is to merely record it, while the goal of the social documentary is to draw attention to social ills with a view to improve, understand or call attention to them. Although many nineteenth- and early twentieth-century photographers used the medium to advocate for social change – among them John Thomson, Jacob Riis, Lewis Hine, and the photographers of the American Farm Security Administration – the term did not come into its own until after the Second World War, with the rise of the so-called Humanist School, particularly in France. Photographers such as Henri Cartier-Bresson, André Kertész, Robert Capa and Chim (see p. 238) pursued an intentionally affirmative style of reportage, distributed largely through picture magazines, aimed at soothing the profound trauma of the war and preventing its recurrence by celebrating commonalities between peoples.

Although the social documentary tradition remains robust and has many adherents, the humanist movement arguably reached a high water mark in 1955, with the presentation of 'The Family of Man' exhibition at the Museum of Modern Art (MoMA) in New York. Organized by photographer, and later MoMA curator, Edward Steichen, it was one of the most successful photographic exhibitions of all time, presented at dozens of venues in the late 1950s and early 1960s and in thirty-seven

Stephen Shore
Clovis, New Mexico, June 1972, from the series
'American Surfaces', 1972–73

other with a neutral expression (see below). Brown and blue suits match the wallpaper behind them, while the harsh light creates deep, unnerving shadows. The brown-suited man wears a blue-grey cowboy hat that seems more befitting of his neighbour. What can such a picture tell us about these men? What can we infer about their personalities, their circumstances, their likes and dislikes? Produced in the manner of a snapshot, it challenges the viewer to confront the limits of meaning in such a picture. In fact, it tells us a great deal, or at least it pretends to.

Ultimately, all portrait photography is social. It may bind us together or drive us apart; it inspires and motivates us, informs and agitates. Portraiture can be used for social advocacy or criticism, as propaganda or to build understanding. Its meaning may be obvious, or its messages obscure. Steichen was undoubtedly right: portrait photographs are our collective family album. Except it was not just the 503 pictures in 'The Family of Man' that define us, but everything: the whole enterprise of portrait photography, the infinity of messages it can convey, and the way we interact with it, reveals our true essence. Like all art, portraiture has many different and sometimes overlapping purposes. Arguably the most noble, powerful and enduring is also the simplest. It heals, comforts and strengthens, by reminding us we are not alone.

Igor Snegirev
Yuri Gagarin, April 1961

Lê Minh Truong

Viet Cong Fighter Wearing a Khăn Rằn,
Ho Chi Minh Trail, 1973–74

Standing in a jungle landscape, her left hand holding the stock of a Kalashnikov strung from a tree and pointed towards her head, a young Vietnamese woman turned guerrilla fighter is shown in the immediate aftermath of the Vietnam War. She wears a North Vietnamese *Khăn Rằn*, or battle scarf, used by rural combatants in place of a full uniform. Alongside these two conspicuous reminders of violence, the picture reveals the innocence, even sweetness of the woman, as her eyes avert the camera with shy determination, her right

hand clutching absently at her scarf. She is resilient, sympathetic, and robbed of innocence, her situation a microcosm of the experience that she, her compatriots and her country have endured.

When hostilities ceased, North Vietnamese photographer Lê Minh Truong travelled the length of the Ho Chi Minh trail, the American-led supply route that transported food, soldiers and weapons into battle, and itself the location of some of the fiercest fighting during the War. Along the way he produced a private album of

landscape and portrait photographs, including this one, interspersed with poetry and notes on the people and places he found. Mournful and reflective, this extraordinary album, now in the collection of the Peabody Essex Museum in Massachusetts, is a powerful meditation on war and its aftermath.

Lee Friedlander
Cray at Chippewa Falls, Wisconsin, 1986

Pamela Singh
Treasure Map 015, 2015

Gabriele and Helmut Nothhelfer
Junges Paar im Zoologischen Garten, Berlin 1977
[Young Couple at the Zoo, Berlin 1977]

John Divola
San Fernando Valley #5 / DSCN0678, 1971–73

Los Angeles's San Fernando Valley, situated just north of the Los Angeles Basin and separated from the rest of the city by a ring of mountains, is a seemingly endless network of roads, suburbs and sprawling developments. This largely artificial environment was home to John Divola, who came to know its quirks and idiosyncrasies intimately. Still in his early twenties and freshly graduated from California State University Northridge (itself in San Fernando), he produced several series of photographs exploring aspects of daily life in the valley. Among these were pictures of suburban houses and carports, homeowners watering their lawns, and people shopping in supermarkets.

While playful, the supermarket portraits have a serious subtext, questioning the limits of individuality in the face of commercialism. In this image, a middle-aged woman is caught seemingly unaware by Divola's handheld camera and flash in the canned food aisle of a Safeway supermarket. Her hair is permed and set, and the glare of her thick, stylized eyeglasses partially obscures her eyes. With her empty shopping cart and handbag at the ready, she is surrounded by a cacophony of packaging and advertisements. Rods of fluorescent light glow on the ceiling, spreading like rays from an invisible sun. Row upon row of indecipherable tins await under signs promising gourmet foods and pork & beans, while dozens of paper 'discount prices' flags and a bundle of shoe forms adorn the shelves. Dimly visible behind the first woman is another, peering over her shoulder, her own shiny black bag echoing the first. The shoppers might be seen as wondrous figures, negotiating the complexities of American capitalism, or prisoners, trapped in a manufactured and dehumanizing environment.

Mike Mandel
Untitled, 1974, from the series 'Boardwalk
Minus Forty', 1973–83

William Eggleston
Untitled (Devoe Money in Jackson, Mississippi),
c. 1970

A distant relative on William Eggleston's father's side, Devoe Money is shown here on a glider, a piece of outdoor furniture that slides back and forth on rails, like a rocking chair. The contrast between the vibrant colours of Money's dress and the riotous pattern of flowers on the seat cushion commands attention, temporarily distracting from the decrepit setting: the seat itself is rusty, crudely overpainted, and has exposed springs; the trellis, covered in blistered paint and with a broken slat, has collapsed backwards; and the ground is covered with the detritus, including a crumpled wrapper, unswept leaves and locust pods. Nevertheless, the seemingly indefatigable sitter sits elegantly, legs drawn together and toes pointed, a cigarette held between gracefully extended fingers.

Eggleston rose to prominence with his controversial exhibition at New York's Museum of Modern Art, 'Photographs by William Eggleston', in 1976, and its accompanying publication, *William Eggleston's Guide*. At the time, critics struggled to accept colour photographs as a fine art, even when exquisitely printed using the dye-transfer process, as this one was. In retrospect, it may not have been colour so much as the prosaic subject matter of Eggleston's work, featuring friends, family and places near his home in Memphis, that viewers found jarring. Pictures like this one resemble scenes from a complex narrative; however, the artist did not intend them to tell stories and presented them without explanation. Instead, they are meant to relay moments of intuitive realization – sensory experiences occurring below, and deeper than, rational thought.

Ketaki Sheth
Munira awaits her marriage ceremony,
Jamnagar, 2008, from the book *A Certain Grace:*
The Sidi – Indians of African Descent, 2013

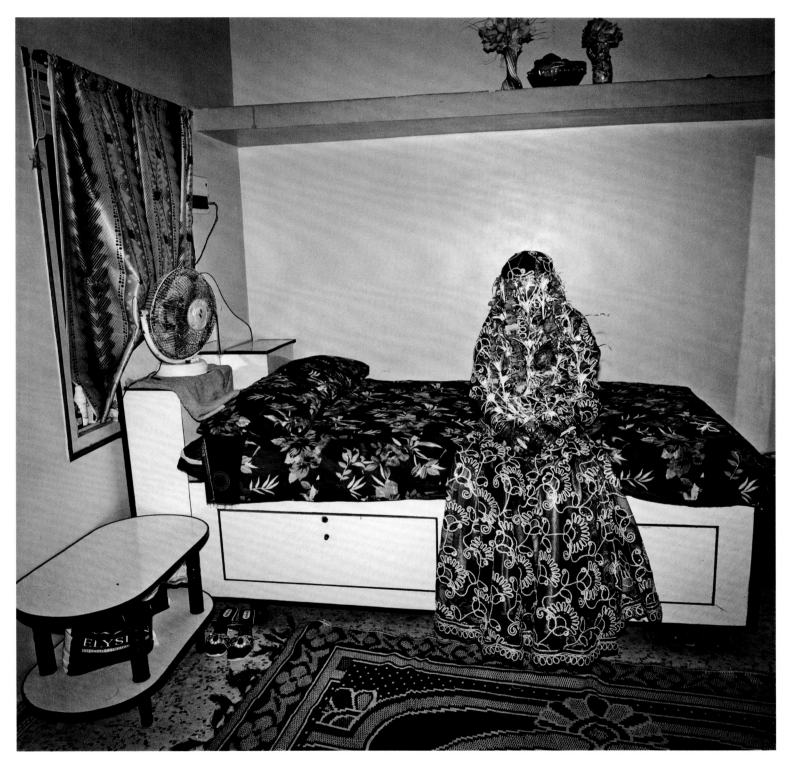

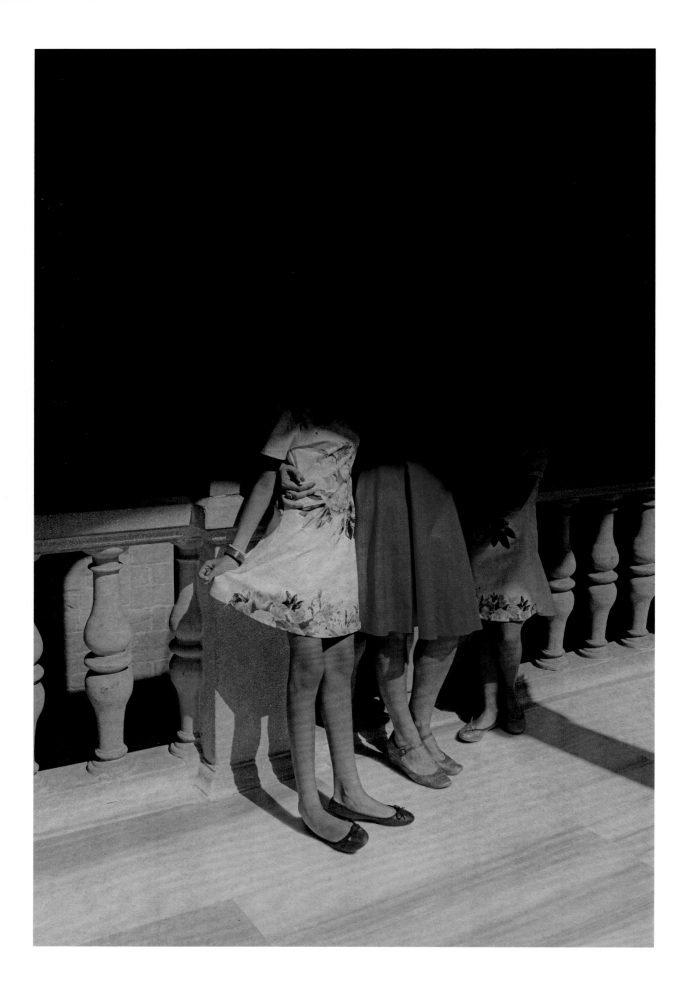

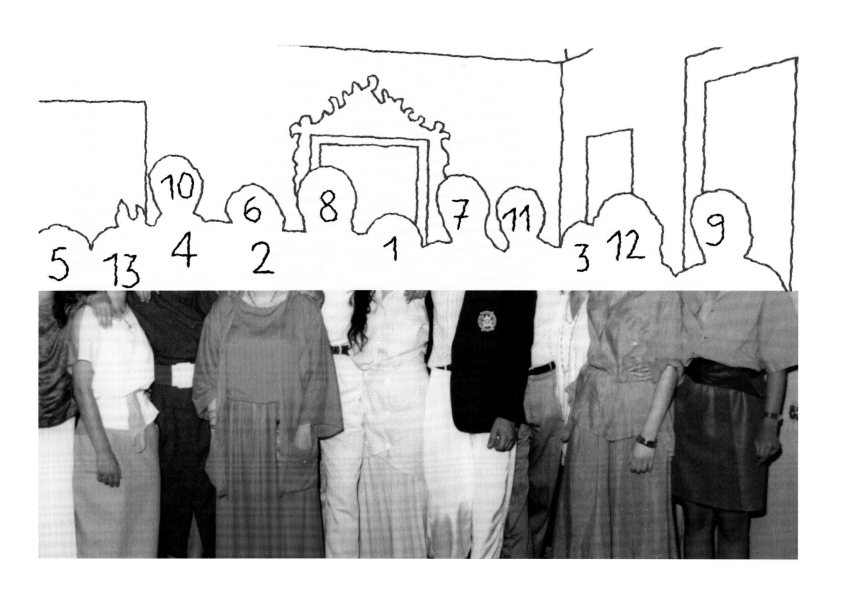

Above **Carolle Benitah**
Group Photo, 2012, from the series 'Photos Souvenirs' (Adolescence)

Opposite **Albarrán Cabrera**
#146, 2020, from the series 'This Is You Here', 2014—ongoing

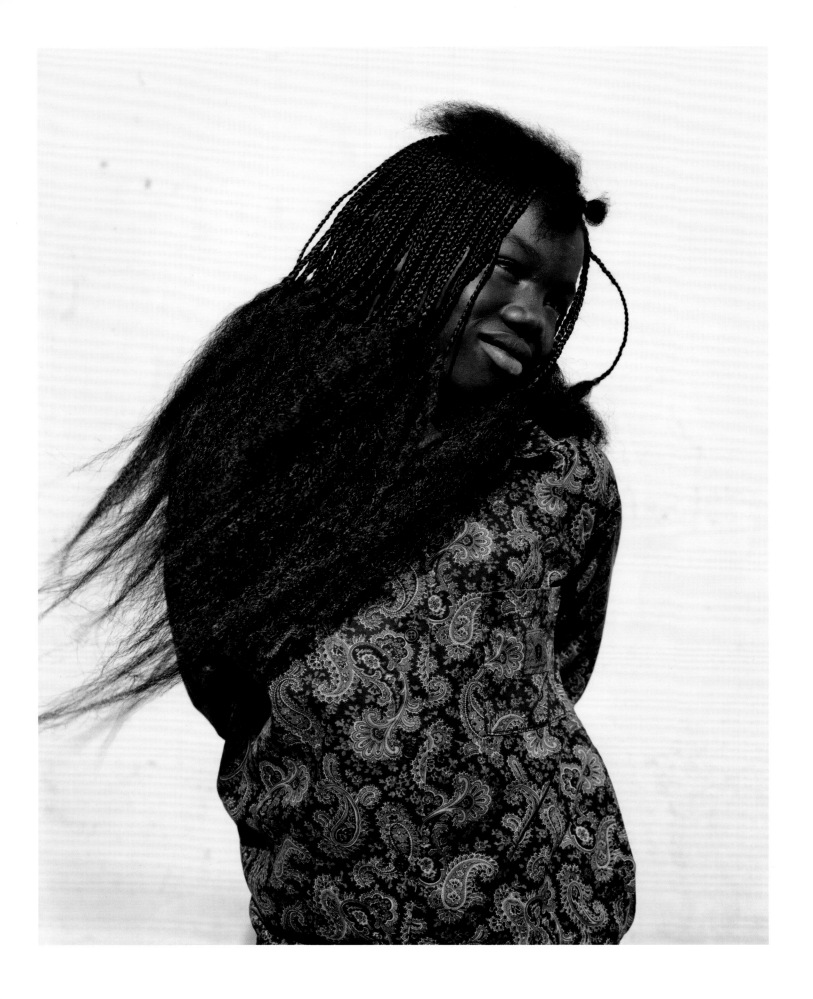

Opposite **Dana Lixenberg**
Wilteysha, 1993, from the project 'Imperial
Courts', 1993–2015

Below **Kirill Golovchenko**
Juggler, 2010, from the series 'Bitter Honeydew',
2009–15

Nicholas Nixon
Taunton Avenue, Hyde Park, Massachusetts, 1979

Marian 'Clover' Hooper Adams

Del and Helen Hay, 1883

Diane Arbus

Identical twins, Roselle, N.J. 1966

Roselle, New Jersey is a working-class enclave across the sound from Staten Island, New York; Diane Arbus is said to have spotted the sisters depicted here at a Christmas party for twins. The 'Sunday best' attire adds to the enigmatic quality of this famous picture, as the girls wear matching corduroy dresses with wide star-like collars, broad headbands, and similar, but not-quite-the-same stockings.

The picture is often interpreted as an exploration of difference and sameness, and close scrutiny does reveal many subtle distinctions between the girls, especially their facial expressions – one comparatively neutral, and the other gently smiling. The clever graphic composition adds to the feeling of discontinuity, as the square format of Arbus's 6×6 cm Rolleiflex camera provides a box-like stability to the picture, partially undermined by the diagonal line where the floor meets the wall, and the positioning of the girls slightly off centre.

Such formal qualities captivate the eye, but it is the sensitivity of the portrayal that makes the picture sing. In the 1960s, Arbus was drawn to photograph people whom mainstream society considered outsiders – circus performers, nudists, transvestites and eccentrics, for example. Although her *Identical twins* are not outsiders in this sense, the picture reveals the same humane, empathetic, and at times alienated vision that informed her practice during this time. The photographer and the two girls are both observer and observed, engaged in an act of mutual self-reflection. Though genetically linked, the distinct personalities of the twins reveal an imperfect equivalence – between them, and within ourselves.

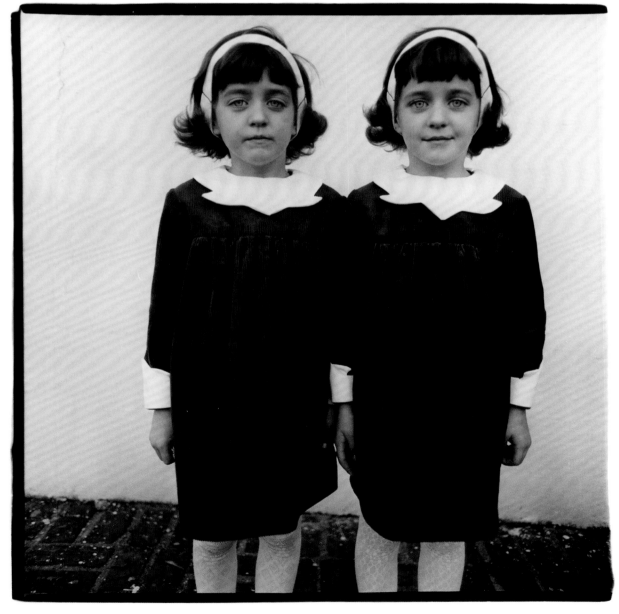

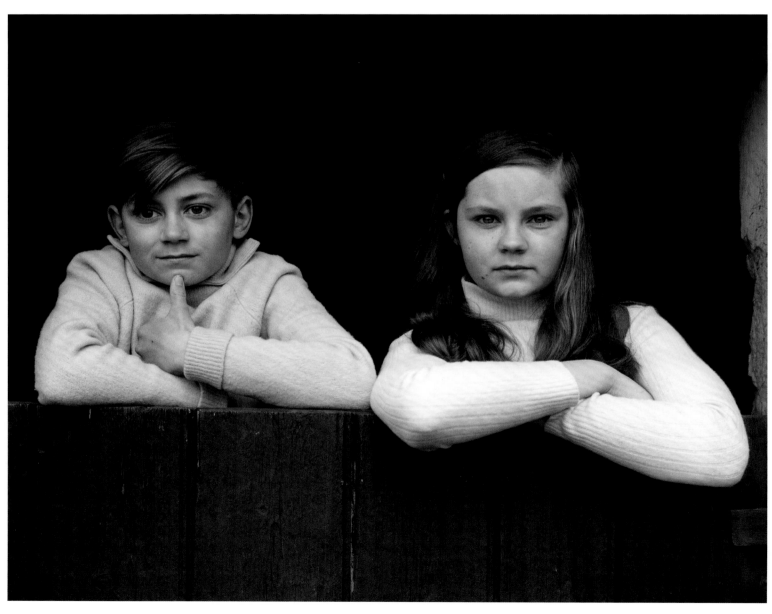

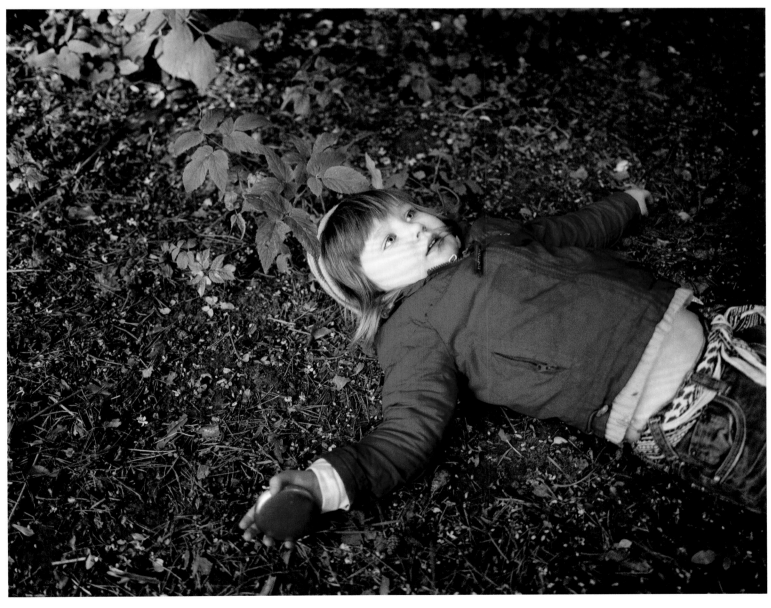

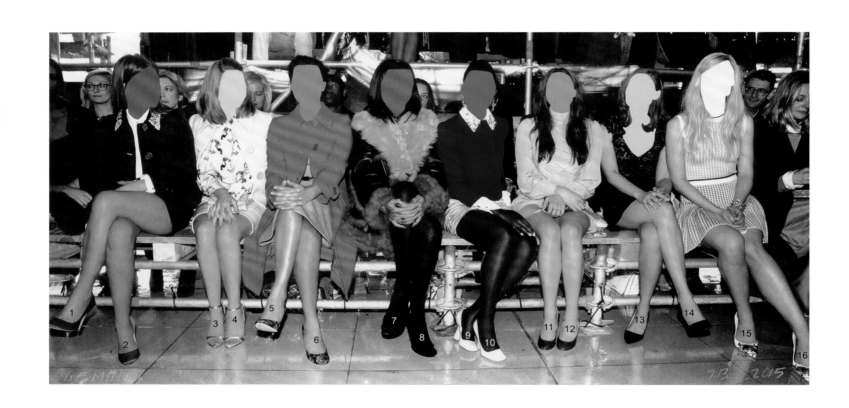

John Baldessari
Numbered Legs, 2015, from the series
'Front Row', 2015

Tazio Secchiaroli
Roma, 1958, Anthony Steel goes against photographers

Tazio Secchiaroli
Roma, 1958, Anthony Steel and Anita Ekberg run away from photographers

Enrique Metinides
Lovers, Chapultepec Park, Mexico City, 1995

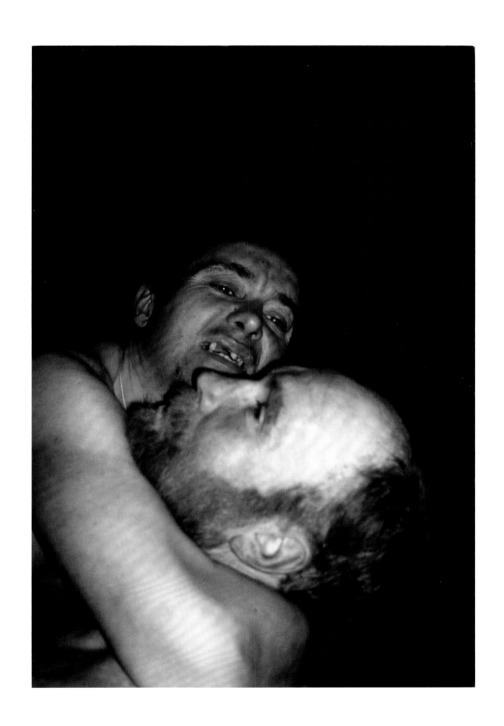

Boris Mikhailov
Untitled, 1997–98, from the series 'Case History',
1997–98

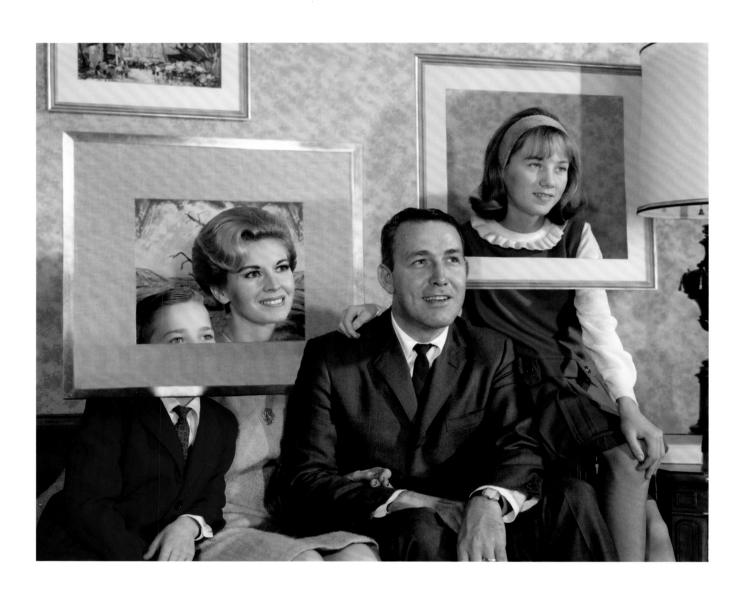

Weronika Gęsicka
Untitled #32, 2016, from the 'Traces' series, 2015–17

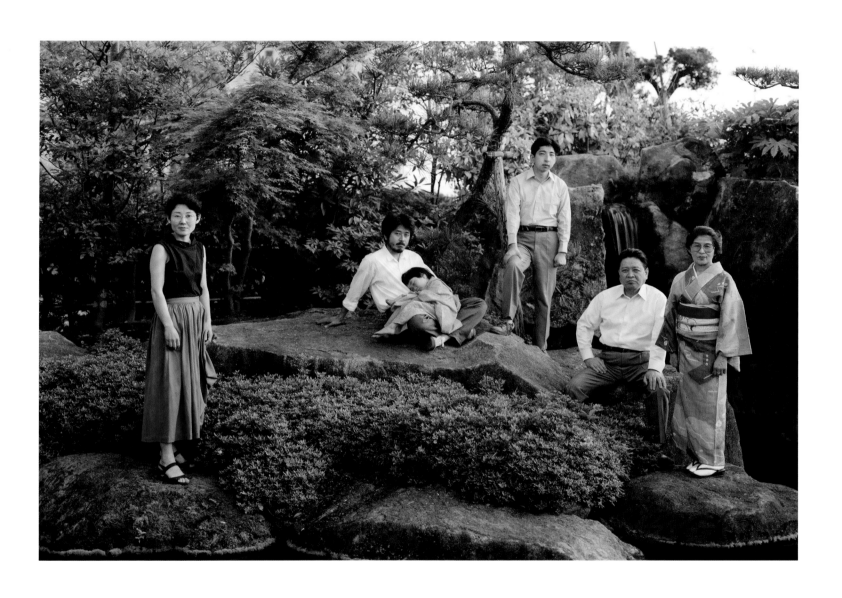

Thomas Struth
The Shimada Family, Yamaguchi, Japan, 1986

Tish Murtha
Karen on an Overturned Chair, 1981,
from the series 'Youth Unemployment'

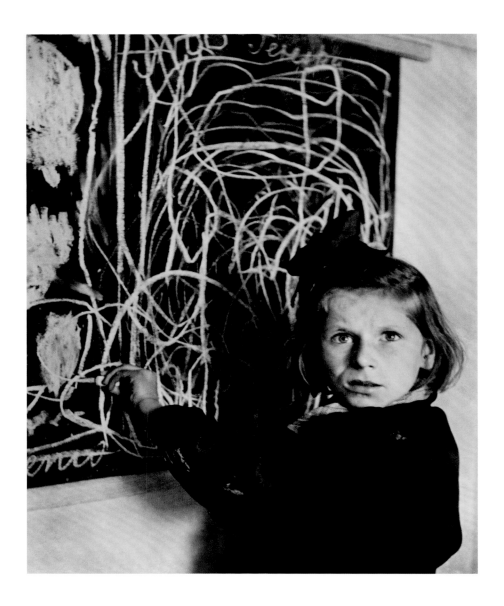

Harry Callahan
Chicago, 1950, from the series 'Women
Lost in Thought', *c.* 1950

Opposite **Consuelo Kanaga**
Young Girl (White Blouse), Tennessee, 1948

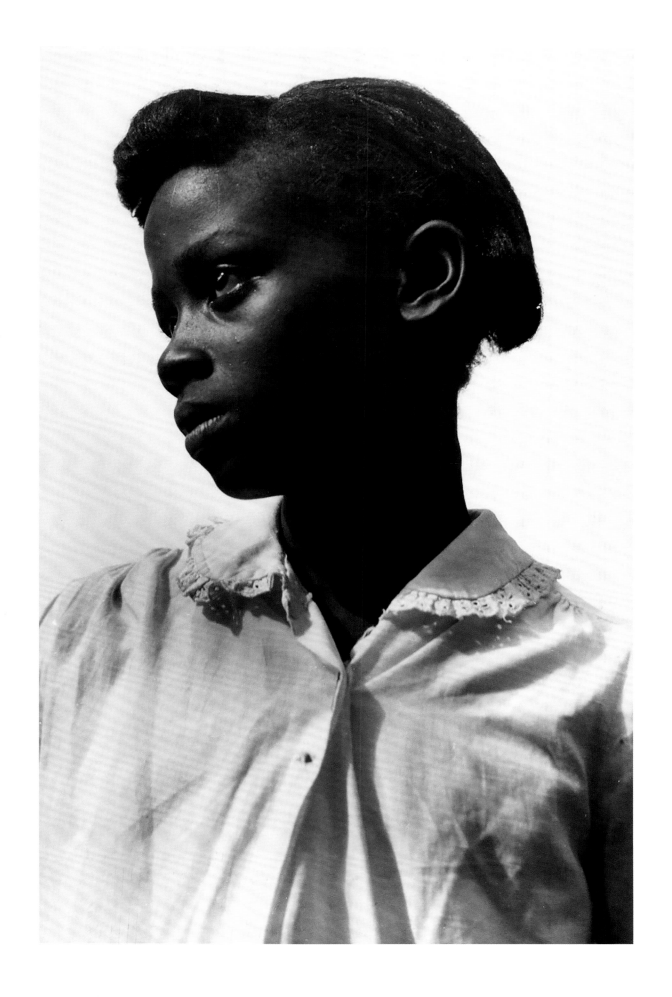

Jitka Hanzlová
Untitled (Julia), 2000, from the series
'There is Something I Don't Know', 2007–13

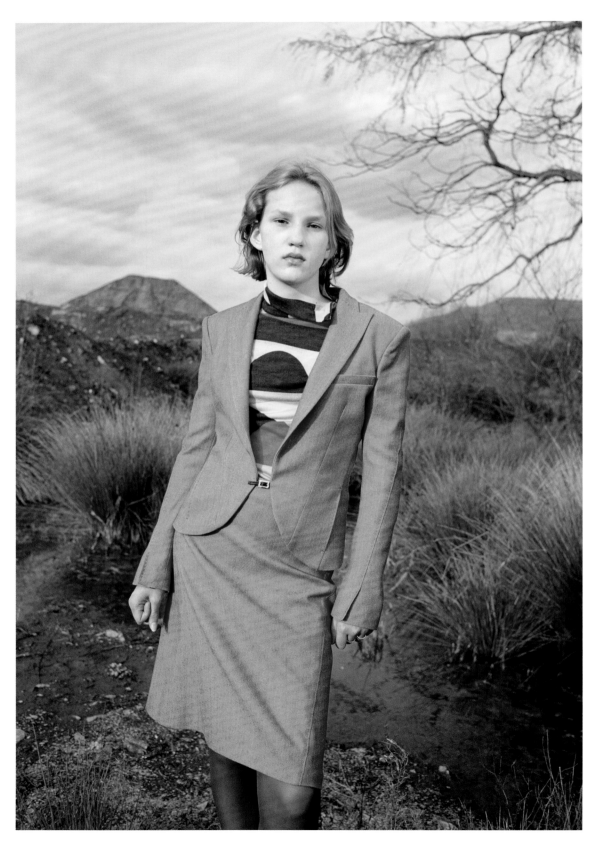

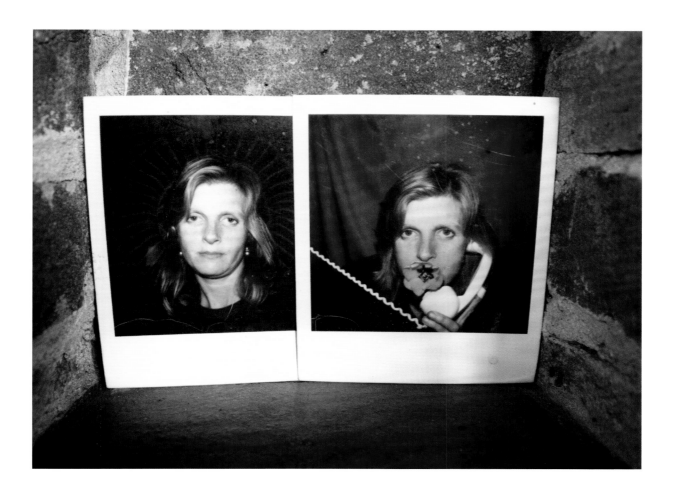

Mary McCartney

In Polaroids, Sussex, 2011

This double portrait shows two self-portraits by Linda McCartney, the artist's mother, sitting on a shelf in the family home, where they have remained since Linda's death in 1998. An accomplished musician and animal rights activist who formed the band Wings with her husband Paul in 1971, Linda began her career as a photographer in the mid-1960s, achieving recognition for her portraits of musicians. Her photography was always distinguished by its personal touch, as she frequently photographed family and friends, at home and on the road. Her playful side is revealed in these pictures, which show her surrounded by a halo on the left, and holding a flower between her teeth on the right, a telephone cord pulled taut across the corner of the picture. The flower portrait may allude to her famous portrait of husband Paul, whom Linda photographed for the cover of Wings's second album *Red Rose Speedway* with a rose in his mouth. The record contained his single 'My Love', a love song written for her. The colour of the backgrounds may also be significant – red, the colour of passion; blue, the colour of sadness.

Mary McCartney's photograph shows the artist encountering this rich history as she moves through the house, reflecting on her mother's memory. Since the two are connected through their respective photographic practices, the picture may also be seen as a private communication across time – me, photographing you, photographing yourself, much as I remember you.

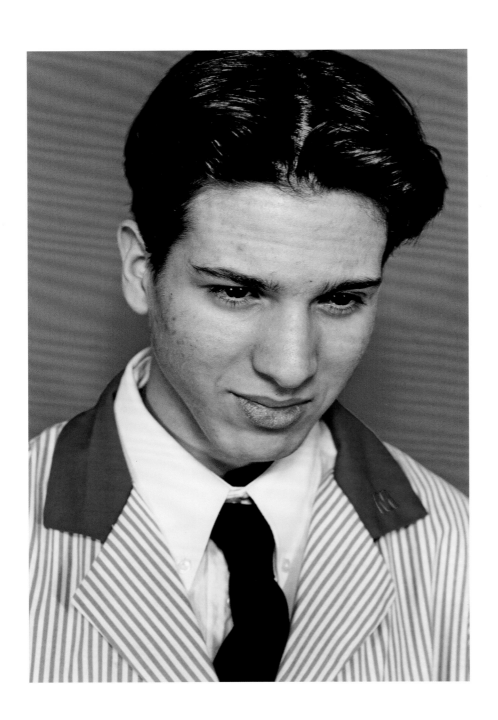

Above **Marianne Mueller**
Untitled, 1998, from the series 'M-Portraits'

Right **Tom Wood**
Rachel, Age 17, 1985, from the series
'Photie Man', 1978–2004

Irina Werning
Violeta, 1981–2011, Buenos Aires, from the series
'Back to the Future', 2011–17

Argentine artist Irina Werning's series 'Back to the Future' begins with a vintage childhood photograph, which the artist then meticulously recreates years later with the same sitter, using identical clothing and props, and where possible the same location. The project began with immediate family and friends, but expanded when viral social media posts inspired strangers to nominate themselves as candidates for the same treatment. The artist insists the portraits are intended only to show the sitters 'then and now' without subtext; however, there is something strangely unnerving about the transformations, since they show the subjects ageing while the rest of the world seemingly holds still. Some have described these pictures as nostalgic reflections on childhood, but they also invite questions of mortality.

In this picture, even though thirty years have passed, the sitter Violeta appears to drink the same cup of maté with the same metal straw; even the bent hook on the tiled wall behind her is unchanged. In addition, the artist has artificially discoloured the contemporary photograph to match the colour shift of the 1980s picture. The reconstruction is a kind of performance, as sitter and photographer try to reinvent a photograph of the past. Surprising and playful as these pairings are, they also remind us that photographs are not memories in themselves, but mnemonics, filtered through the present.

Lisette Model
Gambler, Reno, c. 1947

Opposite **Dieter Meier**
Alice Larson, 1976, from the series 'Given Names', 1976

A chameleon in his own right, the Swiss artist Dieter Meier produced the series 'Given Names' during a visit to New York. Playing on the popularity of urban street photography in the 1970s exemplified by artists such as Garry Winogrand and Joel Meyerowitz, Meier captured anonymous men and women unwittingly going about their business, attaching imagined identities to the subjects after the fact. In this picture, he photographed a middle-aged woman crossing the street, later dubbing her Alice Larson.

Meier's playful portrait inverts traditions of narrative portraiture. Instead of the subject consciously acting a part, the artist assigned a role to the subject without her knowing it, based entirely on superficialities of appearance. Consequently, the picture raises questions not only about names and their significance, but also what can be reliably gleaned about any person from a photograph. While reminding us of the limits of portrait and street photography, Meier also reveals the implicit biases involved in making preliminary judgments about people we do not know.

Perhaps best known as co-founder of the pioneering electronic music group Yello, Meier began his career as a professional poker player. In the 1960s he became known as a performance artist, frequently appearing in public spaces. His photographic work parallels his own, shape-shifting identity.

I only saw her once and later gave her a name

ALICE LARSON

New York, June 1976

Khalik Allah
Hospital (Frenchie), 2013

250

Notes

Chapter 1

1. Elsa Dorfman, in *The B-Side: Elsa Dorfman's Portrait Photography*, directed by Errol Morris, Fourth Floor Productions / Moxie Pictures, 2017.

Chapter 2

1. Felix Richter, 'Smartphones Cause Photography Boom', 31 August 2017, http://www.statista.com.
2. Samuel Morse, 'The Daguerrotipe' [*sic*], *New-York Observer*, 20 April 1839, p. 62.
3. Robert Cornelius to Julius Sachse, as cited in William F. Stapp, *Robert Cornelius: Portraits from the Dawn of Photography*, Washington, DC: Smithsonian Institution Press, 1983, p. 34.

Chapter 3

1. This is not the term Darwin himself used; it was applied later to describe the theory.
2. Darwin did attempt to study expressive behaviours of indigenous peoples across the British Empire and beyond. In 1867, he sent a printed questionnaire called 'Queries about Expression' to correspondents around the world. However, since this depended on observations of peoples whose traditional behaviours had already been changed by contact with Europeans and other ethnicities, and since the correspondents had varying degrees of professionalism and observational skill, the effort was hopelessly prone to error.

Chapter 4

1. Robinson initially hired Cherrill as an apprentice, but the two quickly became business partners operating under the name 'Robinson and Cherrill'. Cherrill left the firm in 1875 and emigrated to New Zealand.
2. Henry Peach Robinson, *The Studio, and What to Do in It*, London: Piper & Carter, 1891, p. v.
3. Cited in Violet Hamilton (ed.) and Julia Margaret Cameron, *Annals of My Glass House* [1874], Seattle and London: University of Washington Press in association with Scripps College, 1996, p. 12.
4. Michael Pritchard, *A Directory of London Photographers, 1841–1908*, Watford: PhotoResearch, 1994, p. 19.
5. Mayall, as quoted in Robinson, p. 37.

Chapter 5

1. Elloise Farrow-Smith and Catherine Marciniak, 'Mystery of the historic Lindt photographs solved by family of main subject', Australian Broadcast Corporation News, 17 April 2015, abc.net.au, unpaginated.
2. The latter were usually narwhal horns, or two horns artificially twisted together and taken from another animal.
3. For a partial list of subjects, see Galton Papers, Wellcome Library, Galton 2/8/1 Composite Photography.
4. Francis Galton, 'Composite Portraits, Made by Combining Those of Many Different Persons into a Single Resultant Figure', *The Journal of the Anthropological Institute of Great Britain and Ireland*, 1879, vol. 8, p. 133.
5. For a more detailed discussion of Huxley and Lord Granville's project, see Phillip Prodger, *Darwin's Camera: Art and Photography in the Theory of Evolution*, Oxford and New York: Oxford University Press, 2009, pp. 61–81.
6. Unpublished correspondence, Thomas Henry Huxley to Lord Granville, 12 August 1869, Huxley Papers, Imperial College London, Folio 77–78, pp. 3–4.
7. Stoneman was principal photographer for forty-one years until his death; it continued under his successor Walter Bird, then Godfrey Argent. It did not end officially until 1970.

Chapter 6

1. Audrey Withers, *Lifespan: An Autobiography*, London and Chester Springs, PA: Peter Owen, 1994, p. 51.

Chapter 7

1. Erving Goffman, *The Presentation of Self in Everyday Life*, Edinburgh: University of Edinburgh Social Science Research Centre, 1956. Revised edition published in the United States in 1959.
2. Numerous translations exist; here I am using Gernsheim's, which is reasonably faithful to the original French. Helmut Gernsheim, *The Origins of Photography*, London and New York: Thames & Hudson, 1982.
3. For more on this subject, see Phillip Prodger, *Victorian Giants: The Birth of Art Photography*, London: National Portrait Gallery, 2018.

Chapter 8

1. Ramina Abilova, 'Family Photo Albums in Historical Studies: A Case Study of the Tatar Village', conference paper, *Photography: Between Anthropology and History,* De Montfort University, 21 June 2016.
2. Ibid.
3. Robert E. Park and Ernest W. Burgess, *Introduction to the Science of Sociology*, Chicago: University of Chicago Press, 1921, pp. 53–54.
4. Ibid., p. 55.
5. This is also the title of Robert Sobieszek's landmark history of photographic portraiture (1999).

Index

Figures in *italic* refer to pages on which illustrations appear

Acknowledgments

I wish to extend my deepest thanks to the extraordinary team at Thames & Hudson for the creativity, imagination and skill with which they embraced this project: Andrew Sanigar, Sophie Mead, Heather Vickers, Karolina Prymaka, Jenny Wilson and Ginny Liggitt.

Sincere thanks also to my long-term editorial collaborator Claudia Sorsby, who provided invaluable comments on early drafts of the manuscript.

I am humbly grateful to the artists, galleries and estates represented herein, who not only generously allowed their works to be reproduced but also shared extremely helpful insights along the way.

I would also like to acknowledge the many experts who assisted me in my research, too numerous to list completely, but notably including former head of the photography section at the National Portrait Gallery Terence Pepper, who much to his likely chagrin became my go-to person for thorny questions. In addition I am particularly grateful to Stephan Loewentheil, Jake Loewentheil and Stacey Lambrow at the Loewentheil Collection; also Ellen Shapiro, Mirjam Brusius, Philippe Garner, Gerlind Lorch, Sofia Maduro and Robin Muir.

This book could not have happened as it did without the support of colleagues and friends at Curatorial, Inc. and the Solander Collection in Los Angeles, led by my dear friend Graham Howe. Curatorial is blessed with remarkable staff, including Marika Lundeberg and Natalia Leal Delgado, whose expert attention and care help bring their collections to life.

This project has allowed me to revisit collections I used to help manage earlier in my career, and I am touched by the support previous employers the Iris and B. Gerald Cantor Center for Visual Arts at Stanford, the Saint Louis Art Museum, and Peabody Essex Museum have given me. My former colleagues in the photography section at the National Portrait Gallery also contributed, each in their own way – Georgia Atienza, Clare Freestone, Sabina Jaskot-Gill, George Mind and Constantia Nicolaides.

I dedicate this book to the infinitely tolerant, kind and brilliant April Swieconek, in whose presence great ideas blossom. And to my young son Leo, much loved by us both, as he builds his own identity and self, now and into the future.

First published in the United Kingdom in 2021 by
Thames & Hudson Ltd, 181A High Holborn, London WC1V 7QX

First published in the United States of America in 2021 by
Thames & Hudson Inc., 500 Fifth Avenue, New York, New York 10110

For picture credits, please see pages 252–53

Designed by Karolina Prymaka

British Library Cataloguing-in-Publication Data
A catalogue record for this book is available from the British Library

Library of Congress Control Number 2021934196

ISBN 978-0-500-54491-4

Printed and bound in China by C&C Offset Printing Co., Ltd.

Be the first to know about our new releases,
exclusive content and author events by visiting
thamesandhudson.com
thamesandhudsonusa.com
thamesandhudson.com.au